# FEMALE GAZES

*Seventy-Five Women Artists*

# FEMALE GAZES

## Seventy-Five Women Artists

ELIZABETH MARTIN

&

VIVIAN MEYER

SECOND STORY Press

CANADIAN CATALOGUING IN PUBLICATION DATA

Martin, Elizabeth, 1946–
Female gazes : seventy-five women artists

Includes bibliographical references and index.
ISBN 0-929005-99-6

1. Women artists — North America — History. 2. Women artists — Europe — History.
3. Art, Modern — North America. 4. Art, Modern — Europe. I. Meyer, Vivian, 1958– . II. Title.

N8354.M37 1997     704'.042     C97-931937-4

Edited by Rhea Tregebov
Colour work by Lazerline

Second Story Press gratefully acknowledges the assistance of
the Ontario Arts Council and the Canada Council for the Arts
for our publishing program.

Printed in Canada

Printed on acid-free paper

Published by
SECOND STORY PRESS
720 Bathurst Street, Suite 301
Toronto, Canada
M5S 2R4

*To the spirit of creativity in all our hearts.*

— EM

*To my family and friends for their faith and patience.*

— VM

# CONTENTS

❧

# ACKNOWLEDGEMENTS

We would like to acknowledge the help and support of the community which made this book possible; our families near and far; Lois Pike, Margie Wolfe and all the women of Second Story Press; Karen Farquhar, whose pursuit of excellence never fails to inspire; Rhea Tregebov, whose eagle eye and sensitive ear allowed us to extend our reach; and our students, whose continuing challenges first inspired this journey. We would also like to acknowledge the unwavering faith and support of Angie Wong and John Botterell of the Visual Arts Department and Myra Novogrodsky of the Equity Centre and the Toronto Board of Education in developing our research for this project, which has been so much a labour of love.

℘

# PREFACE

*Female Gazes* explores the lives and works of women artists from many walks of life and from diverse backgrounds. It celebrates the wide range of contributions women artists have made to illuminating the complexities of our world. Traditionally, women in the art world have been seen as subjects or as muses, representations of women's place in society as constructed by male artists. Such representations created through the prism of the 'male gaze' have been challenged by women throughout history, and with increasing insistence in recent times. Female artists have demanded public space for women's own understandings and representations of the world; they have claimed a space for women's points of view, for a 'female gaze.'

Both of us are high school art teachers; we knew from our students that intense curiosity exists about the role women artists have played. Our research began in answer to this curiosity, as an introduction to the subject of women in the visual arts, and developed into a slide resource kit for art educators. We wanted to draw out for our students and others beyond the visual arts community examples of the powerful art women have created, whatever the obstacles, throughout Western art history as well as in our own time. We wanted also to identify some of these obstacles to women's full participation in the arts, and show how these barriers continue to circumscribe women's choices concerning artistic practice today. The artists included represent a range of periods and disciplines, and are arranged in order of birth date. In *Female Gazes*, we see evidence of hard-won victories by both established and emerging artists: women who challenged the patriarchal social scripts defining women's role as caregivers in the home, rather than creators in the public arena. These pages testify to women's consistent affirmation of their own rich veins of creative expression.

The struggle for women to name, paint and represent their own realities extends back through history. In this book we trace the general contours of the legacy of Western art in Europe and North America through the lens of women's artworks, and pick up the threads of the story with the work of artists like Artemisia Gentileschi and Sofonisba Anguissola from the sixteenth and seventeenth centuries in Europe. As authors, we wanted to examine some of the strands of this historic context as background to the exciting work being done by women artists today, particularly here in Canada. We felt that such a book, in popular form, could help bridge the gap between the general public and the sometimes esoteric art world; it could introduce a sampler of work done by some of the many remarkable women artists, making their work more accessible to the ordinary reader as well as to the specialist.

Despite claims to the contrary, women have made art throughout history; much of it however, has only recently been documented. The United States and Britain have seen many publications reclaiming the lives and works of women artists since the 1970s, but in Canada, we currently have few books for the general public on women's contribution to the visual arts. The task of telling the stories of Canadian women artists is a relatively recent one. This work is now unfolding, but it is still difficult to find material on Canadian women artists without sifting through journals, magazines and newspapers. The work of feminist scholars and organizations such as the Women's Art Resource Centre in Toronto have made this task easier; it will be the scholars of the next generation who will weave the fabric of this new work.

We are creatures of our times, and yet, as we sort through our culture we name it, judge it and try to change it in particular ways. As women, the lives and works of these artists can shed new light on our quest for a more equitable society. One of the exciting developments of contemporary women's art is its focus on bringing to life issues which confront us daily — issues of racism, sexism, violence, empowerment. Art can be an expression of the struggles of women from many backgrounds, from the rich variety of communities comprising contemporary society. Meeting the women in *Female Gazes* through their artworks and stories is an empowering experience which can teach us much about both our diversity and our commonality. ✑

# INTRODUCTION

"Why are there no great women artists?" Professor Linda Nochlin's rhetorical question, posed in the American magazine *Artnews* in 1971,[1] triggered a storm of responses and provoked an unprecedented number of feminist scholars to produce evidence to the contrary. Nochlin was among the first to call for a feminist critique of traditional art history; as the women's movement began to take root, many other women writers and artists also began to challenge the orthodoxies of the art world. The first editions of H.W. Janson's ubiquitous *History of Art* in the 1960s included no examples of work done by women; by the 1986 edition, the number had risen to just 21 out of 1235 entries[2] in response to the changing climate of awareness about women's issues, a rather telling comment on the stoney path to equity. As Christine de Pisan wrote in fifteenth-century France, "How can women's lives be known when men write all the books?"[3] The naming of our own experiences as women resulted in a flurry of feminist texts in the 1970s and 1980s. The uncovering of the history of women in the arts continues unabated to this day, with good reason in a culture where work by women still comprises only nine per cent of the collection in Canada's National Gallery.[4] The difficulties faced by women in becoming serious professionals in the arts are tenacious and deeply rooted. "Always the model, never the artist," as the aphorism goes. Nonetheless the traditional pattern of women filling the art schools, but being poorly represented among teaching and practising artists and in the galleries, is slowly but surely being eroded. We have good reason to celebrate the persistence of those women who drew, stitched, painted, sculpted, photographed and constructed their ways into the public imagination regardless of the historic barriers.

How did women manage to challenge convention and forge creative lives as artists? Artist, wife, mother, woman ... the social scripts for these roles have prevented many from achieving full creative expression. Canadian artist Paraskeva Clark points to some of the dilemmas: "It's a hell of a thing to be a painter. I would like to stop every woman from painting, for only men can truly succeed ... Nonetheless, I have had a very good career, considering a great deal of my time has been spent on being a wife and mother."[5] Some artists, like Barbara Hepworth, seemed able to balance domestic duties and life in the studio, working at families, art and relationships all at the same time. But even a highly politicized artist like Käthe Kollwitz had to insist on her right to be an artist in the face of society's expectations. Her father, who had always delighted in her art, announced when she married, "You have made your choice now. You will scarcely be able to do both things. So be wholly what you have chosen to be."[6] Contemporary artists like Judy Chicago have framed their quest as "a specifically feminist one, how to be both a woman and an artist in a society that has considered them mutually exclusive."[7] And we see the pressure of that exclusivity inscribed hauntingly in Christiane Pflug's painting "Kitchen Door with Esther" on our cover: the artist's home is her prison and her subject, at the same time as the wellspring of her family. Only recently have women argued that "a woman artist's connection to life and its processes can enhance her art rather than detracting from it, that motherhood and, for example, authorhood can be two sides of the creative self."[8]

For women the conflict between domestic expectations and the strong sense of self needed to become an expressive artist was often compounded by lack of access to training. Until the latter part of the nineteenth century, women were denied entry to classes with the nude model. In 1893, "'lady' students were not admitted to life drawing at the official academy in London, and even when they were, after that date, the model had to be 'partially draped.'"[9] A study of anatomy was an indispensible part of an artist's ability to construct compositions based on historical or mythological subjects, so women were immediately disadvantaged in producing such work. Women artists would have to be doubly determined to achieve the level of skill needed to be taken seriously as professionals. Some, like Angelica Kauffmann, did succeed; many others turned to subjects like portraiture or flower painting for which a grasp of anatomy was not so critical, but which were considered 'lesser' arts. Indeed, the so-called 'womanly' arts like needlework and china painting, which afforded many women a more easily available creative outlet, were also deemed second-rate. Deprived of education and finding what they did achieve relegated to second-class status, women found it took strength and vision to persevere. Women were, however, able to show in exhibitions

held by the fine art academies and even eventually became members of a sort. The Ontario Society of Artists's 1872 constitution allowed 'lady' members, but they did not have the privilege of voting or attending meetings except when invited.[10] But despite being barred from life-drawing classes, academies and artists's societies for years, many women found their way onto canvas.

Time and again women who painted came from painting families, where they were able to gain instruction, or more occasionally from wealthy families who were able to afford private tutelage. Baroque painter Artemisia Gentileschi's father trained her to assist him in his commissions. Gentileschi's own strength of vision, however, led her to re-invent the female form. Her painting "Judith and Holofernes" (page 21) represents Judith as a strong, active presence, full of a sense of her own agency. Judith and Holofernes, a Biblical tale, had been illustrated by male artists many times before. Botticelli's earlier version reveals a demure and delicate Judith, hardly up to the gruesome task at hand. The decorous passivity of Botticelli's Judith demonstrates a typical 'male gaze,' not unlike Lucas Cranach's version or Caravaggio's. Gentileschi's treatment

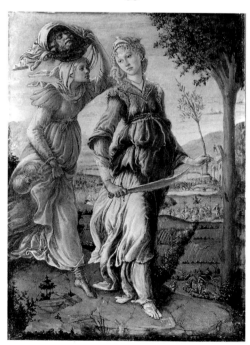

Sandro Botticelli, *Judith with the Head of Holofernes*
Uffizi, Florence, Italy; Giraudon/Art Resource, NY.

acts as a bracing corrective, the full expression of a woman's articulation of women's experience.

Gentileschi's female nudes, for example in her painting "Susanna and the Elders," also represent women as conscious and aware, rather than as idealized muses or objects of adoration. In the long tradition of the female nude as a genre in painting, we more typically find a potent vehicle for inscribing the male gaze on women's bodies, bodies read as objects of beauty, inspiration or contemplation, objects of sexual pleasure, possession and consumption. Such male control over how women are to be seen and represented erases women's real lives and experiences, and serves to maintain and reproduce patriarchal power relations in society.

The question of being taken seriously as an artist is, of course, an even larger one than access to education and development of skills and techniques; it involves as well the all too elusive conditions which make professional success possible. If women wished to paint, they were generally labelled 'lady painters,' expected to cultivate the attributes of modesty and self-denying passivity, and relegated to the ranks of amateurs. The conventional descriptor 'by a lady' assigned their work to a special category, a category well understood by the countless male critics who claimed, as Goethe did of Angelica Kauffmann, that "for a woman, she had extraordinary talent."[11] Women's place was to be that of the domesticated hobbyist, the refined patron, the carrier of culture to future generations, the charming volunteer committee member at the galleries, rather than the producer of art or gallery director. Any departure from this subordinated position would surely lead to anarchy, even 'revolution,' as claimed by Berthe Morisot's drawing master.[12] 'Lady painter' was a confining and regulating category for women, maintaining dominant social relations and using 'feminine' characteristics against women's own interests and as a foil for male privilege. 'Real' painters were those who had received a gift from on high, that inexplicable golden nugget of heroic genius which marked one for greatness. That such 'masters' were white, male and middle class, and that theirs should be the mythologized standards against which all others were measured, meant with rare exceptions the exclusion of women, people of colour, workers and the poor.

When determined women did manage to get some training

and achieve a level of professionalism as artists, they still had to face attitudes which refused them equality. Angelica Kauffmann, whose ambitions and ability brought her considerable success in Europe and England, was a founder of the Royal Academy of Arts in London in 1768. Johann Zoffany memorialized the new academy in the painting seen here; Kauffmann and Mary Moser (the other female founding member) are, tellingly, represented as reliefs on the wall rather than full participants in this historic event. There was not to be another woman elected to membership in this institution until 1922.[13] Emily Mary Osborn also draws our attention to the unstable position of women painters during the Victorian era in "Nameless and Friendless" (page 41); women may dare to paint, as she has, but without the protection of males, they are vulnerable and subject to a precarious existence.

Even today, with easier access to education, institutions and public support, many women artists find the barriers daunting. *Matriart*, a journal published by the Women's Art Resource Centre in Toronto, often includes a report "Who's Counting," which details the yawning gap between the realities of the situation for women in the visual arts and equitable representation. The statistics gathered for 1993 reveal that works by women collected specifically for the Canadian Collection of the National Gallery of Canada make up only 12.5 per cent of that collection, clearly demonstrating just how far off equity is in numbers alone.[14]

In 1970, a group of artists in New York, many from the Art Workers' Coalition, demanded that the upcoming Whitney sculpture show include fifty per cent women; it opened with about twenty per cent representation.[15] The pattern of such exclusion and neglect varies over the decades. In the liberal climate of the early 1930s, women artists had made some headway. Many large group shows in the United States included up to one-third women; in France the Salon des Femmes Artistes Modernes and a major exhibition, European Women Painters, promoted the work of women artists. But after the government-sponsored mural and war artist projects of the 1930s and 1940s ended, women were sent back to the home in the 1950s. In the post-war macho heyday of Abstract Expressionism, painter Audrey Flack noted that to make it women artists had to be

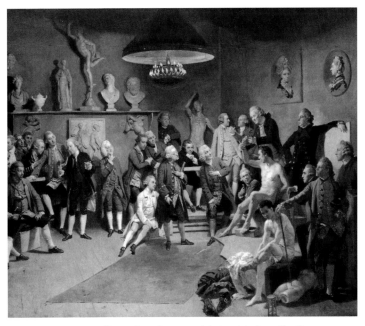

Johann Zoffany, *The Academicians of the Royal Academy* (detail)
The Royal Collection © Her Majesty The Queen

either 'one of the boys' or a sex object. "Unless [women] played the game, they weren't allowed into the inner circle."[16] With the rise of second wave feminism in the 1960s, women began to name their oppression and demand change.

In the 1970s, feminist scholars began to write the lives and works of women artists back into history — women like Judith Leyster, whose paintings had often been misattributed, or Gwen John, whose lifetime of painting had gone unnoticed by the critics who so avidly followed the career of Augustus John, her brother. The silences, omissions and underlying assumptions of the art world were held up for inspection as women looked critically at the institutional biases and social conventions preventing them from laying claim to identities as artists. Canadian artist Vera Frenkel commented in 1974: "Sometimes male artists, because they have it so rough themselves, try to destroy women artists in the early stages of their careers by labelling them in a remarkable contradictory set of ways: too strong (therefore not womanly), too weak (therefore not an artist), too pretty (either stupid or promiscuous), too ugly (deprived or depraved), too young (derivative but available), too old (tough, doesn't fuck but is probably dying to) ... and so on ... There is no approved way of being a woman, (and still alive,

inventive, responsive) let alone an artist, if you concern yourself with the self-contradictory expectations of others."[17]

The questions which then preoccupied many feminist artists and critics evolved into not only how to revise but also how to celebrate women's history and culture with projects like Judy Chicago's "The Dinner Party." Validating women's experiences also meant reclaiming the communal traditions of crafts like quilting and needlework; artists like Joyce Wieland and Faith Ringgold asserted their legitimacy as vehicles of artistic expression. Out of this climate grew a small but vibrant women's art press; journals both popular and theoretical passionately debated the issues of feminism and the arts. A central concern became whether or not a female aesthetic could be identified. Critic Lucy Lippard listed possible characteristics: "an overall texture, often sensuously tactile and often repetitive to the point of obsession; the preponderance of circular forms and central focus ... layers or strata; an indefinable looseness or flexibility of handling; a new fondness for the pinks and pastels and the ephemeral cloud-colors that used to be taboo."[18] For many, however, this search for 'essential' female traits led to the limiting strait-jacket of biological determinism which could only ghettoize women's work. Though artists such as Mary Cassatt had celebrated 'feminine' subjects like maternity in new ways, most had responded to the stylistic concerns and climate of their times, bringing new values and/or formal innovations to their work. Women artists' points of view may sometimes coincide with male ones; or they may present startling illuminations of difference.

Female artists now work from a multiplicity of viewpoints as diverse as their specific experiences, questioning prevailing conceptions of gender, race, sexual orientation, class and power. Their work helps us critique the workings of society in new ways, engaging us in a dialogue which can transform our understandings of history and social relations. Feminist art historian Griselda Pollock speaks of the plurality of positions from which feminist artists and theorists now work: "feminism signifies a set of positions, not an essence; a critical practice, not a dogma; a dynamic and self-critical response and intervention, not a platform ... Seeming to speak in the name of women, feminist analysis perpetually deconstructs the very term around which it is politically organized."[19]

Many artists from the 1980s on shared an interest in language and in psychoanalytic and post-structuralist theory as structuring factors in how women's roles are institutionalized in the family and through concepts of 'femininity.' Artists like Jenny Holzer concentrated on language, on giving 'voice' to women; Mary Kelly added objects to text to deconstruct how patriarchal social discourses structure sexuality, motherhood and gender. Many strands of feminist art explore the interconnections between social analysis and self-knowledge, between the political and the personal. The tracings of memory and history through our bodies has led women artists like Yolanda Lopez to explore autobiography and personal narrative forms. The female body — its eloquence in age as in youth, its processes, fluids, its scarring by diseases like breast cancer and AIDS, its erotic power — marks a continuing site of investigation for artists of all sexual orientations. Others stress political activism, and demonstrate the tranformative potential of women's art to make change. Jane Ash Poitras superimposed images with text to expose the racism of institutions like native residential schools. Artists of colour like June Clark and Brenda Joy Lem used text and images to articulate issues of race and immigration. Their work contributes to fertile contemporary debates on inclusion and equity. Violence against women was unmasked by Sue Coe's brutal depictions of gang rape, and by the many artists whose work dealt with the infamous massacre of fourteen women in Montreal on December 6, 1989. Artists like Lisa Steele use film and video to explore how mass media representations construct, reinforce and influence gender and power relations. Despite the current climate of backlash against women and minorities, the range of practice by women artists continues to broaden, including site-specific and collaborative projects with architects and environmentalists which reach out to public spaces.

In New York in the mid-1980s, a group of women artists donned gorilla masks and held press conferences with the intention of challenging the myth of male genius. The Guerrilla Girls insisted on anonymity, named themselves after women artists from the past, did 'pale male' counts in galleries, satirized the tradition of the female nude, and produced a stream of posters and appearances pointing a critical finger at the status quo in the art world. Their acerbic

and satiric public billboards continue to hammer home the statistics and draw attention to the inescapable facts of women's exclusion from mainstream public art institutions.

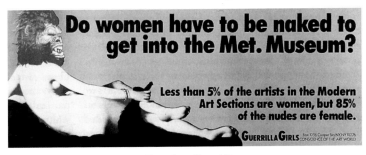

Guerrilla Girls, Billboard/Poster

Women artists today are producing exciting, probing and thoughtful work, despite the obstacles. The stories and artworks in *Female Gazes* just begin to scratch the surface of the wealth of material women artists have developed. Ours is not a close-up mapping of the terrain, but rather an overview of works from different periods, styles and communities. But what wonderful examples they are, from Frida Kahlo's piercing self-portraiture, to the soaring forests Emily Carr re-visions for us; from Faith Ringgold's girl-self flying high over the George Washington bridge in her story quilts, to the rich colours of Barbara Klunder's mordant commentary on breast cancer. In the context of a feminist critique, it is possible to explore Baroque style as well as challenge the idea of the 'male gaze' through the work of Artemisia Gentileschi, to place Berthe Morisot, Mary Cassatt and Helen McNicoll firmly in the Impressionist picture, and to investigate contemporary issues through the work of Liz Magor, Bessie Harvey and countless others. In this collection Canadian women artists from many communities join women from the United States, Mexico and Europe to reveal a myriad of perspectives on history and social issues. From the prints of Inuit artist Pitseolak to the work of Native artists Rebecca Belmore and Helen Hardin; from the images of African-American artists Lois Mailou Jones and Faith Ringgold to the films of Japanese-Canadian filmmaker Midi Onodera, *Female Gazes* explores the complexities of today's multicultural society. Social commentaries like the historic works of Käthe Kollwitz and Paraskeva Clark as well as those of contemporary artists like Janice Gurney and Jamelie Hassan probe women's reflections on power relations in society.

In drawing together the lives and works of these seventy-five artists, we hope to point the reader to the fruitfulness of looking in more depth at women's art. We hope that readers will be inspired to explore works which reveal multi-facetted perspectives on questions of identity, desire, the body, on gender and on the communities in which we live. There have been many barriers to women's full participation in the visual arts. *Female Gazes* reflects the rich vitality women artists bring to making art history as well as art, thus enriching our cultural heritage. ❧

NOTES

1 Linda Nochlin "Why Have There Been No Great Women Artists?" in *Art and Sexual Politics: Women's Liberation, Women Artists and Art History*, Art News Series, eds. Thomas B. Hess and Elizabeth C. Baker (New York: Macmillan Publishing Co., 1973), 1–39.

2 Nancy G. Heller, *Women Artists: An Illustrated History* (New York: Abbeville Press, 1987), 8.

3 Whitney Chadwick, *Women, Art and Society* (London: Thames and Hudson, 1996), 36.

4 Penelope Stewart, "Who Counts and Who's Counting?" *Matriart: A Canadian Feminist Art Journal* 4, no. 1 (1993), 13.

5 Janice Cameron et al., eds., *Eclectic Eve* (Toronto: OFY Project, 1973), unpaginated.

6 Mara R. Witzling, ed. *Voicing Our Visions: Writings by Women Artists* (New York: Universe, 1991), 155.

7 Ibid., 372.

8 Ibid., 276.

9 Nochlin, "Why Have There Been No Great Women Artists?", 24.

10 Maria Tippett, *By a Lady: Celebrating Three Centuries of Art by Canadian Women* (Toronto: Viking/Penguin, 1992), 39.

11 Eleanor Tufts, *Our Hidden Heritage — Five Centuries of Women Artists* (London: Paddington Press, 1974), 120.

12 A. Higonnet, *Berthe Morisot* (New York: Random House/Burlingame, 1990), 19.

13 Chadwick, *Women, Art and Society*, 7.

14 Stewart, "Who Counts and Who's Counting?", 13.

15 Elizabeth C. Baker "Sexual Art-Politics" in *Art and Sexual Politics: Women's Liberation, Women Artists and Art History*, Art News Series, eds. Thomas B. Hess and Elizabeth C. Baker (New York: Macmillan Publishing Co., 1973), 108, 113.

16 Cindy Nemser, *Art Talk: Conversations with Twelve Women Artists* (New York: Charles Scribner's Sons, 1975), 305.

17 Cameron et al., eds., *Eclectic Eve*, unpaginated.

18 Chadwick, *Women, Art and Society*, 358.

19 Ibid., 11.

# SOFONISBA ANGUISSOLA

(1532/5 – 1625)  *Portrait of the Artist's Sister Minerva*  circa 1559

SOFONISBA ANGUISSOLA was one of the first women artists to establish a substantial reputation in sixteenth century Italy; her celebrity was important in opening up the possibility of a career as an artist for other women. From the period of the Renaissance on, we begin to see more complete records and documentation of the lives and works of individual artists. There are over thirty extant paintings by Anguissola to testify to her stature as an artist (many were lost in a seventeenth century fire).

Anguissola came from a noble family from Cremona, Italy; she and her five sisters (three of whom also became painters) and later one brother were educated according to the dictates of *The Courtier*, Castiglione's famed Renaissance treatise which stressed a humanist education for both sexes, an idea then newly popular among the upper classes. The children were set a course of studies that included literature, Latin, music and painting. Thus it was that Anguissola was able to study privately with local portrait artists. Nevertheless, since Cremona was a provincial town away from the major artistic centres of the day, her artistic apprenticeship would have been limited. Her accomplishment is thus all the more notable; she went on to develop portraits which stand as fine examples of the Northern Italian Renaissance tradition of straightforward realism.[1] She remains one of the few early women painters without an artist father as teacher/mentor; it was her aristocratic education that put a career as an artist within her grasp. From an early age, Anguissola's talent for likenesses and for capturing the flavour of 'real-life' incidents and emotion in her work proved to be remarkable. So impressed was her father that he wrote to Michelangelo, who sent some drawings for her to copy, and later commented on them. The Italian writer and biographer Vasari also later admiringly noted her ability to capture "breathing likenesses,"[2] and included her briefly in his renowned *Lives of the Painters, Sculptors and Architects*.

The sense of moving beyond the stiff, idealized conventions of the day to a more naturalistic style is conveyed in Anguissola's portrait of her sister Minerva, whose highly expressive eyes engage us across the centuries. Anguissola's characteristic deftness with crisp details and her strategic use of warm colours are evident here too, picking out a firm composition that leads the viewer's eye from face to hands and back again. The coral of the sitter's beads pick up the warm tones of cheeks and lips, as well as reinforcing the movement of the piece. The sitter wears a symbolic pendant showing Minerva, the goddess of wisdom and the arts; it is set against a gentlewoman's rich tapestry of textures: velvet, lace, fur, contrasting with glowing flesh tones. All are executed with skill, grace and an eye for detail, set against the traditional shallow, dark background.

Portraits were Anguissola's specialty, although she occasionally took on religious subjects as well. But she seems most at home with more intimate scenes. She did her own self-portrait many times throughout her life. Her "Three Sisters Playing Chess" can be seen as a precursor to genre, or narrative, painting. It is a 'conversation piece' which stresses the domestic interactions of everyday life; it also develops the concept of a type of portrait new for the times, the group portrait. The personality of each sitter is captured sympathetically and with a sense of ease. This emphasis on the enjoyment of the everyday, of domestic pleasures, was no doubt one of the reasons why critics in the early 1900s tended to dismiss Anguissola's work as 'sentimental.'[3]

Anguissola's reputation as a skilled portraitist was undoubtedly an enhancement to her invitation to the court of Philip II in Madrid in 1560, where she remained, with the title of lady-in-waiting, for over a decade. While there, she would have been able to study and learn from the Venetian masterpieces in the Spanish royal collection. Without the need to sell her work and with the secure respectability her aristocratic status and royal patronage provided, she was able to develop and paint steadily. Her many portraits of the royal family included a commission from Pope Pius IV, who commended her "marvelous talent." Writing enthusiastically a century later, Filippo Baldinucci rated her portraits equal to those of Titian.[4] In her later years she was visited by the Flemish painter Van Dyck, who notes beside a sketch of her: "She was ninety-six years of age [apparently a bit of an exaggeration], still of good memory, clear senses and kind ... one could see she was a wonderful painter after nature."[5] In the nineteenth century much of her work was misattributed to male painters; since the late 1980s work done by feminist art historians has restored her reputation considerably. ✍

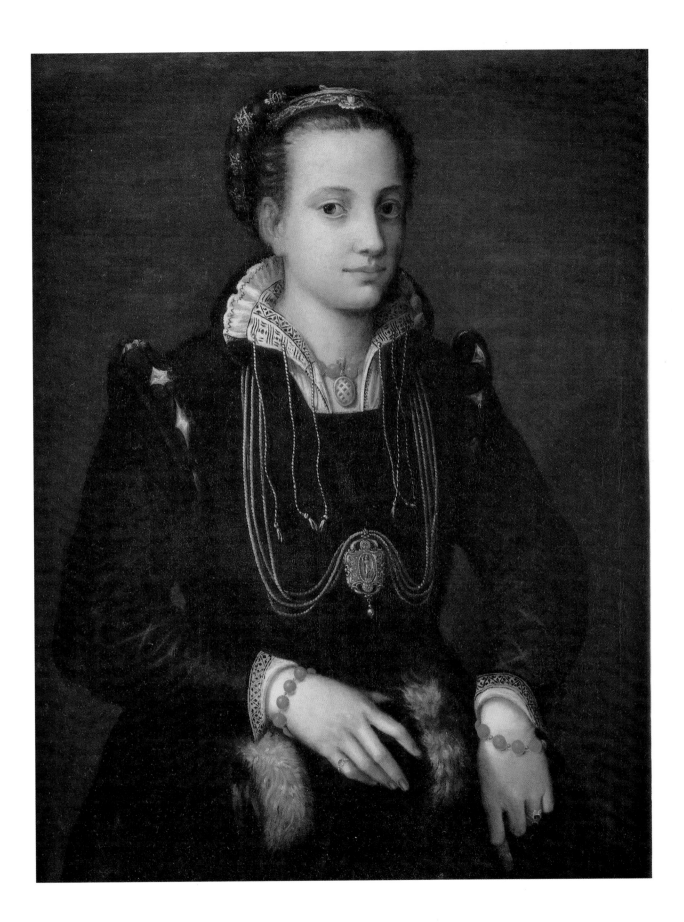

# ARTEMISIA GENTILESCHI

(1593 – 1652/3)  *Judith and Holofernes*   circa 1618

ARTEMISIA GENTILESCHI'S portraits and religious painting gained her a distinguished reputation in the Italian cities of Florence, Genoa and Naples during the Baroque period. Her many patrons from the nobility included the Grand Duke of Tuscany and the royal family of England. Born into a family of painters, like many a woman artist she was taught by her father. Orazio Gentileschi, a follower of Caravaggio, later hired a colleague, Agostino Tassi, to continue his daughter's artistic training. In 1612 Tassi was accused of raping Gentileschi, whose family took the matter to court in Rome. As was the custom of the time, Gentileschi herself was cross-examined under torture — the thumb-screw — but refused to change her testimony. This strength of character became even more evident as her career as an artist of considerable power and renown developed. Tassi, though jailed, was eventually acquitted. There has been much speculation on the connection between this traumatic event and the highly charged portrayal seen here in "Judith and Holofernes."[1] Gentileschi's depiction chooses a most dramatic and forceful moment to tell this biblical story. Judith has saved her besieged town from the Assyrians by seducing their general, Holofernes, getting him drunk, and cutting off his head, which she and her maidservant then spirit back across enemy lines in a basket. The display of Holofernes's head next day was reputed to have caused the Assyrians to flee in terror.

Biblical scenes were very much in vogue for painters of the day; Gentileschi often chose heroic women from the Old Testament as her subjects. The story of Judith had engaged many artists, including Botticelli and Caravaggio. Rarely, however, had Judith been portrayed as more than a delicate and beautiful ornament to the scene. Gentileschi gives us a portrait of a self-confident woman of action. The artist has depicted the human form with great confidence, infusing her figures with dramatic urgency through her tenebrist use of heightened light and shadow. Gentileschi's use of jewel-like colours and bold chiaroscuro effects helped to spread the influence of the Caravaggesque style in Italy.[2] In "Judith and Holofernes," all of her sophisticated technical and anatomical skills are employed to render the physicality of surfaces — draperies, fabrics, flesh — with total conviction. The characterization she draws forth in her subjects moves beyond the idealized to a brutally frank naturalism and an acute observation of emotion. Judith is here no coy decoration; she breaks the feminine stereotype, exuding strength and taking charge of her own destiny. Energy, movement and theatrical gesture combine to form an arresting composition. A complex set of interlocking limbs, thrusting angles and diagonals leads us through a pinwheel composition to the irrevocable moment of action. At the apex of the inverted triangular structure, Holofernes's head is thrust asunder by Judith's determined blow. Her maidservant is her wholehearted accomplice, another spirited actor in the piece; her vertical thrust parallels Holofernes's desperately outstretched arm, and gathers both its force and the viewer's eye into Judith's decisive diagonal. Blood spurts, but Judith is implacable; faces and bodies are grimly set to the task. There is no shrinking for the audience here.

While working within the Baroque conventions of a shallow pictorial space, a shadowy background with dramatic lighting, and a sensuous treatment of form, Gentileschi represents her story in a most atypical way. Her genius is to stage her narrative with an unflinching eye for the revealing moment, and to present her women as heroes, as the agents of their own deeds. Robust strength — psychological and physical — rather than charm and coy delicacy define her women.

Artemisia Gentileschi's success as a painter was enough to warrant a workshop of her own, where she had assistants to help paint in backgrounds and details of her canvasses. When only twenty-three, she had been invited to join the Academy in Florence, a rare honour for a woman. Although her portraits gained attention, her large scale mythological and religious paintings, like "Susanna and the Elders," Cleopatra, Esther, Diana and several variations on the theme of Judith and Holofernes are her most noteworthy accomplishments. In these grand narrative paintings she was able to present active powerful women, alive with the drama of the moment. Her "Self-Portrait as the Allegory of Painting" collapses two genres to give us a portrayal of the artist in full possession of her powers, bent over her canvas and deeply engrossed in the creative act of painting. For the first time, a woman artist represents herself not as a gentlewoman or muse, but as the act of painting itself.[3] Around 1638 Gentileschi joined her father to help him at the court of Charles I in London; her work can still be seen at Greenwich.[4] She continued her prolific life as a painter in Naples until she died in her fifties, passing on some of her skills to her daughter.  ∽

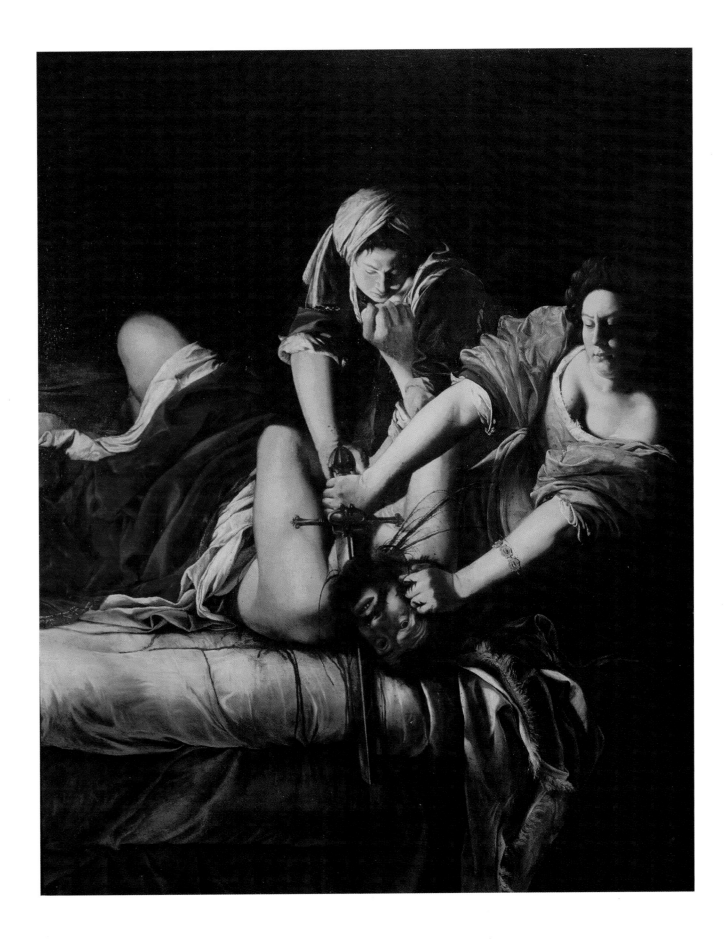

# JUDITH LEYSTER

(1609 – 1660)   *The Flute Player*   1630

ALTHOUGH THERE were several outstanding Dutch women painters of her period who excelled at still life, Judith Leyster is unique in developing intimate genre paintings — story-telling or narrative scenes — which were popular with the developing middle class. Although Leyster did portraiture and still lives as well, she is best know for scenes like "The Flute Player," which capture a 'slice of life,' a spontaneous moment that continues to move the viewer, reaching out to us across the centuries. What we know of Leyster is a tribute to women scholars, who in 1927 began the task of reclaiming many of her works which were previously attributed to Frans Hals and Gerhard van Honthorst. (Misattribution is an all-too common problem for feminist scholarship). At this date, only about twenty of her paintings are known.[1]

Judith Leyster was, atypically, not from a painting family who passed on knowledge and support; her father was a successful Haarlem brewer. Nonetheless, she was encouraged to draw, her talents bringing her a mention in a book on her native city when she was only seventeen.[2] In 1628 the family moved briefly to Utrecht, where Leyster took great interest in a local group of artists who, while visiting Italy, had been influenced by the Caravaggesque style. Some of these ideas found their way into Leyster's work, principally the large-scale treatment of a small number of figures in a canvas, and the tenebrist play of light and shadow which remained a lifelong fascination for her. Many of her paintings employ a single candle as a light source, a device much favoured by the followers of Caravaggio.

Back in Haarlem, Leyster studied with the town's leading painter, Frans Hals, with whom she shared a delight in freely applied brush strokes and spontaneous, high-spirited contemporary subjects. Her work was so well thought of that she was the only woman admitted to the local painters guild in 1633; she soon had three pupils of her own. Unfortunately one of them (and the income from fees thus represented) was lured off to Hals's studio, ending their friendship and resulting in a successful lawsuit against Hals by Leyster.[3] In 1836 she married a fellow painter and moved to Amsterdam to raise a family. The difficulties of juggling two careers — painter and mother — particularly when one of them competed with her husband's, seem to have proven too heavy a task, and it appears that her output declined dramatically from this time.

Judith Leyster's brief career has left us with many wonderful scenes from the life of her times, showing us contemporary dress and settings and portrayed with vitality and *joie de vivre*. Her own self-portrait, brush in hand, shows the strong character and pleasure in life so pervasive in much of her work. Although domestic life and the quiet pleasures of interior family scenes had developed into a favourite subject for the Dutch burghers, Leyster was among the first artists to choose the day-to-day life of women and children as a subject.[4] She probes the psychological inter-relationships of her subjects with great acuity. One painting by Leyster of particular note is "The Proposition" (1631), in which a woman bends fixedly over her sewing, rejecting the unwanted attentions of a man with money in outstretched hand. This was a not uncommon subject in the 'merry company' low-life scenes popular at the time, but Leyster's is a unique version of a tale which preferred to represent women as compliant, rather than defiant of unwanted advances.

In "The Flute Player," we see a rather quieter, more contemplative mood than in many of Leyster's works. The flickering brushstroke is tamed in most passages except for highlights and ruff. Her versatile control of texture and the play of light ranging over tone and colour are evident as the eye takes in the surfaces of flesh, lace, velvet and wood. Compositionally more adventurous than Hals, Leyster here employs intersecting triangles. The eye is led through the coat, bow, flute and arms to the face and then back out of the picture plane with the boy's gaze, in a particularly intricate move. The diagonal of the coat and figure are balanced by the strong, framing vertical thrust of violin and lute on the right. Richly austere colour harmonies allow the red hat and white ruff to further frame a face lost in concentration. "The Flute Player" is a fine study of the intimate moment, of a boy caught up in the magic of his music. ✍

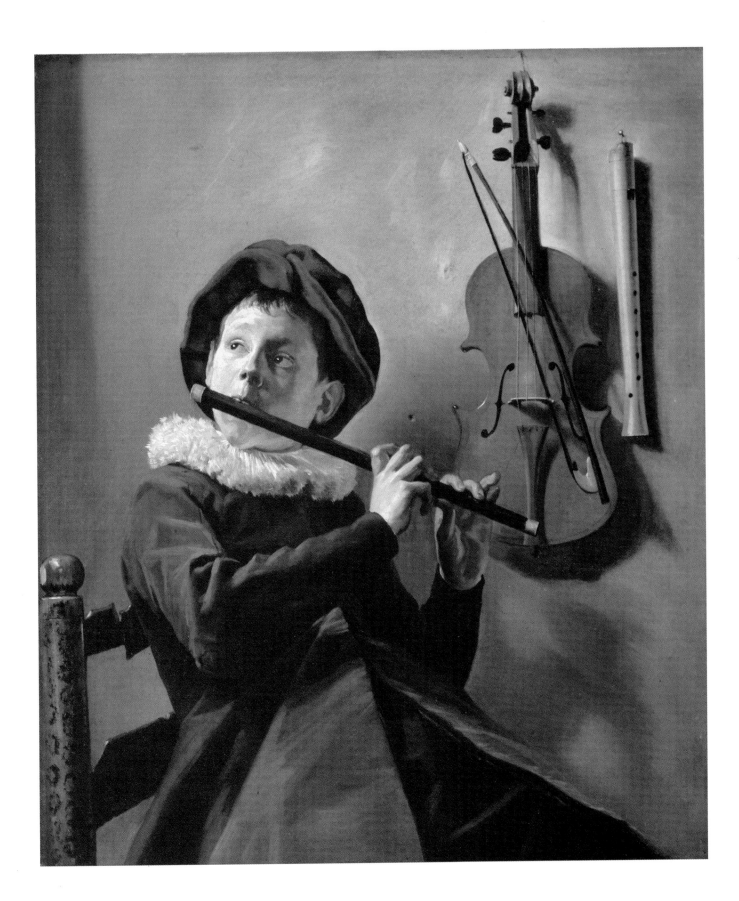

# RACHEL RUYSCH

(1664 – 1750)   *Flower Still Life*   after 1700

THE SEVENTEENTH century in Flanders and Holland witnessed an unparalleled blossoming of still life painting. This particular type of painting appealed to an emerging and prosperous middle class intent on both scientific examination of all the variety of the physical world, and the development of artistic traditions which reflected material beauty. Although still life never managed to attract the critical attention accorded the figurative tradition in painting, it was immensely popular at this time. Substantial patronage attracted many noted painters, both male and female. Women artists, who generally found themselves blocked from the training in drawing from the nude model required for history and allegorical painting, had easier access to developing the skills necessary for still life. They thus enjoyed a more equal footing with male painters in this field. Rachel Ruysch eventually became so widely respected as a flower painter that her works commanded prices comparable with those of her famous predecessor, Rembrandt.[1]

Born in Amsterdam of middle-class parents (her mother was the daughter of an architect and her father was a professor of botany and an amateur painter), Rachel Ruysch apprenticed at age fifteen with the renowned flower painter Willem van Aelst. His asymmetrical, spiralling sense of composition found its way into Ruysch's style of painting, which quickly began to make its mark in the field. In 1693 Ruysch married Juriaen Pool, a portrait painter, and proceeded to have ten children. A woman of formidable energies, she nonetheless produced more than one hundred signed works over the span of a career which lasted into her eighties.[2] In 1701, she and her husband moved to The Hague, where they both became members of the artists' guild. Ruysch's developing celebrity led to a period as court painter in Düsseldorf, where she enjoyed the patronage of the Elector Palatine. The steady and prestigious clientele she was able to establish over the course of her lifetime attests to the exceptional quality of her work, which continues in high repute. In 1973 one of her pictures fetched £31,500 at Christie's in London.[3]

A myriad of the physical specimens — fossils, shells, animal skeletons, rare snails — collected by her father find their way into many of Ruysch's paintings, illustrating her profound knowledge of the worlds of zoology and botany. Her work generally falls into two categories: still life arrangements of flora and fauna set in dark woodland settings, and the widely acclaimed flower paintings. Even in the latter, Ruysch injects a note from the animal world; often an insect or small mammal is present. Her paintings follow the prevalent preoccupation of still life with symbolism — the opulent tangibility of oil paint is demonstrated to be mere illusion through its portrayal of subjects from nature emblematic of the brevity and transcience of life.

"Flower Still Life" can be read as a magnificent example of the *vanitas* tradition: the fresh, perfect bloom of today will tomorrow inevitably decay. But Ruysch's celebration of the ideal in nature, of 'divine creativity,' almost overtakes the moral lesson. She revels in presenting us with a sumptuous vision of perfection, following the notion that the artist's task is "to select from nature and to portray perfectly what nature could only render imperfectly."[4] She ranges her lights and darks, her masses of warm and cool colours dramatically along a strong, sinuous diagonal, choosing energetically twisting stems and leaves and a profusion of sumptuous blooms to draw the eye into her artful composition. Surprises abound: a flower falls over the edge of the table; the weaving spiral is echoed by snail shells; perfect blooms nestle against leaves already drying to dust. A bee draws sustenance from a flawless blossom — as does the viewer — reminding us of the interdependence of the natural world, one of Ruysch's familiar themes. Despite the complexity of design and almost abstract sense of sculptural massing of form, the composition surges with vitality and energy, all expressed with the greatest technical assurance.

Much scholarly investigation remains to be done on this artist, who has often been the subject of misattributions and imitations.[5] The brilliance of her work within her chosen field — her bravura celebration of the transient perfection of nature — should amply reward the research yet to be undertaken. ◌

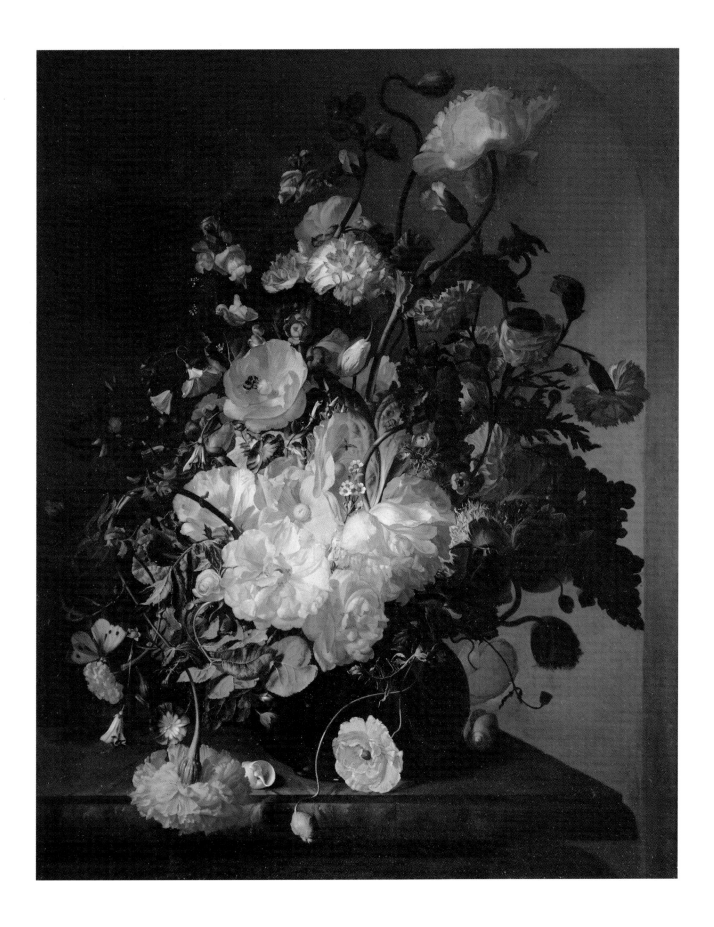

# FRANÇOISE DUPARC

(1726 – 1778)  *Young Woman Mending*  n.d.

A GREAT DEAL remains to be uncovered about this rather unique and little-known French painter. Françoise Duparc's life and work, like that of so many woman painters, awaits the research of those dedicated to bringing to light the contributions women have made to the course of art history.

Duparc was born in Spain and grew up in Marseilles, where she seems to have had some training from her sculptor father as well as a local painter, van Loo. Later in life she moved to Paris, where she may have seen the work of her contemporary, Chardin, and to London, achieving some success; she returned eventually to the city of her youth. Back in Marseilles, she is known to have been a member of the local Academy.[1] Today four of the paintings which she bequeathed to the town hang in the Marseilles Musée des Beaux-Arts, giving us a glimpse of a most original and unpretentious artist painting in an age known for morally edifying allegory and history painting. These four are among the very few paintings known to be by her hand — a sign of the work still needing to be undertaken by scholars.

Neither the grand manner of the Baroque style with its high drama and historic, mythological or religious subjects, nor the fanciful bravura of the aristocratic Rococo style seem to have swayed Duparc. Rather, her work falls more within the style of Dutch genre painting of the preceding century — narrative painting of scenes from everyday contemporary life — but with an emphasis on human dignity that is her own. As we see in "Young Woman Mending," Duparc's genius was to show humble folk engaged in the simple, domestic tasks of everyday life. At a time when genre painting was not yet as fashionable in France as it was elsewhere in Europe, Duparc, like Chardin, chose working-class subjects in settings which allowed her to concentrate with direct and truthful observation on the human figure. Her subjects are engaged in their own world; each of the pictures known to be by her hand tells a small story which eloquently defines the character of the sitter. Thus she combines both portraiture and genre painting. She depicts her sitters as though caught in a fleeting moment, focused on the tasks of everyday life.

Duparc paints here with heavy brushfuls of oil paint and in a rather rough, broad manner, disdaining conventional 'finish.'

Colour is muted, with warm golds and browns set off austerely by the turquoise accent of the cap. She chooses clarity of form defined by gentle front lighting and broad shadows, directing the viewer's gaze from face to hands at work, and back again. Behind the figure a haze of light pushes the sitter forward from the shallow background into the space of the viewer. The mood Duparc sets strikes us as an authentic one of quiet absorption. Her direct and unaffected naturalism shows a profound respect for ordinary people; the mender glows with inner life and a quiet pride in her work. The reverent treatment of such a subject is one of the treasures we find in looking at art by women — Duparc reclaims the significance of women's everyday work in this strong, dignified portrait. As with her three other paintings in the Musée des Beaux-Arts, the concentration is on the human figure and simple tasks rather than on setting. There is no flattery or heroic 'improving message' for our edification here; rather we find an evocatively captured moment celebrating strength of character and pleasure in work.

Glimpses of the working classes are all too rare in the history of art; Françoise Duparc set down for all time in just a few known works the warmth and dignity of working people. The subjects of her other canvasses in Marseilles are a woman selling herb tea, a man carrying a sack, and an old woman, her arms reddened by years of washing.[2] Duparc's career was cut short by illness; she died at age fifty-two, mentioning forty-one paintings in her will. Most of these languish in obscurity and have yet to be tracked down. Perhaps in time they will join the four canvasses of the Marseilles Musée des Beaux-Arts in the annals of history. ✂

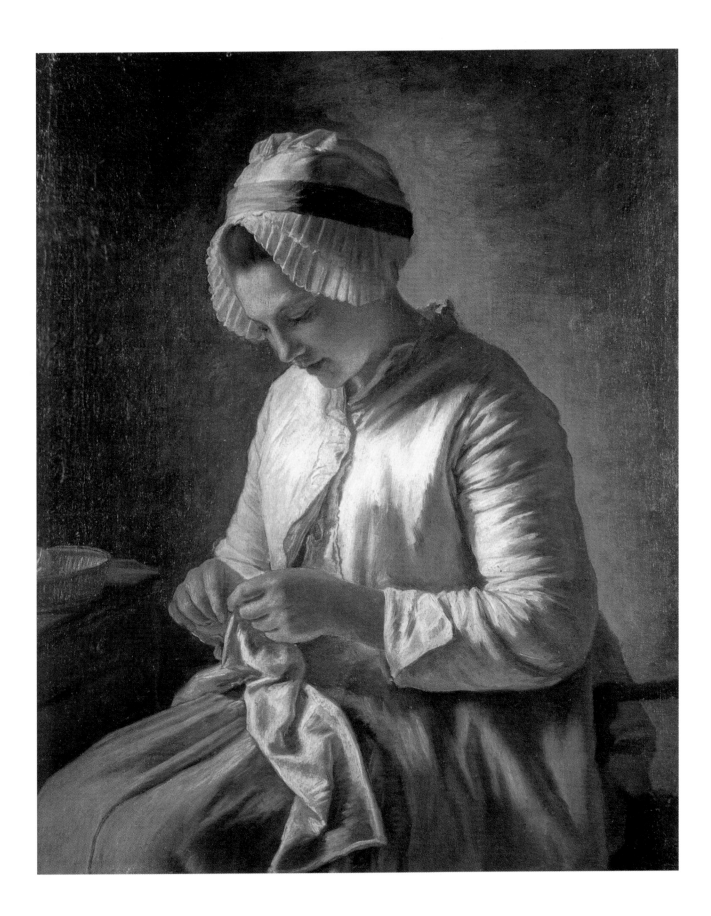

# ANGELICA KAUFFMANN

(1741 – 1807)  *The Artist Hesitating Between the Arts of Music and Painting*  circa 1794

*For a woman, she had extraordinary talent. — Goethe* [1]

ANGELICA KAUFFMANN was a child prodigy. As a young teenager, she traveled throughout Europe with her Swiss father, helping with his commissions for religious paintings and doing many portraits of her own. She had a gift for putting her sitters at ease, and the quality of refreshing informality she achieved is evident even in her later large group works. Her training included travel to Italy, where she copied the works of the 'old masters' in galleries such as the Uffizi in Florence. Here she met the American neo-classical painter Benjamin West, through whom she gained many commissions. She also knew and painted such luminaries as the archaeologist and neo-classical theoretician Winckelmann, the British painter Sir Joshua Reynolds, and the poet/scholar Goethe, with whom she became great friends.

Kauffmann was also remarkably talented as a musician, singing and playing several instruments. When she was only nineteen, she felt she had come to a crossroads in her life, and needed to make a total commitment to either art or music. Her self-portrait (done much later in life) is an allegory of the choice she made and the difficulty she had making up her mind. We see the artist turning reluctantly away from the mourning figure representing Music to the new horizons promised by Art, both represented as idealized mythological figures. The dramatic gestures, fluttering draperies and tempestuous skies portending an emotional decision draw on Baroque conventions. The heroic idealized figures, classical dress and graceful poses shown in a clear light manifest the neo-classical influences of the day, which she had inherited from her mentor Winckelmann. What is unusual here is that the artist has chosen to depict a personal dilemma in terms of an allegorical self-portrait, a rather singular fusing of two genres. She has chosen a pivotal point in her own life's journey as a subject worthy of painting, and staged it in a graceful neo-classical style.

Kauffmann excelled at many types of painting, most particularly history painting, then considered the loftiest category and generally beyond the reach of women painters. It is a tribute to Kauffmann's virtuoso skill and ambition that she was able to compete professionally and so successfully in this area, as well as in the more 'minor' genre of portraiture, despite her lack of access to training from the nude model.

When only twenty-three, Kauffmann was invited to join the Academy of St. Luke in Rome. Thereafter she traveled to London with a British lady patron. She was a great success, and was likened to Van Dyck and Rubens. Distinguished patrons and moneyed families vied for her pictures, and she became a close friend of Sir Joshua Reynolds, the first president of the Royal Academy. In 1768 she was one of the thirty-six founding members of the Royal Academy in England. Kauffmann and the only other woman member, Mary Moser are depicted in Johann Zoffany's group painting of the academicians quite tellingly, as mere portraits hanging on the wall in the presence of the august male members (shown in person)! (In fact, it is not until the 1920s that we again find women elected to the British Academy.) Kauffmann showed history paintings of great originality at the Royal Academy exhibitions, choosing allegorical subjects not only from Greek and Roman history, but also from British antiquity. Her work was instrumental in popularizing neo-classicism in England.[2] But commissions for portraits were more popular and lucrative, so much of her energy went into pictures for the aristocracy, often with as much of an allegorical interpretation as she could manage. She also painted many self-portraits, the earliest dating from age thirteen.

In 1780, Kauffmann settled in Rome, where commissions flowed in from all over Europe. Such was the status she enjoyed that she was able to refuse a position as court painter to the King and Queen of Naples in order to stay in Rome. Her somewhat avaricious second husband took on the role of agent and pressed her to keep up her prodigious output of work, much to the disgust of Goethe, who thought her work of such high quality that she should paint only to please herself.[3]

For the last decades of her life, she was reputed to be the most celebrated living painter in Rome, and received many illustrious visitors in her home and studio. At her death, the Academy of St. Luke erected a marble bust of Kauffmann in the Pantheon in Rome, honouring her as a worthy companion to Raphael and the other distinguished artists commemorated there. ❧

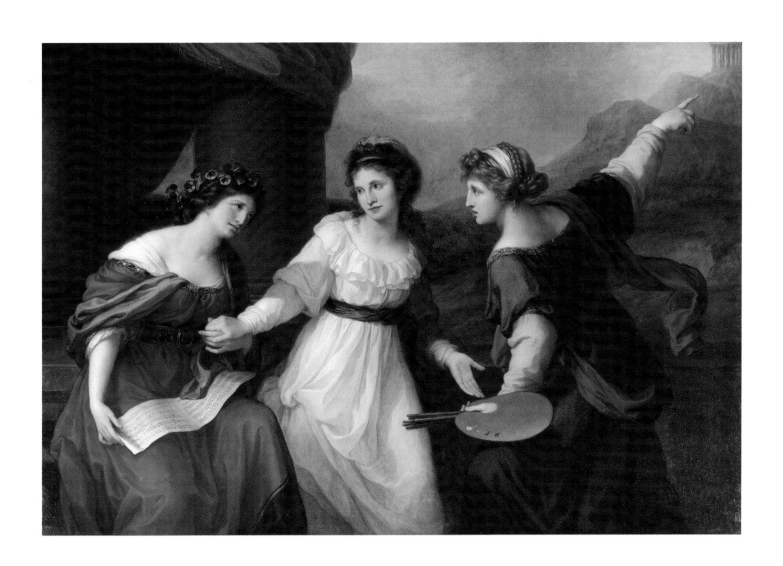

# ELISABETH VIGÉE-LEBRUN

(1755–1842) *Self-Portrait* n.d.

AN EXCEEDINGLY popular French court painter, Elisabeth Vigée-Lebrun occupies a place of prominence among renowned eighteenth century women painters. She survived a life of high adventure: befriended by Marie Antoinette, escaping the terrors of revolutionary France, travelling to the courts of Europe and Russia during a twelve year exile, and finally returning to find acceptance at the court of Napoleon. Her memoirs give a spirited picture of the high society life of the time.

Vigée-Lebrun, like so many women painters, was first taught by her father, a portrait painter. Young women were unable to enter the École des Beaux Arts in Paris, so she studied at home and with her father's colleagues. Her father died when she was twelve, from which time Elisabeth took commissions to support her widowed mother and brother. By the time she was fifteen, she was well established as a portraitist of considerable talent, showing her sitters in a charming manner to their best advantage.

When she was twenty-four, she did the first of many portraits of Marie Antoinette. The Queen was only a year older, and the two had an immediate rapport, which opened many doors for the precocious young painter. To gain entry to the Royal Academy of Painting, Vigée-Lebrun attempted history painting. Members of the Academy flustered that they already had two woman members, and three would be too many, but with Marie Antoinette's support Vigée-Lebrun prevailed.[1] With the advent of the French Revolution, such patronage became a liability, and Vigée-Lebrun and her only child made a dramatic escape from Paris the night Marie Antoinette and Louis XVI were arrested.

In Rome, Vigée-Lebrun was received by the Queen of Naples (Marie Antoinette's sister), and indeed she found the courts of Austria, Russia and England eager for her captivating and idealized portraits. Catherine II of Russia received her thus: "I am delighted, Madame, to see you here; your reputation has preceded you."[2] When she was finally able to return to Paris twelve years later, her commissions continued via the new political order. She painted such illustrious figures as Madame Du Barry, Madame de Staël and Napoleon's sister, Caroline, completing over six hundred portraits in her lifetime as well as many landscapes.[3] Such was her wealth and position that she held many salons, entertaining fashionable Parisian society and documenting her circle in her memoirs.

Vigée-Lebrun's self-portrait shows us a young woman possessed of an eager self-confidence and *joie-de-vivre*. The mood of sprightly gaiety and optimism and her obvious delight in luxurious textures, surfaces, fabrics and details are typical of many of her portraits. Much of her early work shows the influence of the Rococo style, revelling in soft, feathery effects. Later, we see elements of the vogue for neo-classicism in her choice of antique-inspired dress and poses and clear, defined lighting. The self-portrait here perhaps sets a course between the two, showing a physicality and realistic approach grounded in her youth, brilliance and sense of security in her abilities. The bravura handling of anatomy, colour and composition are typical of much of her work. Vigée-Lebrun strikes a symbolic pose with the tools of her trade to be sure, but her gaze, framed by white ruff and hat, moves to lock with ours in an act of communication beyond the pose. Her spirits are high; she has dared much, and she has been a success. The canvas she paints is of the Queen.

Vigée-Lebrun's critics find her vision a flattering and escapist one, a mirror to the way the decadent aristocracy wished to see itself. Nonetheless, she captures individual personalities of the courts and their fading way of life brilliantly and with an attention to superficial appearances which is perhaps appropriate. As one critic notes, her work typifies "a final attempt by Ancien Regime society to shut its eyes to unwelcome realities, and to take refuge in a world of make-believe and fancy dress."[4] ℘

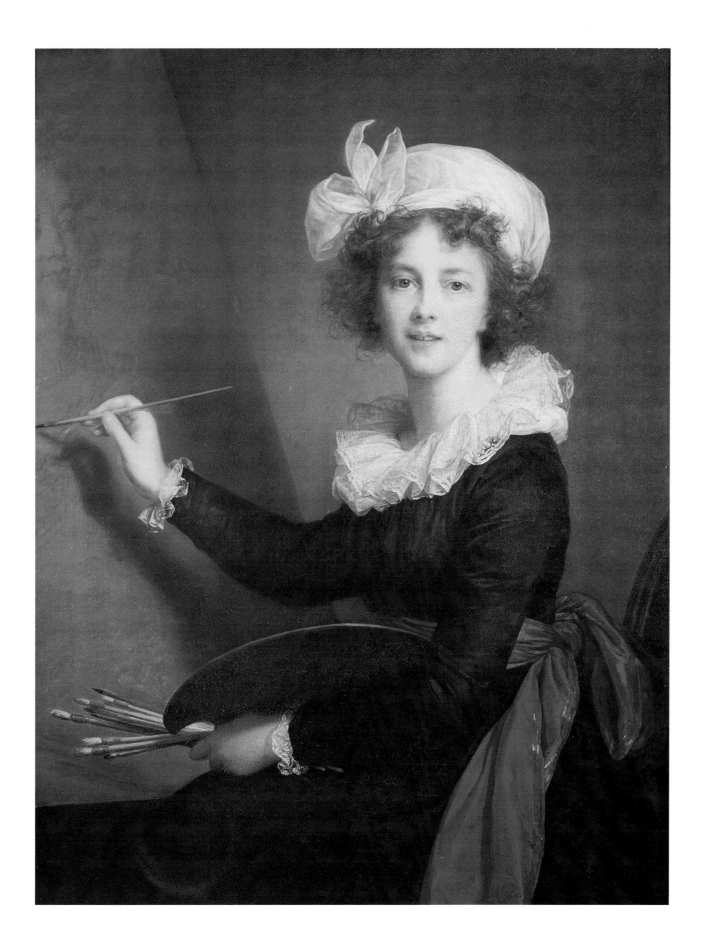

# SUSANNA MOODIE

(1803 – 1885)   *Bouquet of Garden Flowers*   1869

SUSANNA MOODIE'S book *Roughing it in the Bush* chronicled her experiences as an early settler in the 1800s in Canada. In it Moodie revealed how ill-equipped many settlers were to cope with the struggles of pioneering in the new land. Despite her life of poverty and hardships, Moodie achieved status as a writer and an artist.

Moodie spent her youth in Suffolk, England where her writing was encouraged by her family. She married Dunbar Moodie, an officer, and emigrated with him to Upper Canada in 1832. The early years in Canada were especially difficult as the couple tried to hew an existence out of a desolate parcel of land in Douro Township, north of Peterborough, Ontario. In addition to their labours on the farm, Moodie and her husband both wrote articles, sketches of pioneer life, essays and poems which they submitted for publication. Moodie's writing was not overly popular, perhaps because the realism of her early social criticism touched upon issues sensitive to other Canadian settlers. Throughout her life Moodie maintained a particularly close relationship with her sister Catharine Parr Traill who had also emigrated to Canada and written about her life in the new land. The sisters' relationship, often maintained through correspondence, provided Moodie with much comfort; the women supported each other through their difficult lives. "Dear Kate, she has had like myself a troubled walk along the dusty way of life, but has borne a severe lot with the same lovable serenity which marked her youth."[1]

In the mid-1800s Moodie's attention shifted to her developing skill as a painter of flowers. Her watercolours were popular and sold in Belleville, Toronto and Montreal, eventually providing Moodie with a better income than her writing had done. Moodie was now carrying the bulk of the family financial responsibilities since her husband was quite ill. She too had physical ailments resulting from their hard lives.

> I want to get my own living as long as I can work; and as I am not a popular author I employ myself painting groups of flowers, which pay me from a dollar to three dollars a group. I am fast improving this long neglected talent, but my poor eyes suffer more than I like to let my dear husband know.[2]

The literary agents the Moodies dealt with would often only take their writing if accompanied by a watercolour. Moodie enjoyed painting and loved and missed the many gardens she remembered from her youth. She had taken art classes in England as a young woman. Now she found that she could transform her 'amateur' skills into something of a profession, using her own abilities to "keep the wolf from the door."[3] It is unclear how long Moodie painted, but "the works served to supplement a meager income during the years 1863–1869."[4] Her skill was passed on to her daughter, Agnes Fitzgibbon, who eventually produced a book of hand-painted illustrations of Canadian wild flowers.

"Bouquet of Garden Flowers," painted in 1869, a few months prior to Dunbar's death, is typical of Moodie's work. The painting consists of a central arrangement of a variety of flowers in a pleasing array of colours and shapes. As with all her paintings, no background is portrayed. This type of flower painting was taught to many 'gentlewomen' in England, as it was thought to be an acceptable pastime for well bred women. Attention to minute detail and accuracy were emphasized in this genre. Moodie's work is a little less rigorous than traditional pictures in this style; she herself thought she could have had more training. However the immediacy and freshness of composition evident here were undoubtedly what made her work popular. Each flower is clearly represented through colour, texture and form as it emerges from the crowded bunch. Moodie's keen powers of observation, so present in her writing, are also evident in her painting, although in these works social realism yields to a happy expression of nature. Despite her success with her flower paintings, Moodie later went on to turn her hand to subjects such as "The First Mine in Ontario at Marmora, Hastings County,"[5] a documentation of social conditions that interestingly parallels her writerly interests. ◡

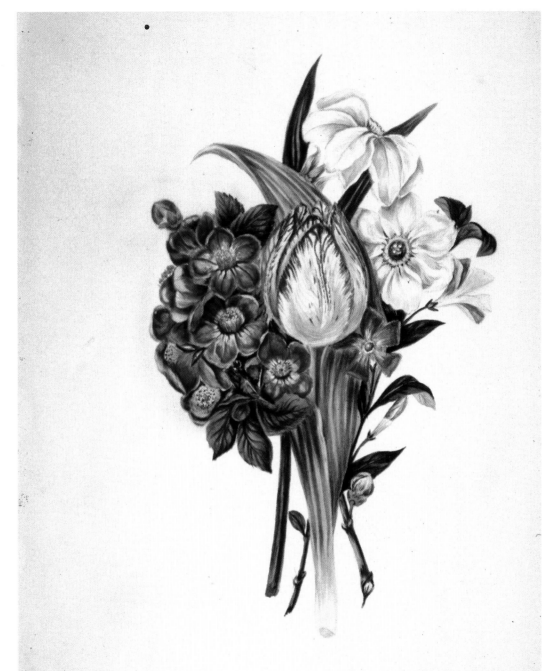

Susanna Moodie
Belleville
June 10th 1869.

# ANNE WHITNEY

(1821 – 1915)   *Charles Sumner*   n.d.

IN THE NINETEENTH century, increasing numbers of women were drawn to painting as a profession despite the educational obstacles and lack of access to study of the nude model which they faced. In America, we see an additional phenomenon in the rise in popularity of sculpture as an expressive medium for women. The production difficulties, expense, and prevailing view that "masses of wet clay, blocks of marble, and castings of bronze are rude and intractable materials for feminine labors,"[1] make the achievements of these women all the more remarkable. Anne Whitney was one artist whose work was a particular triumph over such myopic prejudice.

Born in Massachusetts to a wealthy and liberal family who supported her interest in art, Anne Whitney had the financial means to pursue studies in sculpture in New York and Philadelphia. At the outset of her career in Boston, her main interests were writing and poetry. She was also drawn to the political ideas of women like suffragists Lucy Stone, Elizabeth Blackwell, who was trying to establish a women's hospital in Boston, and Antoinette Brown, the first ordained woman minister in America. Whitney's commitment to progressive movements led to a search for other means of expression for her ideas concerning the abolition of slavery in the South as well as the enfranchisement of women; this she found in sculpture.

In 1867 she went to Rome, where she became part of a circle of American expatriate women sculptors including Harriet Hosmer, Emma Stebbins and Edmonia Lewis. All had studios near the Spanish Steps in Rome, and chose independent, creative lives over marriage. Such unconventionality did not go unnoticed, and Nathaniel Hawthorne, Henry James and other writers visiting Rome immortalized members of the group in their writings. Elizabeth Barrett Browning remarked of these 'emancipated' young women that Hosmer "lives here all alone (at twenty-two), dines and breakfasts at the cafés precisely as a young man would; works from six o'clock in the morning till night, as a great artist must ..."[2] Free spirits all! Whitney's subjects for her sculpture at the time were influenced by her continuing and critical interest in the social issues of the day, and highlight political themes and figures. She chose as an allegorical figure to represent 'Rome' an old beggar woman, with portrayals of the decline of Rome worked into her dress. Such was the ensuing furor from the Papal Court in Rome that the bronze was moved to Florence.[3]

Back in America in 1871, Whitney began to receive public commissions. She worked in marble for a statue of Samuel Adams commissioned by the government in Washington for the Capitol Building. In 1875 she entered a model in a competition sponsored by the Boston Art Committee for a statue of Charles Sumner, an abolitionist senator. The entries for the competition were identified by numbers rather than by the artist's name, and Whitney's model won. Great was her chagrin to find that the committee withdrew its decision when they learned she was a woman, giving the commission to a male artist instead. "It will take more than a Boston Art Committee to quench me,"[4] was her determined response. Twenty seven years later she finished the bronze version of "Charles Sumner" at her own initiative. It was finally installed in 1902 in front of the Harvard Law School, a vindication for her, underlining a sense of justice "that includes the woman sculptor."[5]

We see evidence of Whitney's neo-classical training in the noble mien and monumental proportions of "Charles Sumner"; here is a man cast in the heroic mould. But she sets her tribute within a candid, contemporary frame, choosing to show Sumner engaged in the moment — seated and at ease, clothes dishevelled and book in hand. He is very much a man of his times, brow furrowed with the complexities of the day. The antique dress, pose and idealized formality of much neo-classical work are here replaced with the dignified, vigorous realism which took hold in America after the Civil War. ✏

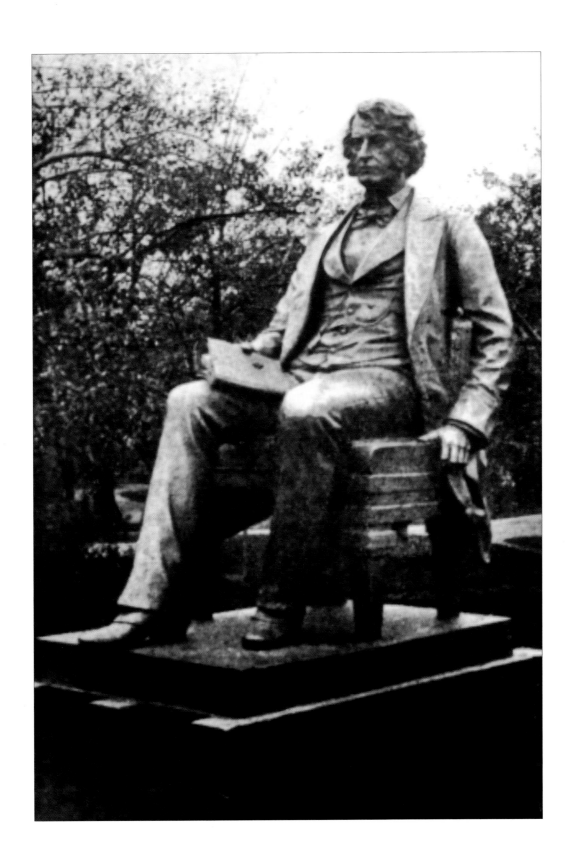

# ROSA BONHEUR

(1822 – 1899)   *The Horse Fair* 1853

> Mlle. Rosa paints almost like a man. What a pity her strong brush is not held also by ... the other précieux [male painters] who paint like young ladies.
>
> — M. Thoré, Parisian art critic, 1847 [1]

M. THORÉ here exposes the dim view the nineteenth century took of 'feminine' abilities, despite having let a few prodigies like Rosa Bonheur slip through the bastions of prejudice. Bonheur was determinedly unconventional, and cut her own swath from an early age. Influenced and taught by her beloved father, a member of the egalitarian St. Simonian group and a painter of historical subjects, Bonheur at age eleven found herself with the charge of her three siblings when her mother died. Apprenticed to a seamstress to help make ends meet, she refused that profession and insisted on becoming a painter. She studied in her father's studio and eventually in the Louvre, where in the time-honoured tradition she copied 'old masters.' Animals were her passion and the subject of much of her work. With her father's encouragement, she had begun meticulous studies from life, believing that scientific observation of nature was the path to anatomical accuracy and a true understanding of her subject. This led inevitably to a study of anatomy in the cattle markets, stockyards and slaughterhouses of Paris. In order to get about more easily and less conspicuously, Bonheur adopted trousers and a smock. To wear such attire (which she continued to do while painting for the rest of her life), she had to get permission from the Paris police department, renewable every six months.

By the age of seventeen, Bonheur had found a market for her work; by nineteen she was beginning to exhibit in the annual Salons. With the advent of the republican ideals of the time came a new interest in realism, in nature and everyday life as opposed to the heroic and the divine. The quiet pastoral scenes of the Barbizon school of landscape painters found renewed interest. Following some of the ideas of the seventeenth century Dutch realist painters, Bonheur was able to imbue her rustic scenes of draft animals and peasant life with a vigour and noble simplicity. Her work soon caught the Parisian imagination, and began to earn medals at the exhibitions held at the Salons.

After a gold medal and impressive reviews in 1848, Bonheur embarked on an ambitious project which was to become her *chef-d'ouevre*, "The Horse Fair." Countless sketches and studies were worked up before she tackled this immense canvas, approximately two and a half by five metres in dimension. She notes in her writing that in conceiving "The Horse Fair" she thought of the Greek Parthenon friezes.[2] The broad, painterly manner of Géricault can be detected in her noble Percherons, rearing and charging in a tumult of fiery energy. Accents of rich blues and reds reinforce the rhythm of line and movement in the Romantic manner, while contrasts in value centre the restless movement, light and vigorous composition of this monumental work. Such was its resounding success that it was shipped to England, and shown for an entrance fee of sixpence. Queen Victoria asked for a private audience, and Bonheur's fortune was secure. Countless lithographs and copies of the famous painting were made and circulated widely in Europe and America, making Bonheur a household name.

Bonheur's income was such that she and her companion of over forty years, Nathalie Micas, were able to embark on many travels, during which Bonheur sketched and collected live animals for her menagerie in Paris. Eventually she bought an estate near the Forest of Fontainebleau, where she was able to set up her studio and house her animals, including lions, deer, horses, oxen and sheep. Here she received many distinguished visitors, ranging from the Empress Eugénie, who awarded her the Legion of Honour, to Buffalo Bill Cody, then on a triumphant tour of Europe. Under the influence of Landseer and the English school of *animaliers*, (painters of animal subjects) she became rather more restrained stylistically than the broad painterly manner of "The Horse Fair." In later years, her work fell from favour among French critics, although she always maintained a loyal following in Britain. Bonheur took little interest in the developments of Impressionism, preferring to dedicate herself to her own singular vision of the natural courage and grace of the animals she loved.

A feminist, Bonheur admired George Sand, Flora Tristan and many of the ideas of the St. Simonians, who favoured free association, the dignity of labour and universal suffrage. She insisted unequivocally on her own ambitions, smoking cigarettes, riding horseback astride, and asserting her independence despite conventional mores. "I have no patience with women who ask permission to think,"[3] she admonished her pupils, and went on to take her own advice. After Micas's death, Bonheur spent her final years with Anna Klumpke, an American painter who bequeathed us a wealth of information in the biography of Bonheur she eventually wrote. ❧

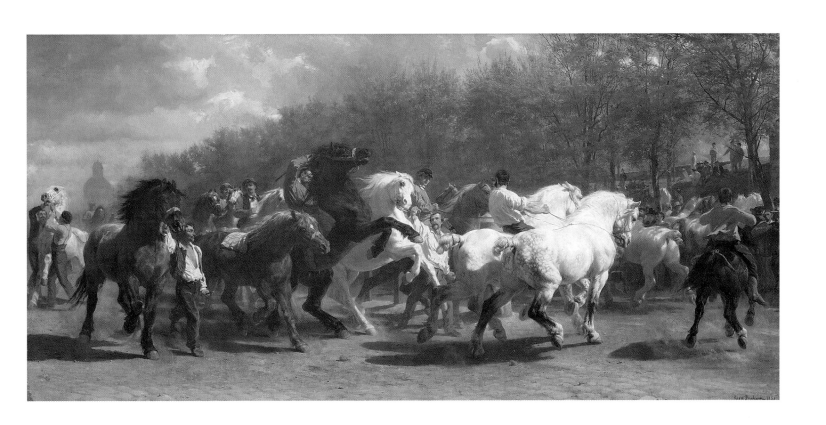

# HANNAH MAYNARD

(1834 – 1918)  *Self-Portrait*  circa 1894

HANNAH MAYNARD was born in Cornwall, England. In 1852, she married and sailed to Canada. She studied photography in Bowmanville, Canada West, and then in 1862 she and her husband Richard moved to Victoria, BC, then a small, bustling outpost community. Although still a somewhat unusual novelty, photography was one of the few business options open to enterprising women at the time; a surprising number of women photographers can be ferreted out of the historical annals. Before long, Maynard set up her camera and opened "Mrs. R. Maynard's Photographic Gallery." Over the course of her lifetime, many of the local inhabitants trouped through her studio to be immortalized by Mrs. Maynard's black box. Her husband Richard, who had opened a boot store, learned photography from Maynard, and went on to secure many assignments from government and international agencies. Unlike Maynard, he preferred wilderness subjects from the forested interior and mountains of British Columbia; in fact there were rarely people in his work. The couple sometimes travelled together, bringing back the scenic 'views' which were fashionable at the time.

Hannah Maynard's portrait business in town did well. Around 1879, she began to turn her boundless energy and creativity to new challenges, and began as a kind of promotion a series of greeting cards for customers. The portrait heads of children she had photographed were cut out and montaged into fountains, crowns, patterns and various elaborate formats. These she called 'Gems,' and eventually each picture contained thousands of tiny heads — cascades of baby faces! Her experiments with montage and other adventurous extensions of photography led her to explore 'photosculpture' — a technique where she powdered sitters' faces and then photographed them in poses that looked like statuary.

Perhaps her most experimental technical innovations, though, were her multiples. As can be seen in this image, Maynard was able to invent and then execute with great skill photographs with a mordant and almost surreal sense of humour. She or her sitter often played several parts at once in her eccentric visions, pushing the limits of photographic technique. By using mirrors and careful lighting, montaging, masking, re-photographing and other means, Maynard was able to cleverly incorporate double and multiple images on a single plate in works which challenged the very basis of 'authentic' photography for what it essentially is — a trick of the eye.

In this particular self-portrait Maynard sits "pouring tea, her morbid sense of herself ... tinged by the comic ... she stares impudently into the camera, challenging the nature of normalcy. She is playing three parts; she is quite proper, she is cocky, and as a studio portrait, she reaches outside its framed reality to pour tea on her own head. Her air of disdain inside the frame is delightful."[1] Maynard uses a conventional, solidly grounded triangular composition, and many domestic details, to make the contrast between conventional form and her tongue-in-cheek content even more pointed.

At a time when much photography reeked of sugary Victorian sentimentality, Maynard's acerbic and imaginative vision is a refreshing one. Many of her multiples were self-portraits or portrayed family and loved ones. Despite her wry and irreverent commentaries on 'reality,' she was not above a little re-touching, often removing lines in her face and nipping in her waist just a touch. And we can detect a certain romanticizing of the self in these magical, theatrical works; she is often the central actor in this bizarre world. Maynard continued to create impressive conventional portraits, landscapes and still lifes, but it is her delightful forays into the absurd, such as this "Self-Portrait," which most distinguish her work. ✍

# EMILY MARY OSBORN

(1834 – ?) *Nameless and Friendless* 1857

THE MID-NINETEENTH century in England saw unprecedented numbers of women painting and exhibiting, despite their continuing exclusion from the Royal Academy (which seems to have used up its tolerance for women with its token female founders Angelica Kauffmann and Mary Moser). However, women could and did show at the Academy's exhibitions without being members, and they could also show at the many other public exhibitions, including the famous International Exhibitions of 1851 and 1862. Queen Victoria took a keen interest in the promotion of the arts; this encouraged many a woman struggling to find a place for herself in a profession that still denied her professional education and access to the training considered so basic to success as an artist: drawing from the nude.

Emily Mary Osborn persevered over her clergyman father's scepticism to study art in London, and by age seventeen she had begun to show her work in the annual exhibition of the Royal Academy. She continued showing there and elsewhere for over thirty years, establishing herself with some financial success as a portraitist. But her originality lay more in the area of genre painting — dramatic scenes that told a story — so popular in England during the Victorian era. Her dramatic narrative paintings and occasional literary themes attracted the attention of some eminent patrons, including the Queen. Osborn won several medals, and was able to spend part of her career in the 1860s painting in Germany.

Since William Hogarth's eighteenth century prints had popularized story-telling scenes, a strong tradition of narrative painting had developed in Britain. There were generally messages and morals to be gleaned from these tales, and the pictures were carefully staged episodes meant to be 'read' as well as to be enjoyed visually. Setting, detail, dress, meaningful gesture — all were symbolically contrived to underscore meaning, strategies not unlike those used in literature and theatre. Popular celebrations of middle-class domestic dramas struck rather different chords with the Victorian public than the subjects Emily Mary Osborn often chose. One of her best-known themes involved young women protagonists, beset by penury and the perils of an unsympathetic and prejudiced world. "Nameless and Friendless" falls into this category, and is in addition a rare

nineteenth century attempt to deal with the lot of the woman artist. Osborn, keenly aware of the economic aspects of the problems faced by women trying to earn an income from their painting, subtitled her painting for the Royal Academy Exhibition of 1857 with a quote from Proverbs (10:15): "The rich man's wealth is his strong city. The poverty of the poor is their ruin."[1] In 1859 she added her name to a petition drawn up by suffragists and women painters demanding access for women to the Royal Academy School; it was rejected.[2]

The plight of a woman dependent solely on her own abilities to make her way in the world is clearly illuminated here. Through composition, detail, character and dramatic moment, Osborn establishes the social, financial and professional pathos of the protagonist's situation.[3] Her black dress tells us she is orphaned or widowed; her lack of an invitation to be seated that she is poor and thus *persona non grata*. Light falls on her face and hands as she stands centre stage against the 'backdrop' of the shop wall. The vertical note and value contrast of the background further accentuate her as the focal centre of the piece, as does the triangular composition of the figure groupings. The movement of her tired, wistful gaze and outstretched finger to the empty chair is contrasted with the imperious, sceptical gesture of the dealer who ponders her proffered work and holds her fate in his hands. In the face of his wealth and confidence she nervously twists a string, as the boy with her gazes up hopefully — but in shadow. The miserable weather outside lends a foreboding note, as do the prosperous male clients on the left as with prurient eyes they look up at her from their print of a dancing girl. Osborn has chosen imagery and attended to every detail with great finish, constructing her *mise-en-scène* artfully. She indicates clearly the sexual and social position of her characters and conveys her sympathies for her protagonist. But the underlying nineteenth century moral is clear: women who do not have the protection and security of home and family are vulnerable, and face a precarious, even menacing existence when they try to find means to make their own way. ∽

# BERTHE MORISOT

(1841 – 1895)   *Young Girl by the Window*   1878

IN THE LATE nineteenth century, the challenge to traditional academic painting that Impressionism presented reverberated throughout Europe, redefining the nature of painting. Berthe Morisot was at the forefront of this new way of painting, showing her work with the Impressionists for all of their Paris exhibitions, with the exception of the exhibition which coincided with the birth of her daughter, Julie.

Born to a wealthy middle-class family, Morisot had the support of her enthusiastic mother and civil servant father in pursuing a career in painting. She was the great-granddaughter of renowned French painter Jean-Honoré Fragonard, and painting was a much valued activity in the family. She and her sister Edma had painting masters from an early age; their teacher Guichard warned their parents that: "With characters like your daughters', my teaching will make them painters, not minor amateur talents. Do you really understand what that means? In the world of the grande bourgeoisie in which you move, it would be a revolution, I would even say a catastrophe."[1] Despite such dire predictions, the sisters went on to copy masterworks in the Louvre in the time-honoured fashion. As a woman, Morisot could never have gone to the Louvre unchaperoned; with the happy fact of Edma's companionship and encouragement she was able to engage in disciplined artistic training without any loss of respectability. In 1861 the sisters met the painter Camille Corot, who became a friend and mentor, encouraging them to turn their backs on the studio and paint *en plein air* (out of doors). "Nature itself is the best of counsellors,"[2] was his advice. Morisot began to show work in the official Salon in Paris in 1865, and continued to do so for some years. In 1868 she became friends with the painter Edouard Manet, for whom she modelled. He took a great interest in her painting, and was not above interfering with her work on occasion, much to her distress,[3] but her own ambition and talent prevailed and eventually she became more stylistically experimental than he. She is credited with influencing Manet's later interest in *plein air* painting.[4] In 1874 she married his brother, Eugène, who championed her work to the extent of challenging a critic to a duel because he referred to the second Impressionist Exhibition as "organized by five or six lunatics, one of whom is a woman."[5]

In 1874 Morisot renounced the official world of the Salon and made the decision to show with those artists who called themselves Independents. Through Manet's circle she had met many of the young critics, poets and artists who frequented the Café Guerbois. The ferment of new ideas there concerning the nature of painting had a profound impact on her. Monet, Pissarro, Renoir, Degas and others were willing to endure official censure and ridicule for their new explorations; Morisot found their experiments most congenial to her interest in a new painterly language, whatever the public consequences. Despite the best efforts of the art dealer Durand-Ruel, who showed these artists in England and America as well as in Paris, commercial success eluded Morisot and her colleagues for some time. Eventually, their work found favour with the growing bourgeoisie, whose interests in modernity and new ideas were often broader than the old avenues of state and Academic patronage.

Morisot's dedication to the Impressionist mode — capturing fleeting moments with spontaneous brushwork, a fresh palette and shimmering light — is evident in her still lifes, landscapes, self-portraits and in the many canvasses in which she takes women as a theme. Her beloved daughter and niece were often the subjects of her interiors, as were quiet scenes of women: looking out a window, picking fruit, reading with children. She celebrated the pursuit of everyday life without sentiment and with an exuberant brushstroke and deep pleasure in pattern and colour.

"Young Girl by the Window" shows the revolutionary flickering Impressionist brushstroke in all its glory. Detail is submerged in evocative suggestion of form; planes in the picture are fused in a dazzling play of light and colour with a fluid painterly hand. The candid sense of a moment captured, the Impressionist 'snapshot,' is here rendered with fresh, audacious colour and texture. Bold cropping contributes to the effect and implies a reality continuing beyond the frame. Blue and green harmonies are touched with complementary rose and reds, lifting the piece into unsentimental vitality. Pure colour is boldly mixed directly on the canvas. The bravura of active, undisguised brush strokes lends intensity and movement, contrasting with the quieter passages in the face. Morisot balances intimacy and the shifting, restless excitement of the moment in this remarkable portrait. ✃

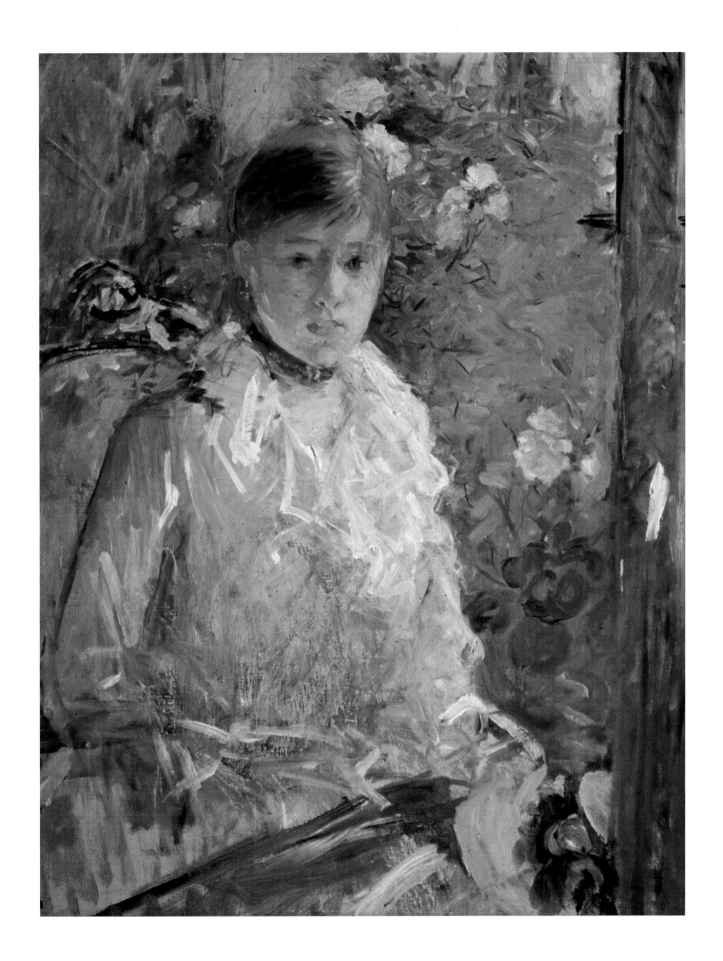

# MARY CASSATT

(1844 – 1926)   *The Letter*   1891

PERHAPS THE MOST well known of nineteenth century American women painters, Mary Cassatt was born into a world of wealth and privilege in Pittsburgh. Her early enthusiasm for art was nourished by the regular family trips to Europe which were *de rigueur* for her class. Despite her father's disparagement of her interests, Cassatt studied at the Pennsylvania Academy of the Fine Arts, deciding early on that the arts in America were decidedly too staid and mediocre for her taste. Paris was then the centre of the art world, and when she finally arrived there in the late 1860s, as she said, "I began to live."[1] She stayed for most of the rest of her life, remaining single. Further travels in Italy, Spain and Holland also helped to consolidate Cassatt's style, and by the early 1870s she was exhibiting both in New York and at the annual Paris Salon. Her interest in the new experiments in French Realism and Impressionism led to paintings in the style of Manet. Degas saw and admired her work, and despite his legendary cantankerousness, their discussions led to an invitation to join the Impressionist exhibition of 1879. She participated in several of the remaining Impressionist shows, sharing with these artists an interest in contemporary subject matter, evocative brush stroke, candid, informal compositions and an exploration of colour as revealed by light.

By 1877 her family had relented and actually joined her in Paris, although they remained bemused by her artistic career. Many relatives and American friends trouped through the household on their visits to France; often they were pressed into service as models, along with her family members, and occasionally they were invited to buy the work of her friends. The breadth of several American Impressionist collections can be traced to this source.

Cassatt particularly enjoyed using women and children as subjects, and her reputation as a painter of *maternité* was soon established.[2] It was a traditional subject, with roots as far back as Madonna and Child themes, but Cassatt treated it with refreshing candour and an unsentimental, realist's eye. Her figures feel unposed, caught unawares and absorbed in everyday interactions with one another that call up a flash of recognized experience in the viewer. Cassatt's contemporary children squirm in the summer heat, gaze intently at the mystery of mother, explore the physical world with the ease and curiosity of innocence.

After the 1886 Impressionist exhibition, there were newer, more radical currents in the air; from this time Cassatt's work changed its focus. Her compositions became less evanescent, more monumental and compositionally stable, somewhat more influenced by aspects of the work of the Symbolists. A large exhibition of Japanese wood block prints at the École des Beaux Arts in 1890 consolidated the influence of this style of printmaking in the art world. Cassatt had always made prints, showing many etchings, drypoints and aquatints. In 1891 she exhibited a series of ten coloured prints at the Durand-Ruel Gallery which stand among her finest achievements. Study of Japanese prints had led to technical simplification, development of a delicate but incisive line and a skilful employment of shape, pattern and colour. Cassatt experimented by rubbing several coloured inks in by hand on each plate, an innovation in the field of printmaking. The resulting work stands among her most creative and interesting pieces.

"The Letter" is drawn from this series, and shows the candid treatment of a casual moment observed from modern daily life so typical of Cassatt's work. The cropping, asymmetry and unusual angle of view are features also to be found in Degas's work. So taken was Degas by his protégé's work when he saw these prints that he allowed himself a grudging compliment: "I am not willing to admit that a woman can draw that well."[3] Perhaps the most striking feature of "The Letter" is its flamboyant delight in pattern. Large, flat planes have been locked together by Cassatt's whimsical spray of decoration on dress and wall; the playful forms almost begin to take on a life of their own. Cassatt shows herself here to be a consummate draftswoman, keenly sensitive to the importance of structure in holding her lively decorativeness to the page. The colouring, which would have been handled with her new approach to rubbing, shows both strength and delicacy, never overwhelming her sensitive drawing.

In 1892, American recognition finally came her way with an invitation to contribute a large mural for the 1893 World Exposition in Chicago. Cassatt chose to show 'modern woman' as a composition of young women plucking the fruits of Knowledge and Science. "An American friend asked me in a rather huffy tone the other day, 'Then this is woman apart from her relations to man?' I told him it was. Men I have no doubt are painted in all their vigor on the walls of the other buildings ..."[4] In 1904, Mary Cassatt was awarded the Legion of Honour by the government of France. ∾

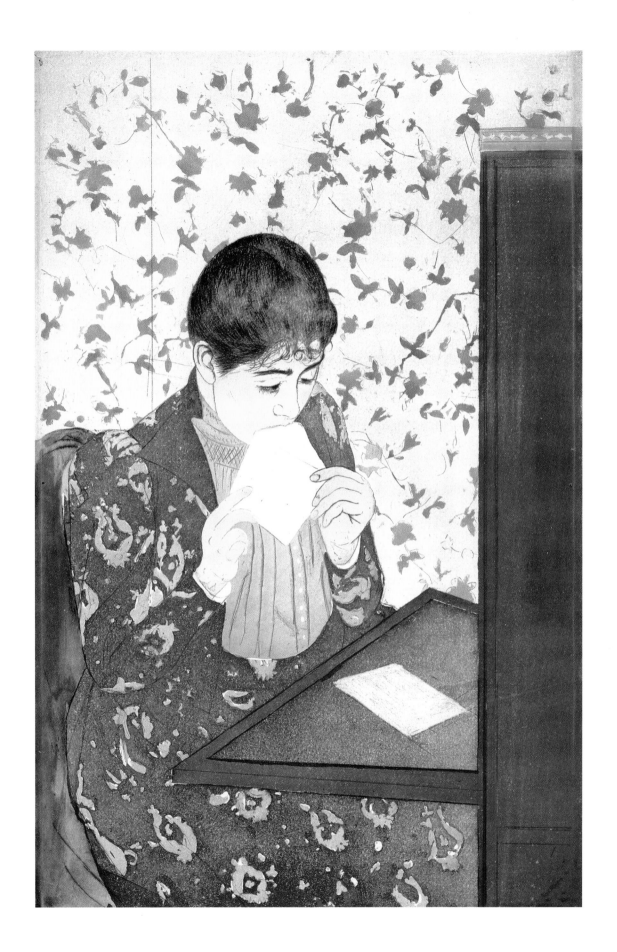

# EDMONIA LEWIS

(1845 – after 1909)  *Old Arrow Maker*  circa 1872

> I have a strong sympathy for all women who have struggled and
> suffered.                                   — Edmonia Lewis[1]

EDMONIA LEWIS was born near Albany, New York, to a Chippewa mother and a Black father. Much of her childhood was spent with her mother in a 'wandering life' following the travels of the Chippewa.[2] Thus she learned the craft traditions of her mother's people. She was orphaned when a teenager. In 1859, with the financial support of a brother who was a California gold miner and several abolitionists, Lewis entered Oberlin College, the first university in America to admit women of all races to its courses. Although she encountered severe racial prejudice there, undeterred she went on to Boston to pursue a musical career. There she was impressed by the many fine examples of public sculpture to be found in Boston at that time. William Lloyd Garrison, an anti-slavery advocate, introduced her to the neo-classical sculptor Edward Brackett, and thus to the study of sculpture, which she took up enthusiastically. The American Civil War broke out in 1861, and Lewis executed many medallions and busts of anti-slavery advocates, including a successful portrait bust of Colonel Robert Gould Shaw, leader of a Black regiment inspired by the Black leader Frederick Douglass. The bust proved to be enormously popular, and enough copies were sold to provide Lewis with a solid financial base.

In 1865 Lewis sailed for Rome, then a mecca for several American women sculptors like Anne Whitney who had been encouraged by the patronage of the wealthy American expatriate Charlotte Cushman. Lewis received a warm welcome from this group of independent-minded women, and, settling into a studio near the Spanish Steps, she began to work directly in marble. Though she was largely self-taught, her work became popular enough to draw many illustrious visitors to her studio. She created portrait busts of notable Americans and drew on her personal heritage for subjects, producing ambitious sculptures which dealt with social themes of oppression and alienation. One sculpture from this period entitled "Forever Free" depicts a Black man and woman breaking the chains of bondage; another, "The Freed Woman on First Hearing of Her Liberty," also speaks to the political issue of abolition. Several other works depicted American Indian subjects.

"Old Arrow Maker" illustrates such a theme, and exemplifies the skill with which Lewis had mastered the art of working in marble. Confident anatomical rendering and details show her careful study of the human figure. The neo-classical aspect of Lewis's training is apparent in the somewhat idealized nature of the subjects, particularly the daughter; details of dress and activity, however, are authentic. The daughter is deeply engaged in her work, making moccasins as Lewis had done with her own mother. The choice of such subject matter shows Lewis's determination to champion the lives of Native people. She also undertook biblical figures who had struggled against exploitation, an example being the Old Testament outcast "Hagar," the subject of the introductory quote above.[3] Her best known work was the monumental "Death of Cleopatra," which took four years to execute. It was exhibited at the Philadelphia Centennial Exposition of 1876, but is today one of her many lost works.[4]

In 1873, Lewis returned to America, where many of her sculptures were successfully shown in San Francisco. Newspaper accounts report that over 1,600 people viewed her work.[5] Eventually she returned to Rome to continue her work as a sculptor, and remained a participant in the activities of the American expatriate community there. Information on her later life is scarce, but it appears that in 1885 she was in Boston to present "Forever Free" to the Rev. Grimes, an advocate of Black equality, at Tremont Temple. After the Civil War, the neo-classical style in which she worked and its idealized forms were gradually displaced in favour of a new more naturalistic realism. Nonetheless, Edmonia Lewis's place as one of the first Black Americans to receive international recognition as a sculptor is secure. ℭ

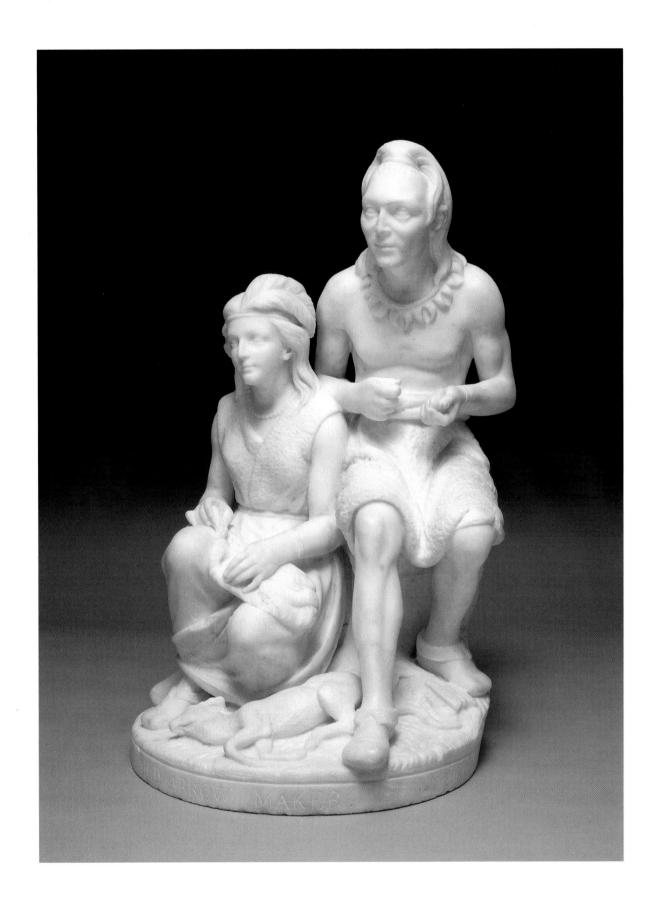

# FRANCES & MARGARET MACDONALD

(1874 – 1921)/(1865 – 1933)  *Poster for the Institute of Fine Arts*  * circa 1896

WHO WERE THE Macdonald sisters, whose stamp we see on this elegant turn-of-the-century poster? Shadowy figures, the sisters proved elusive to research. Feminist scholarship is now sifting out stories like theirs which have slipped into obscurity, eclipsed by the careers of husbands and overlooked by male critics.

In 1891, these two English sisters began their studies at the Glasgow Institute of Fine Arts. Their sense of personal style developed rapidly, and soon drew the attention of the Headmaster, who suggested affinities with the work of fellow students Charles Rennie Macintosh and Herbert MacNair.[1] The influences of Japanese prints, with their strong emphasis on line and flat form, and of Art Nouveau artists like Aubrey Beardsley, were in the air at the time, and "The Four," as they became known, developed a similar aesthetic based on sensuous interplay of line and flat curvilinear form. The ideas of the British Arts and Crafts movement, with its emphasis on breaking down the barriers between the fine arts and everyday life, were also current; The Four wholeheartedly entered into the production of beautiful objects for everyday use, making carefully-wrought designs for everything from chairs to handkerchiefs.

In 1896, Frances and Margaret sent some beaten metal decorative panels and posters to the London Arts and Crafts Exhibition Society. Their work was greeted by a storm of protest over their 'grotesque' stylizations of the human figure and ritual-like use of line and pattern.[2] There is indeed a sense of organic, growing line, of nature, and of magic and ritual present in the imagery the sisters were evolving, as we can note in the poster design here illustrated. The budding arrangement of line surges with vitality into human form in a synthesis of symbolism and design. Adroit use is made of black and white, symmetry and harmony, of the organic and the geometric. Attenuated rectangular and ovoid forms are used in positive and negative, framing and harmonizing the perfectly balanced composition. The eye flows upwards through the path of growth to the human face, is then gathered downward again through the device of the outstretched arms to return to the anchoring type below, symbolically the rock on which all this vital form grows, the art school itself.

There is a characteristic ethereal, trance-like sensibility to the characters developed. It was this haunting, attenuated quality of the figure entwined with the stylized elements of nature, a slightly fevered romantic cast of mind, which was to both attract and repel the public. Beauty of form and elegance of line here exist in the service of other-worldly visions of faerie rings and mythic tales, of subjects like "The Opera of the Winds" and "The Seven Princesses" in other works. Melancholic female figures draw us into a realm of dream and magic, into the cycle of the seasons and the elements, of birth, flowering, harvest and death.

On graduation, the sisters took a studio in Glasgow and established a reputation for imaginative designs for embroideries, illustration, metal and stained glass work, and other decorative and applied arts. Their friends were drawn from the Scottish literary and art world. They entertained a great deal, and tea at their studio was "indeed a memorable event."[3] Charles Rennie Macintosh and Herbert MacNair often collaborated with designs and with furnishings which could incorporate a metalwork panel or a stencilled design to be worked by one or the other of the sisters.

In 1899 Frances and Herbert married. "The Four" broke up as these two moved to a teaching post for Herbert in Liverpool. They continued to execute design commissions until Frances's untimely death fifteen years later. In 1900 Margaret married Charles, now a partner with the Glasgow architect Keppie. Together, Margaret and Charles designed spare and exquisitely ornamented interiors for their first home which were a stunning embodiment of their ideals for modern living. The collaboration appears to have been a happy one, although the subsequent fame for the designs and furnishing accrued to Charles rather than Margaret.

The year 1900 also marked the exhibition of work by the Four at the Vienna Secession in Austria; in 1902 they showed in Turin, Italy. Their designs attracted considerable enthusiasm in Europe, but the British art world was unimpressed. Despite continuing interest by European critics, this was to be their last notable exhibition. Charles Rennie Macintosh's innovative work as an architect henceforth failed to find responsive patrons. He and Margaret did collaborate on several commissions, like the decoration of Mrs. Cranston's famous Willow Tea Rooms in Glasgow in 1917. However, Macintosh's failure to find clients led to the gradual dissipation of his architectural career which has, of course, been blamed on Margaret's influence by some, including his biographer.[4] Whatever the true nature of their collaboration, she attended his declining years of disappointment, submerging her own talents with his into textile designs and watercolours. ✆

* Done with Herbert MacNair

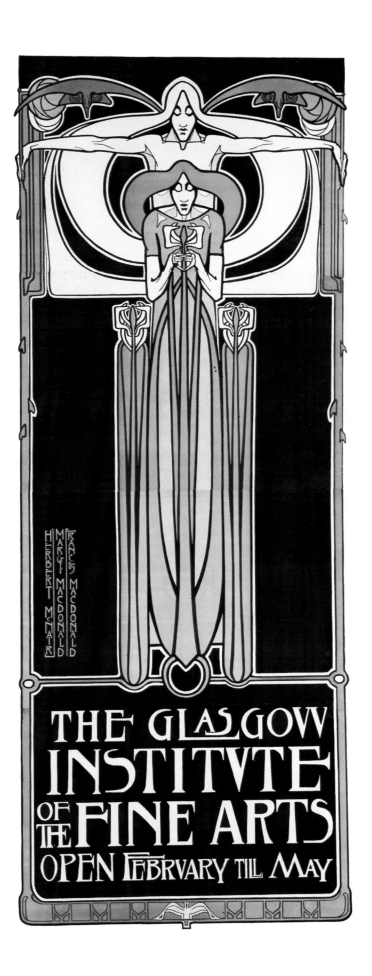

HERBERT McNAIR · MARGT MACDONALD · FRANCES MACDONALD

THE GLASGOW
INSTITVTE
OF THE FINE ARTS
OPEN FEBRVARY TILL MAY

# SUZANNE VALADON

(1865 – 1938)  *Adam and Eve*  1909

> Boldness was her hallmark, boldness of conception, boldness of design, and boldness of execution, and she lived with the same uncompromising boldness. A fierce emotional sensuality lights up the most banal subject in her hands.[1]

BORN THE ILLEGITIMATE child of a laundress, Suzanne Valadon managed to transcend an impoverished childhood and complete lack of formal training to become a successful and highly original painter. After three years as a dressmaking apprentice in sweatshop conditions in Montmartre in Paris, she found herself at age eleven in a variety of odd jobs. Eventually she ended up as a circus acrobat, but this enterprising career was cut short by a fall from a flying trapeze when she was sixteen. Serving as an artist's model seemed a less precarious way to make a living, and Valadon began to pose for Renoir, Puvis de Chavannes, Toulouse-Lautrec and other Montmartre artists. She enjoyed drawing and was a quick study, taking advantage of the opportunity to learn what she could from these artists and developing her own strong linear style. Toulouse-Lautrec introduced her to Degas, who was so impressed by her work that he undertook to encourage and promote her.

In 1883 when Valadon was eighteen, her son, Maurice Utrillo, was born out of wedlock. Flaunting conventional moral standards, Valadon had various lovers, including a wealthy banker, the painter Puvis de Chavannes and the composer Erik Satie. Utrillo was brought up by his grandmother; unfortunately his growing up years were marked by bouts of mental illness and alcoholism. As a distraction and form of therapy, Valadon taught him to paint. Her intense drawings and prints of nudes, still lifes and portraits had begun to attract a following, and Utrillo also began to have some artistic success. His friend, the painter André Utter, fell in love with Suzanne, twenty-one years his elder. They married when he was twenty-eight and she forty-nine, marking the outset of a highly productive and happy period for her. The 'wicked trinity,' as they were known, worked together, and in 1917 showed at the Bernheim Jeune Gallery in Paris.[2] Valadon's paintings often included herself and those close to her, women subjects executed in her highly charged and expressive style. Her stated intention was to "capture and intensify a moment in life,"[3] and Valadon produced arresting images of considerable energy, both in figurative and decorative terms. After the war, sales began to soar; such was the demand for Valadon and Utrillo's work that they were able to buy a chateau near Lyons.

Valadon entertained lavishly at the Château St. Bernard, counting among her friends Picasso, Braque, the Fauvist painter André Derain, the poet Max Jacob and Premier Édouard Herriot. Her eccentricities and excesses were legendary, but throughout her stormy life she steadily produced a strongly individualistic oeuvre. Utrillo was eventually awarded the Legion of Honour, and Valadon lived to see her work included in a large retrospective of French women painters held in Paris in 1933. Characteristically, her conclusion on seeing this exhibition was "I'm very humble after what we have seen this afternoon. The women of France can paint too, hein ? ... But do you know, ... I think maybe God has made me France's greatest woman painter."[4]

Such an ego led to a strong, expressive style, and Valadon's work is immediately recognizable. Stylistically influenced by Gauguin as well as by the colour sensibilities and preoccupation with pattern and design of Matisse and the Fauves, she nonetheless stamped these approaches to painting with her own Post-Impressionist vision. Her work shows a tense, wiry outline enclosing sinewy, sculptural form. In "Adam and Eve" she uses broad, simplified forms in almost flattened planes as a ground for her elegant figures. The brush stroke is crisp and evident, but subordinated to an overall sense of shape and pattern. Valadon's forte was the female nude; in this example we see audacious portraits of Valadon herself and André Utter cast as the archetypal lovers. Eve is self-assured, assertive and voluptuous. Adam, haunted and sexually unsure, contemplates a less certain future as he reaches for the symbolic fruit of knowledge and sin. The rhythmic, supple definition of form is bold and decisive; the figures are incised into their picture space with great presence and energy. Sinuous contours are echoed in the patterning of tree and branches; Eve's hair becomes earth in celebration of her natural, sensual state. The fiery reds and oranges of the fruit of wisdom contrast with deep, blues and greens; Valadon's complementary Fauvist colours vibrate with robust intensity, echoing the boldness of her self-representation.  ℘

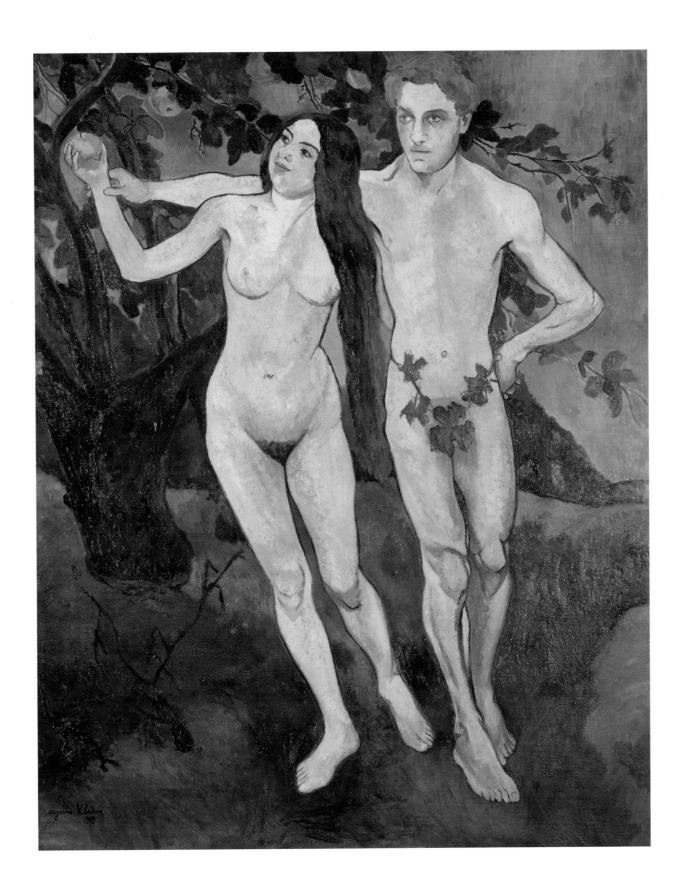

# KÄTHE KOLLWITZ

(1867 – 1945)   *Solidarity — The Propeller Song*   1931 – 32

... I am in the world/ to change the world[1]

KÄTHE KOLLWITZ'S life and art bear witness to the violence and destruction which flooded Europe in the first half of this century. The ravages of war, inflation, unemployment, poverty and political unrest which lacerated Europe and Germany are etched deeply into her work, and into a life of activism. For Käthe Kollwitz, the making of art was a political act.

Born in Königsberg, Prussia, of progressive parents who encouraged her talent for drawing, Kollwitz studied at the Art School for Women in Berlin and Munich, since women weren't admitted to the male academies. Her father, a committed socialist, had his doubts about whether she could combine a career with marriage and motherhood, but Kollwitz determined to do both. In 1891 she married Karl Kollwitz, a doctor whose practice was with a tailors' health insurance fund in Berlin. For fifty years they lived in an apartment block in Berlin's working-class district where he practised.

From an early age Kollwitz was drawn to working-class subjects. She found black-and-white graphic work not only the most expressive medium for her artistic vision; it was also easy to reproduce in posters and prints, increasing the accessibility of the work. In 1892, the play "The Weavers," a veiled allegory on the conditions of the starving proletariat of Berlin, was closed down by the police. The theme seized Kollwitz's imagination, and she embarked on a cycle of prints called "The Revolt of the Weavers." Kollwitz chronicled the struggle fifty years earlier of the Silesian weavers with an economy of means both powerful and expressive. So evocative were her prints that the jury of the Berlin Art Exhibition of 1898 wanted to award her a gold medal — until the Kaiser himself vetoed it.[2] Nonetheless, her reputation as an artist of depth and vision broadened from this time. As trenchant drawings, etchings, lithographs and woodcuts on social themes continued to pour from her studio, recognition and honour came her way. Kollwitz was invited to teach at the Art School for Girls, and became the first woman elected to the Prussian Academy of Arts. In 1904 she travelled to Paris to study sculpture, which became a new expressive medium in her repertoire. The Villa Romana prize was awarded to her in 1907, enabling her to live and work in Florence for a year.

Always an advocate for the poor and the vulnerable, Kollwitz wanted to re-establish the 'lost connection' between the artist and the people. Increasingly her pointed commentaries on the plight of the oppressed came to include women and mothers as major motifs — women prevented from the full expression of love for children and family by poverty, class and suffering. She had always connected the struggle for social democracy with women's fight for justice;[3] with the First World War mothers became dynamic forces in the struggle against conscription of their sons and the crushing of their children by the social evils of unemployment and starvation. She herself lost a son and, in 1942, a grandson to war. "Seed for the planting must not be ground," a quotation from Goethe, became another of her great themes — pacifism — as a commentary on society's wasteful treatment of youth as cannon fodder. Her indictment of oppression was so strong that finally in 1936 the Nazis banned her work as degenerate, removing it from exhibition and interrogating her. She continued to work in her studio in isolation and died in 1945, spared the nightmare of Hiroshima and Nagasaki.

In the lithograph "Solidarity — the Propeller Song," we see Kollwitz's radically simplified formal language at work. This 1931 work was presented by antifascist groups in Germany to the Soviet Union.[4] Typically, Kollwitz foregoes colour and any interest in background to concentrate on gesture and expression, hands and faces in her trademark style. The figure is the locus of her message. Gaunt portraits testify to a life of suffering endured, but the powerful rhythm of linked hands build strength in unity. Although she distanced herself from their themes of individualistic suffering, Kollwitz admired many of the Expressionists, including Munch; here we see her using dramatic Expressionist exaggeration to heighten the impact of linked hands. Her style is taut and spare; with bold, sweeping strokes, dramatic massing of light and shade and monumental forms, she suggests character and emotion with moving simplicity. Kollwitz is able to distil emotional content and embody it within human forms expressive of a strong political stance. The artist often included her own face in a grouping (she did many searching self-portraits over her lifetime), and we see a resemblance to her strong features in the intense figure at the right. It is the "integration of the physical, emotional and social that makes Kollwitz an important artist."[5] In "Solidarity — the Propeller Song" her lifelong compassion for humanity sings out. ❧

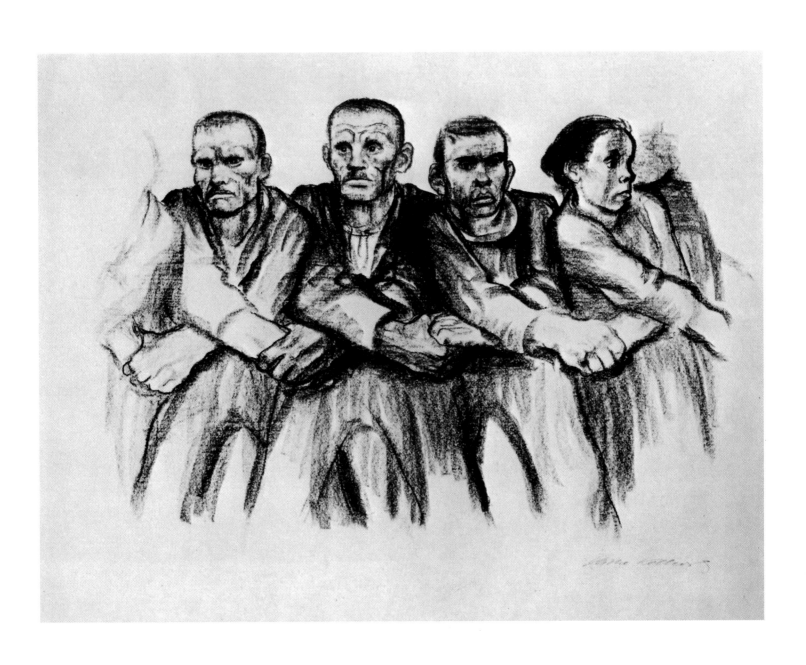

# EMILY CARR

(1871 – 1945)  *Forest, British Columbia*  1932

> The Great West, standing before us big and strong and beautiful —
> what art do we want for her art? Ancient or modern? She's young
> but she's very big. If we dressed her in the art dresses of the older
> countries she would burst them. So we will have to make her a dress
> of her own.                    —Emily Carr[1]

EMILY CARR'S unique blend of vision and eccentricity resulted in a body of work which indeed burst the seams of conventional Victoria, British Columbia. Carr's artistic achievements led her to become the first major Canadian woman artist to be recognized in Canada and abroad.

The youngest of five sisters, Carr showed an early talent for drawing which was encouraged by her British immigrant parents. Her art education continued in San Francisco when she was twenty. Carr later described her early watercolours as "humdrum ... objects honestly portrayed, nothing more."[2] Still, her skills enabled her to teach and successfully save money for a trip to England in 1899 for further study. Unfortunately she was not comfortable in England and her training did not go well there. She spent over a year recovering from a breakdown in a sanatorium in Suffolk.

By 1904 Carr was back in British Columbia, teaching, contributing cartoons to a local periodical, and spending more and more time visiting the forests and Native villages of the west coast of British Columbia. Befriended by the Native people she met there, Carr was named Klee Wyck, 'The Laughing One.' In her attempts to portray the vastness of the Canadian landscape and the harmony of Native life within it, Carr felt once more the inadequacy of her traditional training. In 1910 she left Canada again, this time for France, to immerse herself in the new experiments of modernism which were sweeping Europe. Carr's colours became more vibrant in the Post-Impressionist manner, her form and composition more daring as she strove to express the mystery, power and beauty which lay beneath the surfaces of things.

Unfortunately, Carr's new way of working met with incredulity and rebuffs back in British Columbia. Bitterly discouraged by her unsympathetic reception, she set about the task of earning a living. In 1913 she built a boarding house, "The House of All Sorts." However, her energies soon became drained by the mundane demands of tenants and house; she had little time for her own work.

Painting also became subsumed by raising sheep dogs to sell, along with pottery and rugs.

It was not until 1927 that Carr felt her vision renewed. Ethnologist Marius Barbeau had been impressed by her paintings of Native villages, and had interested Eric Brown, director of the National Gallery, in her work. Carr was invited to Ottawa to participate in an exhibition. While in the East, she was elated to discover kindred spirits in the Group of Seven, particularly Lawren Harris. Carr had worried whether the painters in the Group of Seven would accept her, feeling that "men painters mostly despise women painters,"[3] but they were most supportive. From this time on, her painting took on new energy and originality as she found a painterly language that expressed her quest for the spirit alive in nature. "The objects before one are not enough, nor colour, nor form, nor design, nor composition. If spirit does not breathe through, it is lifeless ..."[4]

In "Forest, British Columbia" giant evergreens seem to rock in the ebb and flow of the currents of the universe. The strength and vitality of growing things leads inexorably to spiritual enlightenment as light breaks through a canopy of foliage. Carr uses dramatically stylized form and colour symbolism to show us the ribbon of life pulsing through nature and binding us to the earth. The tunnel she creates through overlapping forms pulls the viewer right into the picture space, promising rich mysteries and evoking Jungian patterns of the subconscious. Carr was interested in Theosophy — a sense of God in nature — as Lawren Harris was, but her emotive version and colour palette, as we see in this painting, remained her own.

For the duration of her life, Carr remained fired with zeal for her work. She bought an old caravan, "The Elephant," in which she and her beloved animals would camp out each summer in the forest. From this base she would range through the underbrush, sketching by day and writing by night. In *Klee Wyck, Hundreds and Thousands* and other volumes, Carr recorded the passionate journal of an unconventional woman who struggled to paint the intensity of that force which "splits rocks."[5] ℃

# GWEN JOHN

(1876 – 1939)   *A Corner of the Artist's Room in Paris*   circa 1907 – 09

DESPITE THE British Arts Council's pronouncement in 1968 that Gwen John had produced "some of the finest work by any British artist of the time," her work is scarcely known in England or abroad.[1] To this day her flamboyant brother Augustus, who became a fashionable portrait painter and a Royal Academician, overshadows her in the annals of art history, despite his observation in later years that "fifty years from now I shall be known as the brother of Gwen John."[2]

When their mother died, brother and sister were raised in Wales by two Salvation Army aunts. Summers were spent by the sea, where they were fascinated by the holiday beach painters, and themselves began to sketch. Gwen John persuaded her lawyer father to allow her to follow Augustus to the Slade School of Art at the University of London. There she studied the standard curriculum of drawing from classical plaster casts and eventually from professional models. Upon graduation, the siren song of Paris beckoned John and some of her women classmates. In Paris, they took a studio apartment and enrolled at the Académie Carmen, where Whistler taught. Painting was stressed, and John demonstrated an infinitely painstaking approach to building up layers of fine glazes in muted colours. Whistler admired the tonal settings in which she placed her single figures, but failed to notice the intensity of character with which she invested her sitters.

John spent the rest of her life mainly in France, with the occasional foray back to England. In 1900 she showed in London at the New England Art Club. Though she exhibited there intermittently for the next decade, her work rarely sold. In France, she embarked on walking and sketching tours with friends, lived in an attic studio in Montparnasse and modelled to earn a living. She continued to paint in an exacting, refined manner. She chose intimate interiors, portraits of women and occasionally seascapes as her subjects. Work which did not meet her standards was destroyed. Her insistence on privacy and austere living conditions appear to have horrified her middle-class relatives, but John was a woman of implacable will and self-sufficiency; living alone in genteel poverty with her cats suited her. Disinterested in marriage or the constraints of conventional bourgeois femininity, she pursued her art with single-minded purpose. Her quiet self-assurance is apparent in her comment on an exhibition of Cézanne watercolours: "These are very good, but I prefer my own."[3]

In 1906 at age thirty, John met Rodin, whose model and lover she evidently became for a period. His secretary, the German poet Rainer Maria Rilke, also became a friend with whom she corresponded for years. John's innate sensitivity increasingly led her towards mysticism, and in 1913 she converted to Catholicism. She never married; "My religion and my art, they are all my life."[4] The American collector John Quinn had begun to support her work in a modest way. Despite a one-woman show at the Chenil Galleries in London in 1926, however, public recognition continued to elude her. Her trenchant character studies now included the nuns of the Dominican Sisters of the Presentation, as well as her usual themes of isolated woman sitters and interiors. Her work was usually small, rarely signed or dated. Stylistically she developed an increasingly concentrated and intense approach, abandoning the carefully built up glazes for scumbled swatches of colour applied in a layered impasto style. Her touch became bolder, more considered and assured; she sometimes left the ground of the canvas showing, and constructed nuanced planes of light and texture in a looser, freer manner. She moved on her own course, relatively untouched by the currents of French modernism surrounding her. Hers was "a journey away from inherited statement to an inner truth;"[5] each canvas became an introspective point of concentrated energy and mood. In 1939, feeling ill and longing for the seaside, she took a train for Dieppe without any luggage and died on arrival. She was seventy-two.

"A Corner of the Artist's Room in Paris" — John's room in Montparnasse — reveals an interior replete with mood, conveyed with restrained economy and intensity. The implied presence of the inhabitant of the room haunts the viewer's imagination in this evocation of a spare but intensely felt life. Value, light and texture contrasts, nuanced colour harmonies and an almost abstract sense of composition are orchestrated into a picture of ethereal physicality. The heaviness of the pigmentation is belied by the fragility of its effect; light appears to suffuse the very substance of space, texture and surface in this quiet and eloquent celebration of intimate domestic space. ✑

# META WARRICK FULLER

(1877 – 1968)  *Talking Skull*  1937

PRIOR TO THE 1920s there were few opportunities in America for Black artists. The "largest community of Blacks lived in the South, and were constrained by laws which kept them disenfranchised."[1] The Black artists who did emerge in the North, usually from the Black middle-class communities in Boston, Washington or New York, eventually found it easier to study, work and exhibit in Europe where they found greater acceptance. Around the 1920s, a different climate emerged in America with the development of a new Black awareness. In 1925 Alain Locke, a leading Black philosopher, published *The New Negro*, an anthology of essays, short fiction, poetry and illustrations by Harlem Renaissance writers and artists, as a manifesto concerned with the "search for elements of Black culture reflecting their African origins, and with incorporating this ancestral heritage into an African-American aesthetic." In his words, "Nothing is more galvanizing to a people than a sense of their cultural past."[2]

This rise of African-American awareness not only provided the heady climate for the Harlem Renaissance — the name given to this time of fertile creativity in Harlem, New York — it also provided offshoots elsewhere, mostly in the Northern United States. Black artists, writers and musicians flocked to Harlem, where a wealth of talent and thriving artistic scene flourished. One artist whose work stands as a precursor to this Renaissance is Meta Warrick Fuller. While she began her career in much the same way as other Black artists, she was among the first to explore the reclamation of African themes and styles in her work.

Fuller was born in Philadelphia to a Black middle-class family. She received encouragement as well as scholarships for her studies in art and attended the Pennsylvania Museum and School for Industrial Arts. Fuller went on to study in Paris and then returned to attend the Pennsylvania Academy of Fine Arts. In Paris she met the Black writer and intellectual W.E.B. Du Bois, whose Pan-Africanist ideas and vision of Africa as a spiritual homeland she found most compelling. Her work was well received in Paris, where she studied with the sculptor Auguste Rodin, and even though her themes were to change with the emergence of African-American consciousness, the stylistic influence of Rodin would remain. Her sculptures usually exhibited a blend of realism with a little of the expressionism familiar in Rodin's work. In 1909 Fuller

married and moved to Massachusetts; she continued to work in the Boston area. This deeply spiritual, proper Victorian woman built her own studio against her husband's wishes and worked as a sculptor while taking care of her family. Both her ground-breaking imagery and her artistic determination served as inspiration for future artists.

Fuller's 1914 work "Ethiopia Awakening" anticipated the spirit of the Harlem Renaissance. Using a style more severe than usual, Fuller gives us 'Ethiopia' as an Egyptian/Nubian princess mummified to the waist and in ancient headdress. The figure, on the verge of awakening, has become the symbol for an awakening giant — the African-American consciousness. Though Harlem was not her home, this highly polished bronze sculpture effectively established Fuller as an important figure in the movement for the realization of the artistic power of Black artists.

"Talking Skull," exemplifies Fuller's skill and sensitivity to form. Although she continues to blend her romantic European style with African themes, this work seems to explore the question of life and death with a directness that makes it universal. The figure of a young Black male kneels in the earth, leaning forward to communicate with a partially submerged skull. The figure is carefully modelled to reveal the young man's vitality as he silently meditates on the skull. His hands appear to have pulled back at the liquid earth around the skull as if to bridge the gulf between life and death. Are the delicately modelled fingers flowing into the skull? This passionate work exudes pathos and warmth, reminding the viewer of the need to ponder that space between life and death. Fuller's interest in the afterlife was derided as overly emotional and even macabre by contemporary critics; however such an interest was common in African societies concerned with rites of passage and Voodoo religious practices. This awareness of heritage is something that Fuller wished to bring back to her people.

Fuller died in 1968 at ninety-one years of age. Her children, who had supported and admired her work, helped to ensure that it remained well cared for. Meta Warrick Fuller's renown, her artistic integrity and her images of African themes and Black aspirations led her to become an inspiring figure to a generation of Black artists who followed her.  ℘

# VANESSA BELL

(1879 – 1961)  *Lytton Strachey*  1912

VANESSA BELL was born to an illustrious British family of letters. Along with her famous sister, Virginia Woolf, she was part of the fashionable Bloomsbury group living in early twentieth century London. The brilliance of this circle of writers, intellectuals and artists is legendary to this day. Vanessa Bell's early studies in art were at the Royal Academy schools, where she worked under the painter John Singer Sargent. After the *de rigueur* trip to Italy, she settled with her sister and brothers in London to paint in earnest. Her friends included art critic Roger Fry, and art historian Clive Bell, both important figures in the London art world. She married Bell in 1907, had three children, and continued to take a great interest in the revolutionary artistic experiments current among French and European painters.

In 1910/11, Fry organized the first of two Post-Impressionist Exhibitions at the Grafton galleries, events which scandalized London gallery-goers.[1] Through Fry's efforts, the British public was exposed to the work of Cubist and Fauvist painters like Picasso and Matisse, then busy shocking Parisian society. Bell was deeply influenced by this flood of new ideas in the world of painting, and by the defiant liberation of colour and form these artists were exploring.

From 1912, the period of the second Post-Impressionist Exhibition, Vanessa Bell began to be associated with Duncan Grant, another painter and member of the Bloomsbury set. The artistic sustenance lacking in her marriage seemed reciprocal in this relationship, and they remained companions for more than fifty years. Remarkably, they managed a relationship which seems to have allowed each their own creativity. Both experimented audaciously with the new approaches to colour and line; Bell actually carried her work to the point of pure abstraction in this period, marking her as a pioneer in the British art world. "In these dramatic early years, no British artist's work represented more purely and outspokenly than hers and Duncan Grant's a fully fledged Post-Impressionism."[2]

Lytton Strachey was a cousin of Grant's and another literary member of the Bloomsbury group. Many of the notable figures in the group had their portraits done by Vanessa Bell over the years. "Lytton Strachey," painted in 1912, affords a good example of the influence of the Fauvist movement on Bell's work; she had been much impressed by the bold works of Matisse, Picasso, Derain, Vlaminck and others. There is an interesting decorative sense about the conception of both figure and environment here. She applies large areas of flat, barely modulated colour with daringly crude brush work, simplifying form in large, freely outlined planes. The rather austere palette used in the figure is offset by an intense and patterned background, almost as alive as the figure, with its rich accents of complementary colours. Yet for all the bold flattening of form and schematic treatment, Bell's sure hand deftly communicates the mood and person of the sitter pungently and with great economy. The intellectual's books are almost overtaken by the sensuality of treatment here; Strachey's aestheticism comes alive through Bell's vital brushwork. Her keen interest in formal relationships is evident in the painter's own words; "It is ... so absorbing, this painter's world of form and colour, that once you are at its mercy you are in grave danger of forgetting all other aspects of the material world."[3]

From 1913 to 1919, Bell participated in Roger Fry's Omega Workshops with their interest in bringing art into everyday life and challenging the "Victorian distinction between high and low art ... art and craft."[4] Here she turned her attention to developing designs for textiles, a mosaic floor, pottery, book illustration and screens. Thus she becomes part of the tradition of women painters whose art overflows the canvas into the so-called 'decorative' arts, claiming a place for the applied arts in the artistic firmament. Some critics have speculated on the connection between her design work and the interest in abstraction evident in her painting.[5]

Bell's attention was by no means claimed entirely by portraiture, and she worked in the genres of landscape, figure studies and still life throughout her career, bringing to them her expressive and stylized sensibilities. A bold use of flattened, simplified forms and colours applied with fluid brush-strokes characterize her style.

"Although the detailed research for which Vanessa Bell's body of work calls is in its infancy, it is increasingly apparent that her achievement has far greater richness, individuality and historic significance than was generally claimed at ... her death in 1961."[6] ℘

# HELEN McNICOLL

(1879 – 1915)   *Under the Shadow of the Tent*   1914

DESPITE A TRAGICALLY brief career, Helen McNicoll gained prominence as a painter of strong, light-filled Impressionist works. Her ability to portray a world of quiet, everyday pleasures in high-keyed colour led her to be called "the painter of sunshine."[1]

Helen McNicoll was born in Toronto in 1879. After the family moved to Montreal she became deaf in early childhood from scarlet fever. Her deafness made it difficult for her to develop outside friendships; however she was very close to her large family, and later formed a lifelong friendship with the English Impressionist artist, Dorothea Sharpe. McNicoll's father, a vice president of the Canadian Pacific Railway, provided for her early education with a private tutor; her parents always supported her love for art. Because she had independent means, McNicoll was later able to keep a studio in Montreal, study art in England as well as live and travel abroad. She studied at the Art Association of Montreal with Canadian painter William Brymner, and the Slade School of Art in London, England. In 1906 she worked in Cornwall with the British Impressionist painter Algernon Talmage.[2] Her favourite painting locations came to be Quebec and France.

McNicoll had met Dorothea Sharpe in 1905 and the two travelled, painted and shared a studio together in London. *Plein air* painting — painting out of doors — was one of the major tenets of Impressionism, and McNicoll sketched and painted outdoors, exploring the world of light, reflections and atmosphere and trying to convey the "sharpness and freshness of ... initial sensation"[3] in her luminous works. Both McNicoll and Sharpe painted seashore and garden subjects as well as women and children in various outdoor scenes. Sharpe had been working on sunny light-filled Impressionist works prior to meeting McNicoll, and the two influenced one another's style. McNicoll's subtle and lyrical touch and subject matter have been compared to those of earlier French Impressionists Berthe Morisot and Mary Cassatt. The publication of illustrations of McNicoll's work in London's prestigious *Studio* magazine brought her to the attention of a wider audience.[4]

McNicoll exhibited frequently and won a number of awards. At a time when full membership in many Canadian art institutions was denied to women, she won the distinction of being elected to the Royal Society of British Artists in 1913 and was one of the few women to become an associate of the Royal Canadian Academy in 1914. (In fact, it was not until 1933 — sixty-one years after the founding of the Royal Canadian Academy — that a woman was elected to full membership.) McNicoll dedicated herself wholeheartedly to her development as an artist; in the space of a career that lasted not much more than a decade, she produced well over a hundred canvasses.[5]

By 1914, one year prior to her death of diabetes in Swanage, England, McNicoll's works contained mostly pure light values. The Victorian beach scene "Under the Shadow of the Tent" is typical of her later works. Like other Impressionists, she uses a 'cropped' frame, showing the influence of early photography. Two women relax in natural poses on the strand, occupied with reading and working at a paint-box. The golden light intermingled with the high-keyed blues of the shadows bathes the work with a flickering warmth. The graceful rendering of the scene is enhanced by broken brush-strokes which capture the brilliance of reflected light and the rounded curves of fabric in the tent, dresses and hats. In the background, closer to the water, are suggestions of other people swimming and sitting in the sun. The viewer's eye moves through the scene following the forms of warm colours and resting once again on the main figures in the foreground. The palette of colours McNicoll employs are adventurous; to interpret the sun-drenched mood of the light, she has chosen vigorously handled gold, green and blue colour harmonies to enliven shadows with rich hues, enhancing form in the Impressionist manner. One has a sense of tranquillity and well-being, of a quiet, pleasurable moment. "Under the Shadow of the Tent" is an example of McNicoll's work at the height of her style; her explorations of light and colour are quite bold. The idyllic world of ease and pleasure she portrayed was soon to be shattered by the First World War. Although four of McNicoll's paintings were exhibited in the inaugural show of the Art Gallery of Toronto in 1926, her accomplishment lapsed into obscurity for decades. Today there is a resurgence of interest in her light-filled canvasses, but surprisingly little has been written about this artist who achieved such success in her brief lifetime. ✺

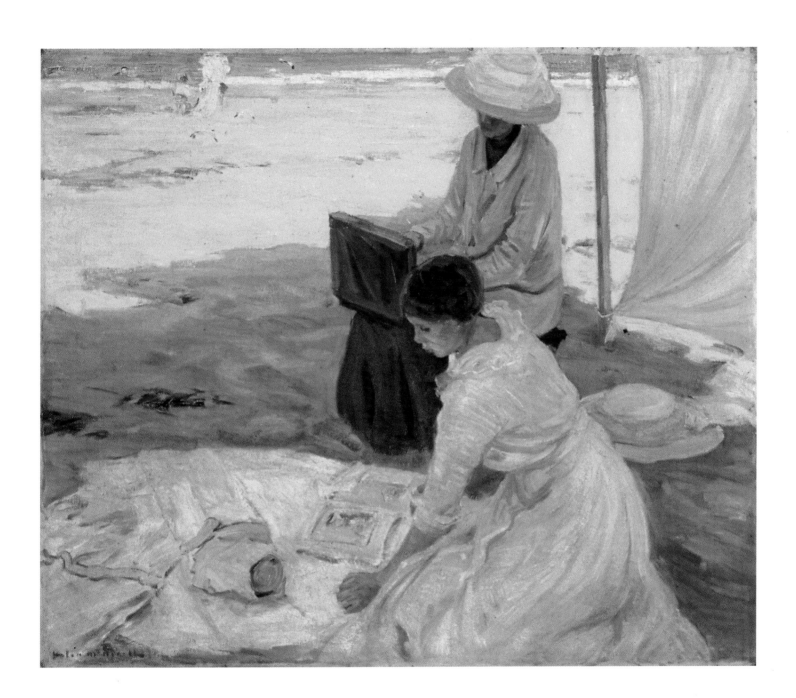

# NATALIA GONCHAROVA

(1881 – 1962)  *Linen*  1912

NATALIA GONCHAROVA was one of the pioneers of modern art in the early twentieth century in Russia. Born of impoverished landowners south of Moscow, Goncharova studied at the Moscow School of Painting, Sculpture and Architecture, eventually specializing in sculpture. While there, she met fellow student Mikhail Larionov, a painter; they were to become lifelong companions, finally marrying when they were in their seventies. Together they experimented with the new styles emanating from Paris — Impressionism, Post-Impressionism, Abstraction.

Russia at the time was in a pre-revolutionary political and artistic ferment; new ideas concerning the workings of society and the role of the arts abounded. Since the 1860s, women had claimed an equal voice in many political, intellectual and artistic circles, contributing to the challenge of articulating a new, more egalitarian society. Folk and peasant art — icons, embroideries, woodcut prints and decorative arts — were being re-evaluated and claimed as a national heritage. Goncharova began to fuse together the flat, simplified planes of Post-Impressionism with the rich, vibrant colours and decorative designs of folk art in her painting, claiming that her study of traditional embroideries had deepened her understanding of colour.[1] Her work was shown in Paris at the 1906 Salon d'Automne, in Munich with the Blaue Reiter group, and in London at Roger Fry's Second Post-Impressionist Exhibition in 1912.

In 1908, Larionov put together the first "Golden Fleece" exhibition in Moscow, showing new Russian and French work. He and Goncharova emerged as important members of the new avant-garde, taking their place alongside other giants of Russian modernism like artists Malevich and Tatlin.[2] Together they created 'Rayonism,' an offshoot of Cubism which helped to consolidate its ideas and usher in the era of abstraction in modern painting. By 1912, Larionov and Goncharova were experimenting with this new style which blended influences from Russian folk art with a Cubist technique of fracturing the surface with 'ray'-lines reflecting from and interlacing objects. The two were fascinated with modern technology: how could electric light or speed or the excitement of the machine age be shown on canvas? Goncharova maintained that "the principle of movement in a machine and in a living being is the same, and the joy of my work is to reveal the equilibrium of movement."[3] Their Rayonist Manifesto, published in 1912, proclaimed their dedication to the development of a Russian national art[4] in the midst of a flurry of exploratory new work, some totally abstract, some with still recognizable subjects. Goncharova had her second

one-woman show in 1913, and managed to exhibit the astounding number of 761 paintings. Her prodigious output had its admirers; ballet impresario Sergei Diaghilev noted that "the most celebrated of these advanced painters is a woman ... This woman has all St. Petersburg at her feet."[5] Goncharova's appetite for new explorations at this time led as well to the fields of book illustration and theatre and textile design, where her use of brilliant colour and innovative formats challenged tradition. Many Russian avant-garde artists felt that the mystification of traditional 'high art' needed to be challenged by a new dedication to the applied arts with their wider audience; the applied arts could provide an avenue for bringing the vitality of modern art to the people.

"Linen," painted during this period, is an interesting juxtaposition of familiar subject matter and innovative technique. Goncharova reclaims the homely subject of ironing — women's work — in a collage of starched shirts and lace. Her choice of subject validates the humble labours of folk life, which she often raised to an almost epic level, interpreted with all the force and energy of modern expression. Here her prosaic and unconventional subject is seen with fresh eyes, as the artist collages shapes, splinters them apart and stitches the whole together with a compelling interplay of colour and pattern. The picture space is an invented rather than a 'seen' one; text nestles beside starched cuffs, and differing angles of view jockey for attention. The result is a dynamic painting enhanced by Goncharova's use of complementary colours and intersecting diagonals.

Goncharova was instrumental in the tremendous success of Serge Diaghelev's famed "Ballets Russes" in Paris, designing stunning and original decors and costumes. In 1914 Diaghelev gathered the most promising Russian artists he could muster around him in Paris to produce "Le Coq d'Or," his first modern ballet. Goncharova joined him to paint ornate, glowing sets in brilliant colours, reflecting her Russian folk art influences. She continued to design costumes, sets and curtains for the Ballets Russes for many years, breaking new visual ground side by side with Diaghelev's new vision of dance. Stravinsky's 'music-painting' for the spectacular ballet "The Firebird" was complemented by Goncharova's settings, which again integrated modernism and her Russian heritage; the ballet remains one of the landmarks of modern dance. Goncharova lived out the rest of her life in Paris, continuing to paint and designing for many ballets as well.  ✑

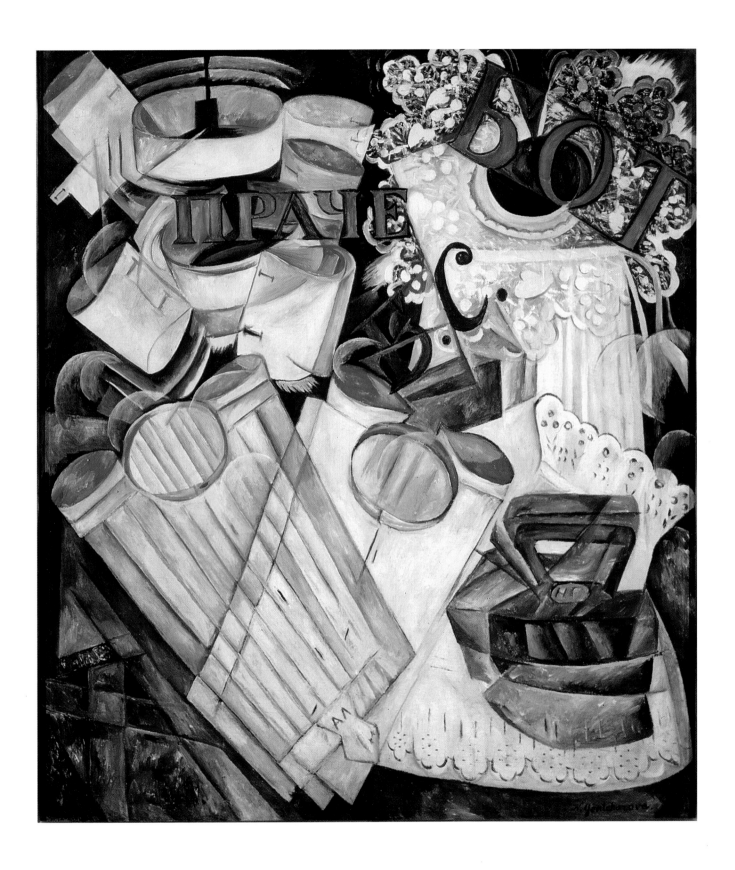

# FRANCES LORING /
(1889 – 1968)   *Furnace Girl*   1918 – 1919

# FLORENCE WYLE
(1881 – 1968)   *Noon Hour*   1918 – 1919

WHILE FRANCES Loring and Florence Wyle are now widely acknowledged to have been among Canada's important sculptors, only dedication, a firm belief in their work and a great sense of humour enabled these two women to overcome the prevailing stereotypes of the time.

Frances Loring was a self-possessed young woman who grew up in a supportive family; she was able to study art in many European art centres. It was in Europe that Loring grew to love the work of Rodin. In 1905, Loring began studies at the Art Institute of Chicago. Florence Wyle had a very different early life, receiving little support for her choice of vocation. Her early upbringing did, however, provide her with useful training for the frugal lifestyle that she and Loring later endured. Wyle chose initially to study medicine, but received so much encouragement for her anatomical drawings and sculptures that she switched to sculpture. Loring and Wyle met at the Art Institute of Chicago in 1905. Despite differences in family and artistic backgrounds, the women immediately "clicked."[1] The 'girls,' as they were referred to locally, both worked in the classical style of sculpture. They would begin in clay and work alternately from plaster cast to clay mould up to a final cast in bronze. Loring was interested in creating monumental sculpture. Preferring to work in the framework of classical Greek sculpture, Wyle's smaller, extremely accurate renderings of the figure benefited from an early study of anatomy in pre-med school. Both intended their works to represent their ideal of visual harmony and classical perfection.

Wyle had continued to study and teach at the Art Institute of Chicago until 1909, when she and Loring moved to a studio in New York. They remained working and living in New York until 1912, when Loring's father, concerned about their 'bohemian' lifestyle, took it upon himself to close their studio in their absence.[2] Loring later said she chose to move to Canada, "to be a big fish in a small pool."[3] After a short while working in a studio on Church Street in Toronto, the women moved to a drafty old converted church in the Moore Park area where they were to live and work for over fifty years.

The church became a regular meeting place for artists and other interested people. Even though the women rarely had ample means, they always welcomed and fed any visitors and stray cats or dogs. They even kept chickens for a while in the backyard — the flock was named after the Group of Seven because "whenever they laid an egg they had to make a great to-do about it to be sure that everyone noticed."[4]

Both women continuously worked at their own sculpture, which often celebrated the dignity of labour. They survived the lean times through surreptitious gifts from friends, who would ask for sculpture lessons in the studio or for a small commission to be done. Despite difficulty in achieving major recognition, Loring and Wyle continued to work, teach and promote sculpture, to found societies for sculpture and to share their enjoyment for life. In their later years it was most disappointing for them to realize that interest in classical sculpture was waning. They lived and worked together throughout their lives, dying within a year of one another.

"Noon Hour" by Wyle and "Furnace Girl" by Loring were both created in response to a commission of several bronze figures representing the "various types of girl war workers"[5] for the Canadian War Records of the government. At first glance, these two sculptures seem very similar. Both works reveal an interest in classical form, albeit somewhat stylized. Both artists use the folds of the uniforms to enliven the surface. The subjects seem to be drenched with the sweat of their labour, revealing their underlying anatomy and giving a feeling of fluidity and exhaustion. Characteristically, the artists have chosen to show the workers at different times in their day. Wyle shows the worker at a moment of rest; she uses the 'contraposto' pose, the weight fully on one leg and the tilt of the shoulders counterbalanced by that of the hips. Loring's "Furnace Girl" is more actively involved in her job. There is still the supple sloping action but the movement and twist in the form are more exaggerated. The two poses play against each other, reminding us of the two artists' interest in creating harmony. Their fluid classical form gives the subjects — working women — a timeless dignity and beauty. The works were well received. A.Y. Jackson is reported to have said upon viewing these works, that "You have done a series of bronzes which make [him] wish to knock down all the statues in Toronto and let you replace them with anything you wish."[6] Perhaps this was an indication of both the state of sculpture in Toronto and of the considerable respect that local artists had for the talent of Loring and Wyle. ✿

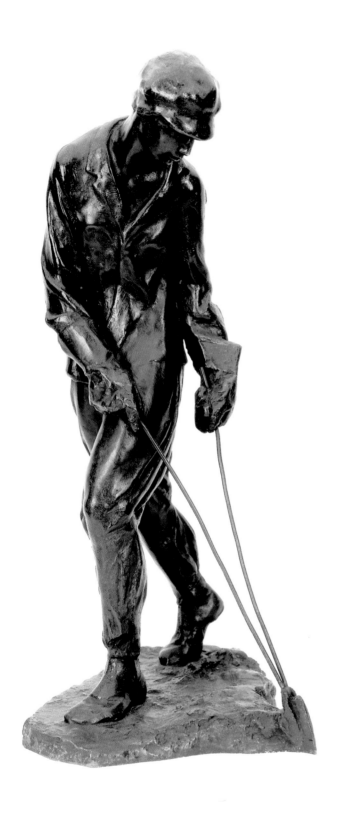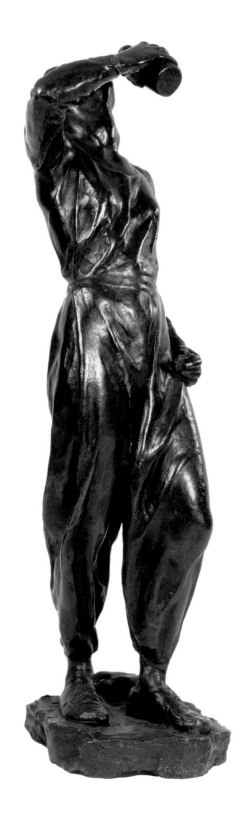

# Georgia O'Keeffe

(1887 – 1986)  *Yellow Calla*  1926

AMERICAN ARTIST Georgia O'Keeffe was raised on a farm in Wisconsin. An early habit of close observation of nature, of the discovery of worlds within worlds, stayed with her for life. Her studies at the Art Institute of Chicago and the Art Students League in New York from 1905 to 1908 gave her a conventional grounding in drawing, but neither representational work nor the current interest in Cézanne and the European experiments in painting seized her imagination. O'Keeffe became an art educator in Texas, and then in Virginia and South Carolina. The theories of Arthur Dow, who stressed using natural forms to express emotion, as well as oriental concepts of space and tonal harmonies, began to have a deep influence on O'Keeffe. She also read Kandinsky's *On the Spiritual in Art*. Just before her thirtieth birthday, she re-assessed her work, found it derivative, and proceeded to destroy much of it. "I realized that I had a lot of things in my head that others didn't have ... I decided to start anew — to strip away what I had been taught — to accept as true my own thinking."[1] Such uncompromising individualism informed the rest of her career, whatever the prevailing currents of painting.

What was "in her head" was truly remarkable for its time, because her first explorations in charcoal and watercolour were often purely abstract. As she later noted, "I found I could say things with color and shapes that I couldn't say in any other way — things I had no words for."[2] Abstraction was a new phenomenon in Russia and Europe, and was often regarded with suspicion in America. In 1916 some of these works, which O'Keeffe had sent to a woman friend, were shown in New York by Alfred Stieglitz at his 291 Gallery without her permission. O'Keeffe argued with Stieglitz to take them down, since she had done them for herself, but he persuaded her not only to leave them up, but also to send him more. This she did, though the works were often summarily rolled up in newspaper and sent through the mail. In 1917 O'Keeffe had her first solo show at 291, which garnered critical attention and enough sales to allow O'Keeffe to devote herself to painting. She also gained access to a circle of notable (male) artists and photographers like Paul Strand, Marsden Hartley and Charles Demuth. Many of them took Cézanne more seriously than they took her.[3] That year, Stieglitz took the first of around five hundred photographs of O'Keeffe. The fascination had other aspects as well; in 1924 they married.

Life in New York City in the 1920s was exciting, and O'Keeffe turned her attention to abstract celebrations of the urban cityscape. Skyscrapers were still new enough to be a modern marvel, and she treated them in paint with a strong sculptural sensuality that awakened the admiration of even 'the men.' Then from monumental subjects she turned to microcosmic ones, beginning the series of flower paintings which continued for years and for which she became so well known. In them she distilled form and colour to purified, intense essences. To her surprise, her flowers began to be equated with female sexual symbolism, an interpretation with which she did not feel comfortable. In 1939 she wrote "Well — I made you take time to look at what I saw and when you took time to really notice my flower you hung all your own associations with flowers on my flower and you write about my flower as if I think and see what you see of the flower — and I don't."[4] Nonetheless, the 'reading' of lush vaginal imagery persists, illustrating the contentious gap between intention and interpretation in images.

"Yellow Calla" dates from O'Keeffe's early work with the abstraction of flower forms. Nature is a springboard for her explorations of form and colour, which she has refined and condensed to strong, basic essences. As with much of her work, there is an almost meditative energy here, enhanced by the glowing colours and stylized shapes. She brings us much closer to these tactile, sculptural forms than we would normally be, intensifying our appreciation for their sensual surfaces and shapes, forcing us to take time with our looking in order to discover worlds within worlds.

From 1929 on, O'Keeffe spent most of her summers in New Mexico, camping, walking, finding transcendent beauty in the austere desert, for which she tried to find visual equivalents. Harris and Nochlin describe her work as "a network of rich correspondences between the optical, the biological and the spiritual."[5] She would paint a beautiful pelvic bone bleached by the desert sun, spare and simple but with a life of its own, then the sky glowing through it. Her work often shows a fascination with openings — pelvic bones, windows, doors, sky, shelters opening up to spiritual infinities.

By 1927, the Brooklyn Museum had presented the first of several retrospectives of O'Keeffe's work, which continued to gather acclaim particularly towards the end of a long career of highly focused energies and output. ✑

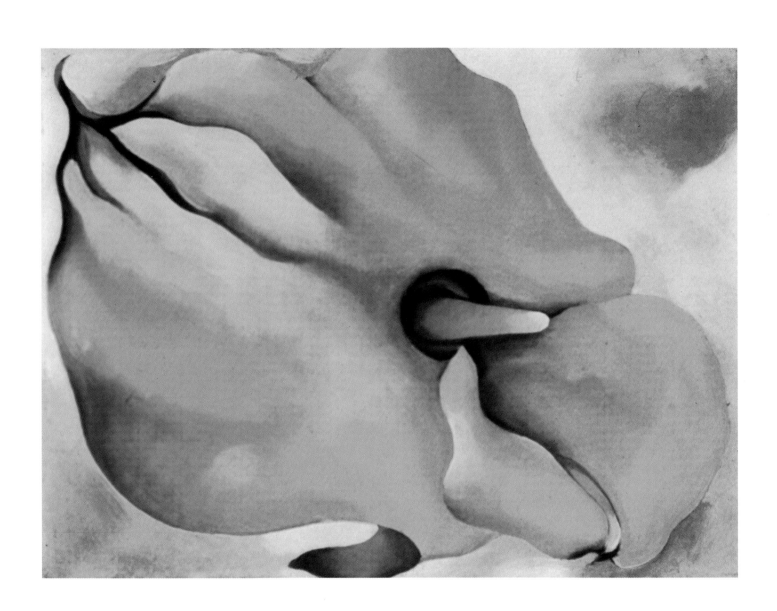

# DOROTHEA LANGE

(1895 – 1965)   *Migrant Mother, Nipomo, California*   1936

SOME OF THE most powerfully moving images of people caught up in the crush of the Great Depression are the work of a determined American woman photographer, Dorothea Lange. She began her career thinking of photography as "a good trade, I thought, one I could do. It was a choice ... But I never picked the role of artist."[1] By the mid-1930s her work was indeed that of an artist, despite the customary disparagement of the discipline of photography by the 'high art' world. Lange's vision of the enduring dignity of people who had been robbed of their livelihood by dust-storms and the economic juggernaut impressed itself indelibly on America, and was to affect government policy as well as the public imagination. Her work helped to establish the power of documentary photography as an art form.

Dorothea Lange grew up in New Jersey, and attended school in the Lower East Side of New York City. Her wanderings through streets thronged with the immigrants then pouring through Ellis Island sharpened her observational powers and her keen interest in the human condition. Lange's early studies in education were soon abandoned for photography. This led to apprenticeship in commercial studios, the purchase of a large format camera, and then to her own commercial portrait work. In 1917 Lange travelled west with a girl friend to San Francisco. They were robbed of all their money, so Lange found herself a job in a photography shop. There she met Imogen Cunningham, who impressed her as working at photography with a sense of mission, for reasons other than 'just a trade.'

The portrait studio Lange soon opened was thriving in no time, but her attention was increasingly drawn from the studio to the street, to the notion of documenting what she saw, whether for money or no. She began to include more background, more context in her work, rooting her subjects in the real world rather than isolating them in the classical 'timeless' style of studio portraits against a backdrop. Her interest turned to the bread-lines of the late 1920s, the homeless, the unemployed: the portents of the Depression years. "Five years earlier I would have thought it enough to take a picture of a man, no more. But now I wanted to take a picture of a man as he stood in his world — in this case, a man with his head down, with his back against the wall, with his livelihood, like the wheelbarrow, overturned."[2]

In 1934, Paul Taylor, a professor of economics, saw Lange's first exhibition. He felt his research on migratory labour could use the particular eloquence of photography, and began to work with Lange. Thus began her field trips to tent cities, to families living in old jalopies, to bone-weary tenant farmers, to the exhausted land. She would discuss her work with her subjects, withdrawing if they found her intrusive, and photographing whatever she could.

Lange and many other photographers like Ben Shahn and Walker Evans were hired by the federal government's Farm Security Administration to "give their fraction of a second's exposure to the integrity of the truth,"[3] to document American rural life in depth. This innovative use of photographers put the plight of the poor before the public. Lange went on countless trips, initially with directives to shoot certain subjects, but eventually with permission to use her own judgment entirely. Twelve million people were out of work.

In "Migrant Mother, Nipomo, California," Lange gives us the riveting image of a woman who has endured adversity, who has fought for her children's health and security, but whose gaze is deeply inscribed with anxiety for the future. Lange finds the moment of dignity despite the odds, the honest heroism in this parched existence. It was pictures like this that John Steinbeck studied when working on his celebrated novel *The Grapes of Wrath* in 1939.

Lange's own book, *An American Exodus* (done with Paul Taylor), disappeared quietly from public view as the Second World War began to occupy the public mind. Lange continued to do documentary work for the government, and eventually as her health began to fail did more personal work based on home and family. Like many women artists, the tension between home and work plagued her, leading to conflicted relationships with her children and in her two marriages. Her work for *Life* magazine, which included a collaboration with Ansel Adams on the Mormon community, continued to bring her celebrity. In the 1950s, she worked with Edward Steichen at the Museum of Modern Art to help co-ordinate "The Family of Man," an exhibition of over five hundred photographs which travelled to seventy countries. Its success was legendary, introducing more than nine million people to the artistic power of photography. It remains in circulation as a book by the same name, a fitting legacy for Dorothea Lange. ℘

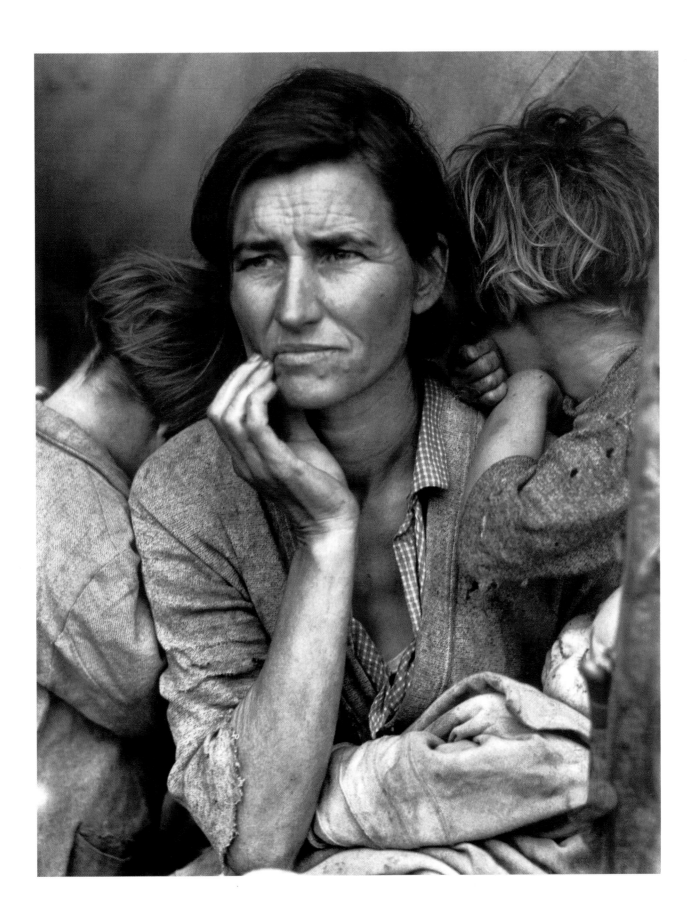

# KAY SAGE

(1898 – 1963)  *I Saw Three Cities*  1944

SINCE THE 1930S, Surrealism has been a major cultural force in Western society, affecting the course of film, literature and the visual arts, and continuing its influence right up to contemporary rock videos. Though Dali and Magritte have almost become household names, predictably, less well known are those women who took a Surrealist approach to imagery in their work: Remedios Varo, Dorothea Tanning, Leonora Carrington and Kay Sage, to name a few. All have produced evocative works which tap into the subconscious by means of irrational juxtapositions of symbolically charged objects. The results, as in Kay Sage's "I Saw Three Cities," forge new understandings of what is 'real' as these artists chart the fascinating territories of dream and the subconscious.

Kay Sage was born to a wealthy family in New York state and spent her early years in Europe and America, with brief studies in art in Washington and later, Rome. Her marriage to an Italian prince lasted for ten years; after her divorce, she began to write and paint in earnest. Following her first solo show in Milan in 1936, she moved to Paris and became involved with Surrealist circles. As the Second World War began to ravage Europe, Sage returned to America permanently along with many European artists and intellectuals also seeking refuge from the savagery of the war. They found New York receptive to avant-garde ideas like those of Surrealism. Sage had her first American show in 1940; in the same year she married French Surrealist painter Yves Tanguy. Their relationship fostered a cross-fertilization of artistic ideas, and both evolved imagery that explored deep, illusionistic space, architectonic forms and a synthesis of realism and abstraction. Sage's style differed in the palette she used, which was more inclined to quiet, subdued tonalities, and in the haunting air of melancholy and unease which pervades much of her work.

A sense of foreboding suffuses "I Saw Three Cities," though no human figures are present. So adept is the artist at suggestion that we read her biomorphic treatment of draperies as an evocation of human form, present as an illusion, but present nonetheless. The organic curves and folds of the drapery, so evocative of growth and nature, stand sentinel in stark contrast to the barren, geometric cityscape. Sage represents one of the central dilemmas of our age: the tension between humans as both natural beings and as creators of the 'unnatural,' the urban. The windswept 'figure' reaches out dramatically to the air, but stands rooted in place by the harsh perspective angles of mechanical, man-made forms. Typically, the canvas is not large (36" x 28"), but is epic in scope. The theatrical lighting and stark architectural forms are reminiscent of de' Chirico, an Italian predecessor of Surrealism with whose work Sage was familiar. Like de' Chirico, Sage also conjures a dreamlike landscape haunted by intimations of an alienated human presence. With austere beige tones drained of vitality, Sage reinforces the melancholic mood she sets; the only note of vital colour is the ochre of the wooden post anchoring the two modes — the natural and the mechanical — together, a tree planed into utility.

Sage commented on her work, "There is no reason why anything should mean more than its own statement."[1] Certainly Sage's work cannot be pinned down with precision, and yet it is ripe for the decoding of symbol and allusion so typical of Surrealism. The aura of mystery Sage so powerfully evokes invites our participation as we try to puzzle a meaning out of her invented world. The forms are indeed abstract; this is not a world we have seen, but Sage's imaginings raise echoes of our own. However, the technique used flows directly from the realist tradition. Imperceptible brushstrokes are finely shaded together, subsumed by the forms they describe. The illusion of concrete three-dimensional materiality is achieved through traditional rendering, perspective and chiaroscuro tonal techniques. All this we recognize as familiar; yet the image they serve is new and ambiguous, desolate. The several volumes of poetry that Sage wrote also express a harsh, arid landscape of the mind, littered with unfinished projects and full of existential malaise.[2]

Sage and Tanguy showed their work in both America and Europe through the 1940s and the 1950s. In 1947, both participated in the last major group exhibition of the Surrealist movement, organized in Paris by André Breton and Marcel Duchamp. After the death of her husband in 1955, Sage battled depression and failing eyesight to continue to paint. In 1960 a retrospective of her work was shown in New York. By 1963 she had succumbed to recurring bouts of depression, and died tragically by her own hand, shot through the heart. ☞

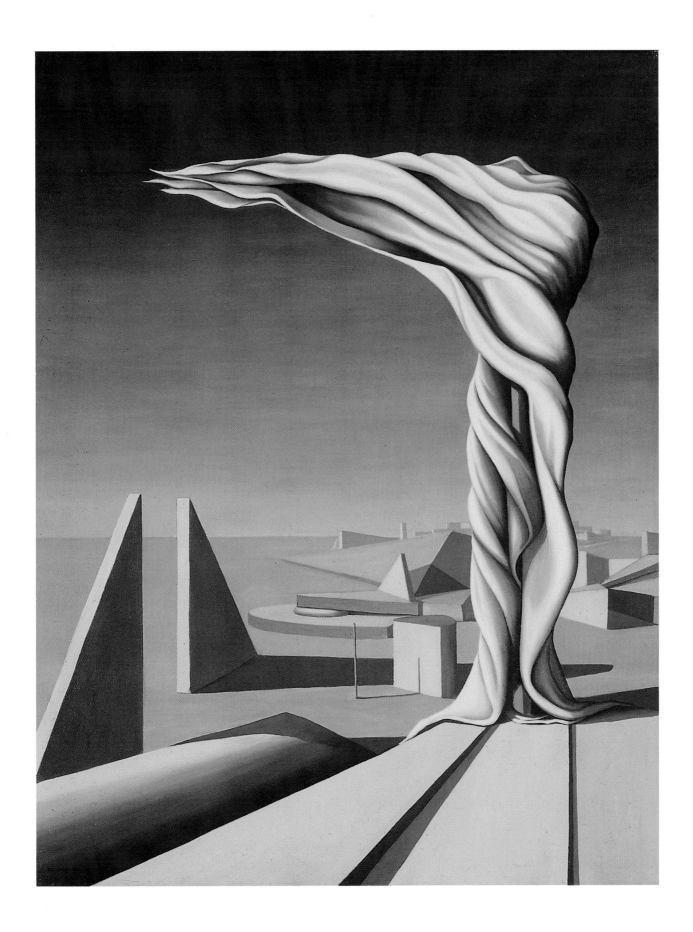

# PARASKEVA CLARK

(1898 – 1986)   *Petroushka*   1937

It's a hell of a thing to be a painter. I would like to stop every woman from painting, for only men can truly succeed ... Nonetheless, I have had a very good career, considering a great deal of my time has been spent on being a wife and mother.

— Paraskeva Clark[1]

DESPITE BEING a major figure on the Canadian art scene from the 1930s to the 1950s, Paraskeva Clark was never able to think of herself as a first-rate artist. There's always "cooking, cooking, cooking," she laments in the National Film Board film made of her life, "Loblaws and Dominion, Loblaws and Dominion ..." An irascible and passionately opinionated personage, she faced the conundrum so central for many woman artists — the balancing act between a domestic life and a creative one. Although in the end her devotion to home and family, particularly to her schizophrenic son Ben, overcame her drive to paint, her legacy to us is a strong and vital body of work with concerns unique and important in Canadian art history.

Born to a working-class household in St. Petersburg, Russia, Clark lived through the cataclysmic changes of the Russian revolution and was able to study at the Free Studios established by the new regime. Her interest in drama led to a job painting scenery, where she met and married an Italian, Oreste Allegri. Just after the birth of their son, tragedy struck: Allegri drowned on a summer outing. Clark moved to Paris, where she met Philip Clark, a Canadian accountant. In 1931 they married, and she accompanied him to Toronto and a new life.

Clark, with her disciplined European training, was shocked and dismayed to find that the new European theories of painting barely existed in Canada. "It was a dead place," she recalled, "Nothing but the bloody Group of Seven. Nothing but landscape, landscape, landscape ..."[2] Still, she soon met the artistic community; Lawren Harris in particular was encouraging about her painting and Clark quickly gained attention. Her outspoken, self-assured European sophistication occasionally sent shock waves through the establishment, but the humanist note she sounded was a salutary one.

In 1936, Canadian socialist Frank Underhill excoriated Canadian artists and writers in *The Canadian Forum* for turning a blind eye to the convulsions taking place in Europe. Sculptor Elizabeth Wyn Wood replied, writing that "the Canadian artist treated civilization as it should be treated, by walking off into the bush at every opportunity."[3] Clark supported Underhill in her now-famous article

"Come Out From Behind the Pre-Cambrian Shield," further refuting the notion that spiritual communion with nature was the best response to the complications of modern life.

In 1936, Clark also met Norman Bethune, with whom she became intensely involved until his death in China three years later. The relationship strengthened her political resolve and led to her support of the Republican cause in Spain. She tried valiantly, and unsuccessfully, to interest people in bringing Picasso's "Guernica" to Toronto. Later, she arranged sales of her work to raise money for supplies for the Russian people. Above all, she painted.

"Petroushka" springs from this period of political intensity. It is her comment on the police shooting of five workers in a Chicago steel strike, and on the nature of capitalism. The allegorical device that she uses is straight from her St. Petersburg childhood — a puppet show based on the character Little Peter. A smiling policeman, gun in hand, stands over the fallen body of a worker, cheered on by a leering capitalist complete with top hat and money bag. The scene sways madly, dangerously; the crowd gapes and jeers, but does nothing. Her biting commentary is fleshed out with a harsh palette of primary colours. Forms are stylized and tilt towards the centre of interest, the eternal triangle of cruelty: capitalist, henchman, victim. Clark draws on Cubist formal means to concentrate her message, handling brush and colour in a structured, planar way to reveal the essential structure of the forms involved. At the picture's pinnacle, and engaging the unholy triangle the most seriously: a mother and child, rising determined above the ebb and flow of despair, derision and escapism.

Pictures with such clear political intent recur but rarely in the body of Clark's work, which included portraiture, subjects from her home life, and yes, even landscape. But her interest in the figure and social concerns led to Clark's commission as a war artist; she chose to paint women at home, propping up the Canadian economy, running the factories, building airplanes. She became involved in the societies which were artists' main outlet for public exhibition in Canada in the 1940s and 1950s. In later life, she stopped painting, weighed down by domestic duties. Among the most important gifts she leaves us is confirmation of the notion of an art committed to the betterment of humankind. "Those who give their lives, their knowledge and their time to social struggle have the right to expect great help from the artist."[4]  ✣

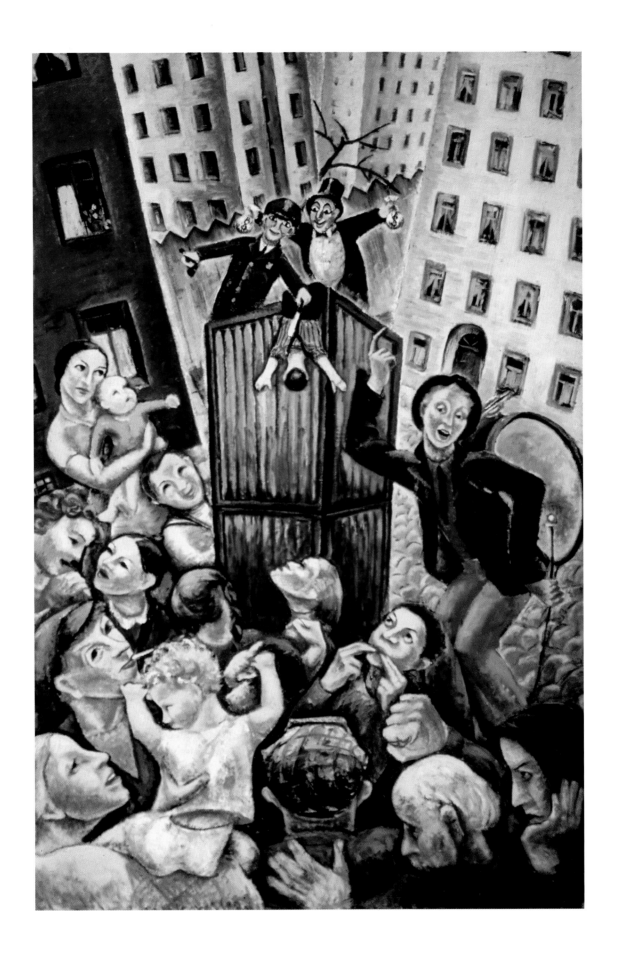

# LOUISE NEVELSON

(1899 – 1988)  *Mirror-Shadow II*  1985

My interest is to reveal to myself the greatest possibility of life.
— Louise Nevelson[1]

ONE OF THE *grandes dames* of the American art scene whose eccentric persona became almost as famous as her work, Louise Nevelson remains a flamboyant figure, as equally outrageous in her theatrical personal style as in her pronouncements on the art establishment. Photographs reveal a proud, severe visage, a wise-woman swathed in ornate ensembles and sculptural jewellery. An individualist to the core, this sculptor survived the scoffs of the art world of the 1950s to become a distinguished institution in her own right.

Nevelson was born Leah Berliawsky in Kiev, Russia. Her family immigrated to Rockland, Maine to escape persecution, but found that discrimination against Jews persisted in the United States. From an early age she declared her intention to become a sculptor. Her family encouraged her ambition, and her early studies in New York City included dance, drama and singing. She married in 1921 because "the world said you should get married,"[2] and had one child. The marriage lasted ten years before Nevelson pursued the freedom she wanted. Nevelson's training in the visual arts included studies with abstract painter Hans Hofmann and a stint at the Art Students League in New York City. She met the painters Diego Rivera and Frida Kahlo in New York, and worked as Rivera's assistant. Her commitment to life as an artist continued to sustain her despite her impoverished existence in the 1930s and 1940s, when she lived on money sent by her family and government-sponsored projects. During this period, Nevelson's production consisted of small anthropomorphic proto-Cubist sculptures in terra cotta, stone, wood and plaster. Her first solo show took place in 1942 at the Nierendorf Gallery in New York. The following year she exhibited "The Circus," a sculptural collage of circus performer and animal subjects which was the beginning of her assemblages of mixed media and found objects in constructed environments.

In the 1950s, Nevelson visited Mexico, where she saw the monumental sculptures of the Mayan culture. These works served as an inspiration for a new way of working. She began to see sculpture as environment on a large scale. Her assemblages from this period dipped into the detritus of urban life — milk crates, toilet seats, stair railings, scraps of packing cases — and pieced together a new order out of the washed-up chaos. Since the 1940s, she had brought Surrealist methods of "chance meetings and spontaneous

discoveries"[3] to bear on her own sculpture. Now her method was to stack and weave these bits and pieces, these cast-offs of modern society together intuitively, according to her own sense of their physical and psychological meanings, and on a grand scale never before attempted. Walls of this type of construction, such as "Sky Cathedral" or "Moon Garden Plus One" from 1958, were painted in monochrome black, white or gold to fuse each item into the identity of a more monumental whole, a kind of "phantom architecture."[4] The viewer is drawn into shrine-like environments of constantly changing spaces, crevices, planes, objects, meanings.

"Mirror-Shadow II," another such wall of assembled elements, constructed as well as found, is a sculpture of considerable meditative power. Nevelson's admonishment to students of her work was to empty their minds of the trivial, to polish the receptiveness and purity of their minds, so that "when you see something, you see it totally."[5] Her work rewards the contemplative viewer with a complex yet unified presence and the power of Nevelson's own monumental, totemic vision. "The person who wants to express something will cause a shift ... I like to think that where I am has all the intensity, the light, the speed, and the white heat that will burn you in a second."[6]

To her detractors, who included the influential art critic Clement Greenberg and his avant-garde followers, Nevelson maintained a pose of haughty indifference. She set her course in the 1950s and pursued her own individualistic vision with enough passion to exist outside the ebbs and flows of Abstract Expressionism and mainstream movements. It was not until 1967 in a retrospective at the Whitney Museum in New York that the art world acknowledged the power of her work. Her stormy career, strewn with affairs, had the support of a close companion, Diana MacKown, for the important productive last twenty-five years of her life. And the renewed interest of feminists in the 1970s in art made by strong pioneering women like Nevelson helped consolidate her stature. Nevelson's individualism was often tinged by presumption, as is evident in her audacious, disdainful claim: "I am a woman's liberation."[7] Proudly arrogant, certain of her originality, Nevelson's long career compels our admiration through her character as well as her unique body of work. As she has said, "It's a hell of a thing to be born, and if you're born you're at least entitled to your own self."[8] ∽

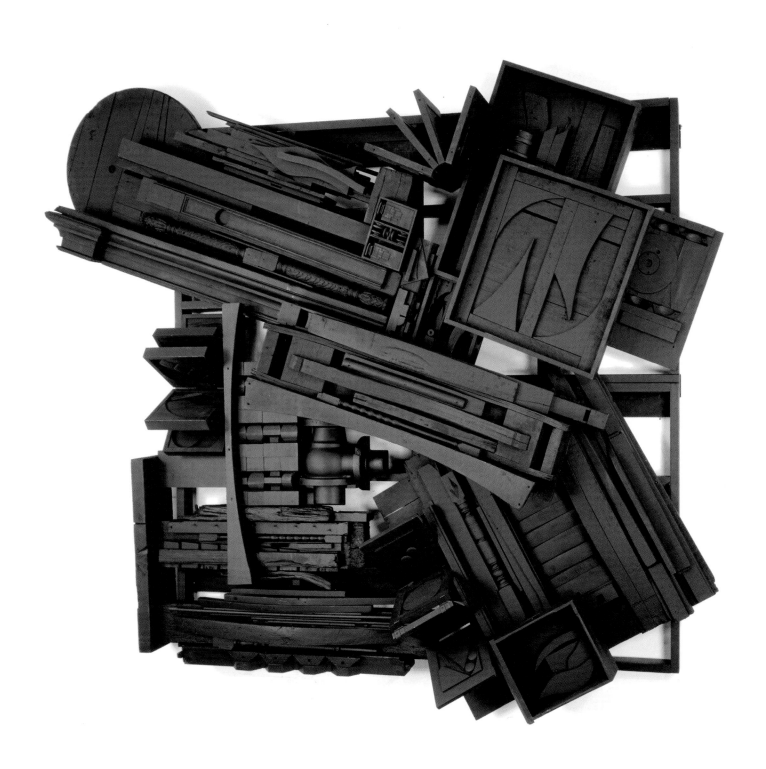

# ALICE NEEL

(1900 – 1984)  *Margaret Evans Pregnant*  1978

> Some ... chap used to say of me, "Oh, Alice Neel — the woman who paints like a man." I always painted like a woman, but I don't paint like a woman is supposed to paint.  — Alice Neel[1]

LIKE SO MANY women painters, Alice Neel was torn between the life women are 'supposed to lead' and an authentic vision. A conventionally pretty woman who liked having "all the boys crazy about me," she speaks of the double life she felt forced to live: "I'm not sure I was ever myself. I was myself but myself in our social systems. The place where I had freedom was when I painted ... I just told it as it was. You see it takes a lot of courage in life to tell it how it is."[2] A flood of her portraits, like "Margaret Evans Pregnant," tell it "how it is" in their forthright, honest depiction of people revealed in the unflinching light of reality.

Neel came from a well-off Philadelphia family and received her art education at the Philadelphia School of Art and Design from 1921 to 1925. 'La vie boheme' exerted a stronger pull on her than conventional middle-class values, and she married a Cuban painter she met at art school. They struggled to survive in a hand-to-mouth existence in New York's Greenwich Village; the couple's first daughter died of diphtheria. Eventually he took their second daughter off to Havana and Paris, deserting Neel. Neel began to paint furiously, but was unable to stave off the furies of depression, suffering a year-long nervous breakdown. Her recovery led to a return to painting. From 1933 to 1943 she was able to support her painting with mural work for the government's Works Progress Administration art project, which funded work by many women artists like Isabel Bishop and Dorothea Lange. Through this period, Neel also developed a greater consciousness of social issues. In 1938 she moved to Spanish Harlem. She lived there for twenty-five years, chronicling through portraits the life she saw around her, the character and personality of neighbours, friends and family members. Her empathetic portraits invariably revealed their sitters frankly, their bodies "marked with the price the world exacts for survival."[3]

Always an individualist struggling to set her own course, Neel was remarkable for her unfashionable resistance to the prevailing mythos of the art establishment. Through the eras of Abstract Expressionism, Op, Pop and Minimalism she steadfastly painted the figure. Although she was occasionally able to show her work, she was ignored critically for years. Because of the unsettling honestly with which she portrayed them, her subjects rarely bought their portraits. Nonetheless, a stream of people from all walks of life sat for her, from neighbourhood children from Spanish Harlem, to curator Henry Geldzahler, dean of modernism at the Metropolitan Museum, to cult figure Andy Warhol. At one point *The Village Voice* referred to her as "court painter to the underground art world."[4] But her subjects ranged through a wide spectrum of urban life to include the poor alongside the bourgeoisie, the disenfranchised and oppressed as well as the luminaries of American culture. As early as 1933 she was producing portraits considered scandalous; her portrait of beat poet Joe Gould sports three sets of genitalia as a comment on his literary exhibitionism. (The painting was not shown until 1971.)

The gaze which meets us from Neel's portraits is direct, uncompromising and challenging. Neel often chooses an unusual portrayal of the sitter, using full frontal nudity and choosing, in "Margaret Evans Pregnant," to show us an unconventional look at pregnancy. This is no romantic eulogy to motherhood, but a penetrating treatment of an aspect of everyday life too often banished from public scrutiny. Neel insisted on painting "the complete personality as she encountered it ..." noting that "the scars left by the psychological and emotional battles her sitters had endured revealed themselves to her as she painted."[5] Using her characteristic expressionist line and expressive colour, she incises a figure that captures the essence of Margaret Evans's condition at a particular moment. The sometimes exaggerated and idiosyncratic drawing out of form (as in the feet and reflection) is yet another means to set down the 'truth' of the character and condition of the sitter. The rough, active handling of paint and spatial distortions in the background areas are further evidence of subordinating all else to the incisive line which etches out the sitter's presence.

In 1974, when she was seventy-four, the Whitney Museum finally accorded Alice Neel the retrospective which had been so long in coming. Neel's final years brought her the recognition that had eluded this 'collector of souls' through a career in which her main sustenance was the intensity of her own vision.  ☙

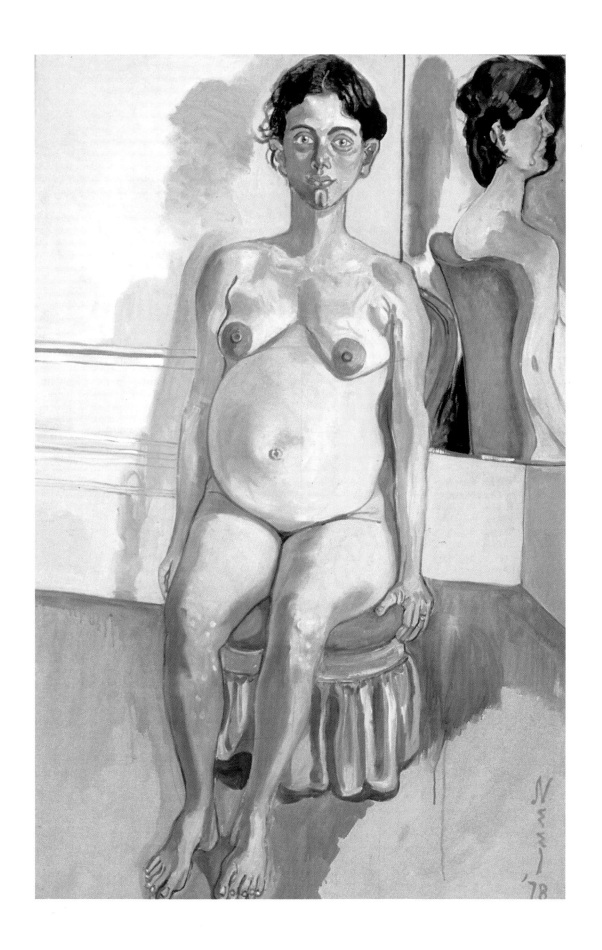

# ALEXANDRA LUKE

(1901 – 1967)  *Surge into Summer*  circa 1950

THROUGHOUT HER adult life, Canadian painter Alexandra Luke was better known as Mrs. C. Ewart McLaughlin, or Margaret McLaughlin. The wife of the wealthy scion of the McLaughlin car works of Oshawa, Luke struggled to balance the demands of 'high society' with a personal quest to find her own voice as an artist. Her double life led her to use her maiden name for her persona as a painter. The traditional attitudes of small-town Ontario and the dismissiveness with which her husband and family treated her art did not deter her from an extraordinarily unconventional career as one of Canada's first women Abstract Expressionists with the group Painters Eleven.

Born in Montreal, Luke and her family soon moved to Oshawa. She maintained a strong interest in art through her period of training as a nurse and her marriage in 1928 to C. Ewart McLaughlin. A woman of prodigious energies, Luke involved herself in the good works and public service required of a wealthy woman, as well as her social and domestic duties.

Given Luke's social context, it is surprising to find her as early as 1933 vigorously defending modernist art in the local papers in response to a diatribe against modernism written by the president of the Royal Canadian Academy. In 1945 she travelled to the art school at Banff to study under painters A.Y. Jackson and Jock Macdonald. Though her early work consisted of landscape, still life and figurative work, under their tutelage she was introduced to the concept of Surrealist automatism and began to experiment with form and colour. MacDonald encouraged her to create automatically, from "within, with no relation to natural forms,"[1] advice that struck a chord with Luke's artistic temperament. Further summer studies with abstract painter and theorist Hans Hofmann in the United States allowed Luke to act as a valuable conduit for ideas concerning abstraction for the small group of interested painters back in Toronto.

In the early 1950s, the reception for abstract work in Canada often bordered on outright hostility. Luke campaigned publicly on behalf of modernism through articles and talks. In 1951 we find her writing in the local paper: "The true artist recreates his subject, gives it an entirely new entity. The experience of this new vision is almost unknown in this country, and people fail to perceive its true content as yet. It will be some time before it is generally realized that abstract painting expresses the rhythm of life in its most intense and eternal aspect."[2] In 1952 Luke organized for the Oshawa Y the first Canadian all-abstract group exhibition; it travelled throughout southern Ontario and to Montreal. In 1953, many of the painters with similar views she knew banded together as Painters Eleven. The group had its first meeting at her studio in Whitby; among the members were Jack Bush, Hortense Gordon, Harold Town, Tom Hodgson and William Ronald. Luke complains in her diary of all the drinking and swearing she had to put up with from these men half her age. Nonetheless, the rich society lady had found firm ground, and her painting from this time grew in strength and dynamism.

Luke's interest in Theosophy and the spiritual theories of mystics Gurdjieff and Ouspensky found a visual equivalent in action painting, where colour and form could operate as purely as musical notes. "Art is a powerful instrument, a magical key and a universal language. It should not stop with already discovered beauty but should continue searching forever."[3] The search for new depths of expression is evident in "Surge into Summer," in which Luke uses vibrant, harmonious colour to evoke the high heated energy of a sun-drenched summer day. Using brilliant pigmentation and rhythmic, floating brush-strokes, she recreates her subject, giving it an entirely new reality. Colour, form and line converge dynamically in a vortex that tumbles us into the picture space she has created; shifting planes and diagonals propel the viewer into this abstract evocation of a summer charged with vitality.

Despite the increasing confidence of her output, Luke had only three solo shows. The others in Painters Eleven went on to fame if not fortune with the rise of commercial galleries in Toronto; many of them had considered Luke one of their most promising members. Said Jack Bush: "The way she has been treated in this town makes us weep blood all over the floor." "Well it doesn't bother me," Luke said. "Well, it damn well bothers us," Bush replied.[4]

In 1967, at the height of her powers, Alexandra Luke died of cancer. Her invisibility as a creative force would perhaps have been complete save for her bequest of thirty-seven paintings to the city of Oshawa. C. Ewart McLaughlin then donated funds for what became the Robert McLaughlin Gallery; he was heard to remark at the sod-turning ceremony that he didn't like contemporary art. In recent years, Luke's work has been given the serious attention it merits by the work of Joan Murray and the staff at the McLaughlin Gallery. ℘

# ISABEL BISHOP

## (1902 – 1988)  *Bootblack*  circa 1933 – 34

AMID THE EXPLOSIONS of abstraction and other avant-garde movements in the twentieth century art world there continued the quieter, but nonetheless stubbornly popular tradition of figurative painting. Eras like the depression-razed 1930s were characterized not only by the modernist experiments of the Bauhaus and the Surrealists, but also by a strain of social realism which found a particularly hospitable climate in the United States. The work of Isabel Bishop, with its emphasis on the human figure and the lives of ordinary working people, found a ready audience in New Deal America. The patronage of government programmes in the arts at this time supported the work of many women artists like Dorothea Lange and Alice Neel, with subjects and styles often identified as socially conscious treatments of the human condition. "Bootblack" is a summation of many of the concerns of Bishop's work and an example of what came to be known as 'American Scene painting.'

Isabel Bishop grew up in Detroit, taking Saturday art classes from the age of twelve. Upon graduation from high school, she moved to New York to study illustration, then painting at the Art Students League. Throughout her studies, she maintained a strong interest in working from the nude model. In 1926 Bishop moved into a studio on Union Square in lower Manhattan. From this vantage point she painted the daily comings and goings of the denizens of the busy square, from working girls gossiping on their lunch breaks to the shoeshine bent over his work pictured in "Bootblack." With an eye attentive to the poetry of the smallest nuances of human relationships, Bishop documented the commonplace moments which make up urban life. A fine sense of accurate drawing and classical treatment of the figure were to inform all her work. Her first exhibitions in New York in the 1930s drew a positive response; she continued to have shows in the United States throughout her long career. In 1975 the University of Arizona Museum of Art accorded her a major retrospective.[1]

In 1931, Bishop travelled to Europe where she was drawn to the work of Renaissance and Baroque artists; later she kept a reproduction of a small Rubens painting in her studio. From the grand manner of classical painting, Bishop gleaned her careful rendering of the figure in all its variation, her understanding of the use of light and shadow to model form on a traditional white ground overlaid with luminous oil glazes, and her use of sophisticated compositional structures to create movement. Her task, as she saw it, was to put these tools to the service of a more modern vision. Classical means could depict the workaday world of ordinary people in the city, rather than the heroic schemes of the past. Modern American life, she felt, was better characterized by a sense of bustling mobility, of the ever present potential for change.[2] Through dynamic use of pose and composition, her work is infused with the vitality of modern city life, a metaphor for the possibility of a better life for the women and working folk she chose as her subjects.[3] As well, Bishop often returned in her work to the challenge of conveying a spirit of modernity through the vehicle of the female nude.

In "Bootblack" we can discern the careful studies from life Bishop made. Often she would ask people from the street into her studio to pose. With apparent simplicity, sun-bleached tones and animated brush-strokes, she portrays a scene dominated by the quiet integrity of her subjects. On closer inspection, however, such simplicity is belied by the zigzagging complexity of the composition chosen to capture the impression of a moment caught. In a second the shoe shine will be finished, the newspaper put down, positions shifted, life carried on. This is not a lofty classical tableau for our edification but a passing moment from daily life observed with great acuity. The eye is led from the shoe to the bootblack's parallel alignment with the object of his work, to his client's gaze and newspaper, through the hand and pose of the lounger, to rest on the woman who walks away from us in one direction and gazes in another. She sends our eye eventually to the fragment of statue in the upper background corner, which completes the diagonal sweep of the bootblack and his work. His highly polished boot is itself an accent point, etched more sharply than much of the picture, a source of pride to the bootblack perhaps, and a summation of the picture's subject. Such deft execution of spatial control and interlocking diagonals draws us into and through the painting. Yet the restraint of Bishop's quiet palette and the humbleness of her subject balance the painting's dynamism with a warm and gentle view of contemporary city life. Her celebration of ordinary people and moments stand in tribute to Bishop's democratic humanism. ✍

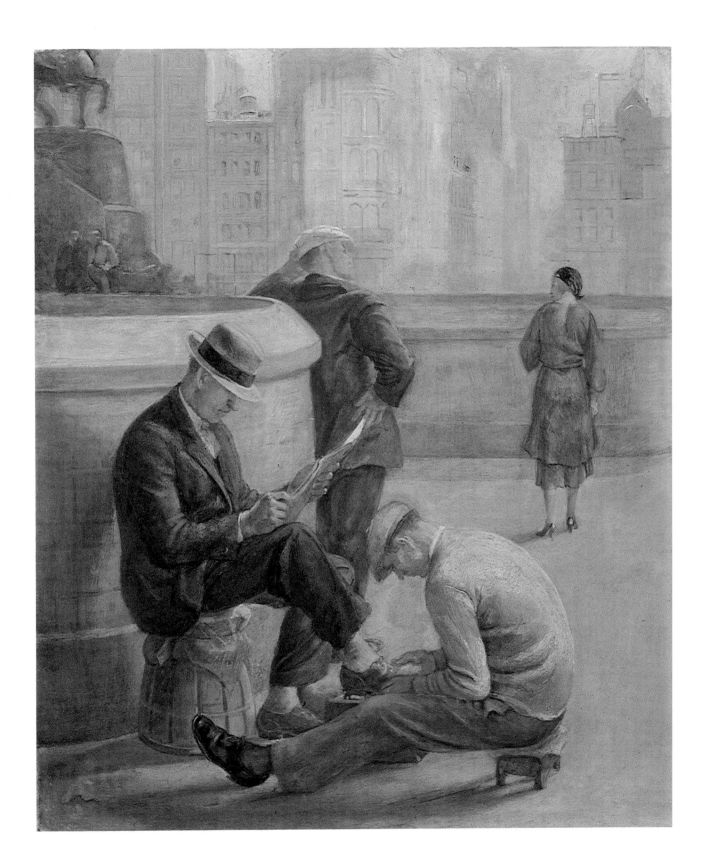

# BARBARA HEPWORTH

*(1903 – 1975)* *Single Form (Memorial to Dag Hammarskjöld)* 1961 – 63

> We return always to the human form — the human form in land-
> scape.                                              — Barbara Hepworth[1]

BARBARA HEPWORTH is one of the twentieth century sculptors who forged new links between the world we know through our eyes — our abiding fascination with the geographies of the body and nature — and abstraction. Intensely interested in the pure abstraction of form explored by Mondrian, Arp and Brancusi, Hepworth chose her own method of working wood, stone and eventually bronze to evoke the rhythms of nature through essential and eloquently simplified forms.

Raised in the rolling hills of Yorkshire in England, Barbara Hepworth enjoyed the support of her family in searching out an art education to develop what she felt she always knew: "... how to carve. No credit to me. I was just born like that."[2] At age sixteen, her talent led to scholarship studies at the Leeds School of Art (where she met Henry Moore) and London's Royal College of Art. There she earned a grant to study in Italy for two years. She travelled, looked and learned, but returned to London with no work to show and a husband (sculptor John Skeaping) in tow. "I was in terrible trouble because the committee of men said they would never again give a scholarship to a woman. But if I'd done a lot of work and got married, they would have said the same."[3] The marriage deteriorated, and in 1931 she married painter Ben Nicholson, with whom she had triplets (to add to the son she already had.) Impressively, she managed to achieve a balance between family life and work that allowed her sculpture to continue to develop. "We lived a life of work and the children were brought up in it, in the middle of the dust and the dirt and the paint and everything."[4]

In the early 1930s Hepworth had visited Paris and had been deeply impressed with the work of abstractionist painters and sculptors there. In 1933 she joined the Association Abstraction-Création in Paris, and went on to develop through her own work an important link between the international abstract movement and England. Hepworth managed to establish herself in St. Ives on the coast of Cornwall as the Second World War loomed. There she was surrounded by space and light, the sea and the cliffs which so greatly influenced her sculpture. She worked to capture a sense of truly organic energy in forms that echoed the curves and subtleties of both the land and the body. She thought of sculpture as environment, as allusion to our presence in the physical world and to the poetry of wind, rock and sea. Hepworth's work eventually began to incorporate the tension of line — of string and wire — in counterpoint to the mass of her carved forms. Of central importance was a sense of truth to the materials used, a respect for wood or stone which unlocked their particular strengths through her. The life she lived and its attendant losses and pain, whether through illness, the demands of family or the tragic death of her son, was annealed into her artistic vision. Only through creating something pure, clean and beautiful did she feel she could counterbalance the tension and pain, the chaos of life.

In 1931, Barbara Hepworth was the first sculptor to begin piercing her abstract forms with a hole, a revolutionary concept also adopted by Moore and other modernist sculptors. By thus revealing the inner space of her forms, she was able to punctuate the rhythmic dynamic of her work in a way which "radically alters ... mass and balance ... destroys the mystery of the interior while creating a new ambiguity between inside and outside, front and back, edge and centre, space and solid."[5] "Single Form (Memorial to Dag Hammarskjöld)" exhibits this formal device typical of Hepworth in a particularly compelling way.

Commissions for large scale work and critical success finally came her way in the 1950s. "Single Form" was commissioned by Secretary-General Hammarskjöld for the United Nations Plaza in New York City. He died in 1961, and on its completion she dedicated the work to him. Here we see the grandeur and dignity of Hepworth's vision expressed in a pure, lyric form of massive presence. The eloquent forms she uses invite the viewer into this primordial reminder — juxtaposed with the crush of urban busy-ness — of the timeless bedrock of the earth which folds us all into a common heritage.

Barbara Hepworth died in 1975 in a fire which consumed her studio. ✃

# PITSEOLAK

(1904 – 1983)  *Woman Hiding from Spirit*  1968

I am going to keep on doing drawings until they tell me to stop. If no one tells me to stop, I shall make them even after I am dead.
— Pitseolak[1]

PITSEOLAK, one of the most prolific artists of the celebrated Cape Dorset West Baffin Eskimo Co-operative, completed some seven thousand drawings over the course of her lifetime. Hers was an extraordinary life, stretching from a reliance on the old Inuit hunting ways to a career as a respected artist able to support her family comfortably. Her thoughts on her life and art have been documented in *Pitseolak: Pictures Out of My Life,* a book of interviews and reproductions published in 1971, and a film of the same name produced by the National Film Board of Canada.

Pitseolak was born in a skin tent on a remote island in Hudson Strait; she spent her 'remembered life' around Foxe Peninsula, Baffin Island. Her father was a renowned hunter, providing well for his family. The preparation and working of skins into embroidered and appliquéed garments which she began in her youth continued into her marriage to Ashoona, also a prolific hunter. The feeling for design and texture so evident in Pitseolak's prints and drawings undoubtedly had its roots in her skilled needlework. Of the seventeen children she bore, only five survived. Several died in a wave of poisoning which swept their community, also claiming her husband Ashoona's life. After his death, existence proved increasingly difficult for Pitseolak and her still young family; they lived in camps near Cape Dorset, where they moved in the early 1950s.

In 1957, James Houston, the government's Northern Affairs administrator for the region and an artist himself, began encouraging local Inuit to draw and sculpt their traditional ways. Out of these experiments grew the first Inuit-owned art co-operative. Pitseolak was one of many local people to discover a talent for drawing and for the printmaking techniques Houston introduced. The Co-op was to prove the prototype for many such artist groups in the north, which subsequently found an audience in the rest of Canada.

The subject matter of Pitseolak's work was drawn from the legends and myths of her childhood, from the spirit world of the shamans, from the nomadic life she had grown up with. "I draw the things I have never seen, the monsters and spirits, and I draw the old ways, the things we did long ago before there were many White men."[2] She began with blacks and browns, using form and colour with great economy for a bold effect, only later branching out to a fuller range of colour. "Woman Hiding from Spirit" utilizes this restricted palette eloquently. The drawing has been transferred to a stone cut and printed in stark black on a white ground. The use of a white background, rather than European notions of three-dimensional space, is typical of much Inuit work from this period. Space and form are symbolic, rather than naturalistic. Pitseolak plays off detailed textured areas with large, anchoring solids which dissolve into soaring spirit shapes. Perspective and scale serve the narrative line; this is not an image recorded by the eye, but an imaginative evocation of forces seen and unseen, magical and symbolic, as the stylized woman in her amautik (parka) sprawls amidst various creatures.

"Does it take much planning to draw? Ahalona! It takes much thinking, and I think it is hard to think. It is hard like housework ... Sometimes when I see pictures in books of my drawings and prints, I laugh. I laugh to think they have become something."[3]

Pitseolak's laughter is also a wellspring for much of her work, which is often marked by her keen sense of delight and "contagious exuberance for life."[4] Pitseolak's dedication to drawing and her prodigious output led to considerable attention and an impressive list of exhibitions across Canada and abroad. In 1967 she was awarded the Order of Canada. In the early 1970s she travelled to Montreal for the release of her book, granting interviews through a translator. In 1976 the Winnipeg Art Gallery held a major retrospective of her work, which later travelled to the United States. Her legacy of mythic figures has evoked for thousands the way of life and cultural values of Inuit society.  ✣

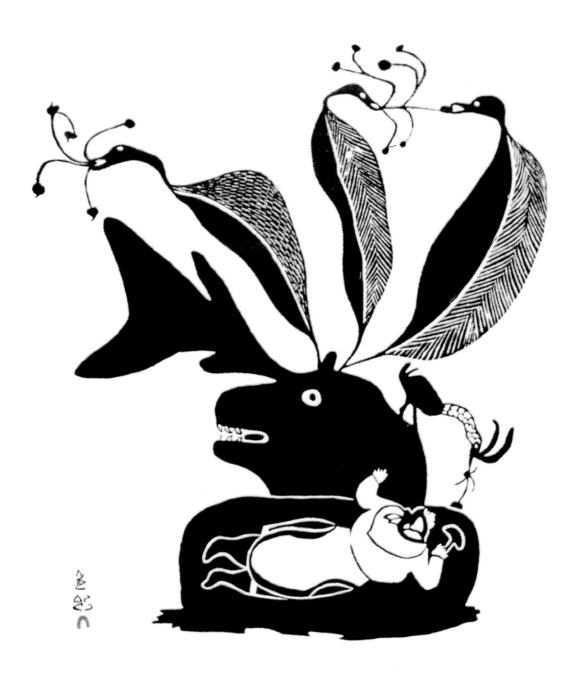

# LOIS MAILOU JONES

(1905 – )   *Les Fétiches*   1937

It takes only a little analysis to see the patterns of neglect, exclusion, condescension and exploitation in the treatment of women artists of color in this country. The double bind of racism and sexism cramps creativity ...[1]

LOIS MAILOU JONES was a woman of colour who faced such challenges and went on to become a renowned artist as well as a professor at Howard University in Washington, DC. She worked tirelessly to develop a slide collection at Howard on Black women artists to serve as a resource and source of role models for younger women artists today. Her own teaching and work inspired many in the struggle for minority artists to find voice.

Lois Mailou Jones grew up drawing, in Boston; her interest in art from the age of fourteen was encouraged by supportive parents and sculptor Meta Warrick Fuller, whom she met at the family summer home. By age eighteen she was studying full time at the Boston Museum School, and went on to become a freelance illustrator and textile designer. In 1930 she began her career at Howard University, where she was to teach for forty-seven years. There she encountered Dr. Alain Locke, head of the Philosophy Department, who was a strong advocate of the importance for Black American artists of reclaiming the ancestral legacy of African forms.[2] Her girlhood dream, however, had been to study art in Europe, and in 1937 she won a fellowship to study at the Académie Julian in Paris. Here at last she felt free to develop as a painter. The prolific results were works influenced by the Fauvist, Cubist and Post-Impressionist styles current in Paris at the time, but with "an original note of her own ... She has a commanding brush that does not allow a nuance of the poetry to escape."[3] Back home the following year, Jones exhibited work at the Vose Gallery in Boston. For several years, she continued to spend summers painting in France.

Over the course of her career, Jones developed differing approaches to imagery, incorporating a variety of ideas and influences into her painting. In the 1940s, she shifted from early landscapes and cityscapes to an exploration of her own background as a Black woman. Subjects such as "Mob Victim" used a more traditionally realist approach to document the history of her people in America.[4] "Les Fétiches" was painted in Paris where Jones discovered African masks in the galleries. "Les Fétiches" offers a more stylized treatment of form in which Jones traces her roots to traditional African tribal sculpture and masks. She uses bold, exaggerated forms, strongly designed patterns and sharp contrasts of light emblazoned against a dark background to heighten the sense of mystery and power. The viewer's attention is drawn first to the compelling central face, with its harsh geometric planes and emanating lines of energy. We are then led back through space by a succession of dramatic overlapping masks lit by the same handling of contrasting highlight and shadow. The subdued palette Jones uses for these haunting faces is in marked contrast to the small vermilion beaked figure, which floats at the front of the canvas in its own 'aura.' This 'fetish' begins to claim our attention with an increasingly powerful presence. The brilliantly painted figure sets up a tension with the mask it faces, suddenly throwing the central face into a 'push-pull' situation and accenting the dynamic of jagged movement Jones employs to heighten the drama of her piece. The mood is one of strong foreboding, of mysterious forces at work. The mask was to continue as a powerful theme in her work.

In 1953, Jones married painter Louis Verniaud Pierre Noel, whom she often accompanied on trips to his native Haiti. There she found painting commissions and took on an active role in the arts community of Port-au-Prince, finding *veve* or voodoo motifs of great interest.[5] From 1970 she also toured and lectured in Africa, using her travels as an opportunity to expand the collection on Black artists she developed at Howard, as well as to enhance the articulation of her artistic vision of Black culture and African motifs.

Jones's long career at Howard University saw the fruition of a body of work which explored varying stylistic approaches; she also encouraged many young women, like Elizabeth Catlett, to see the possibilities of an artistic career, both by example and through her work as an accomplished art teacher. Retrospectives of her painting were held in 1972 and 1983, and she went on to garner three honorary doctorates and more than forty-five awards in recognition of the power of her work.[6] ℘

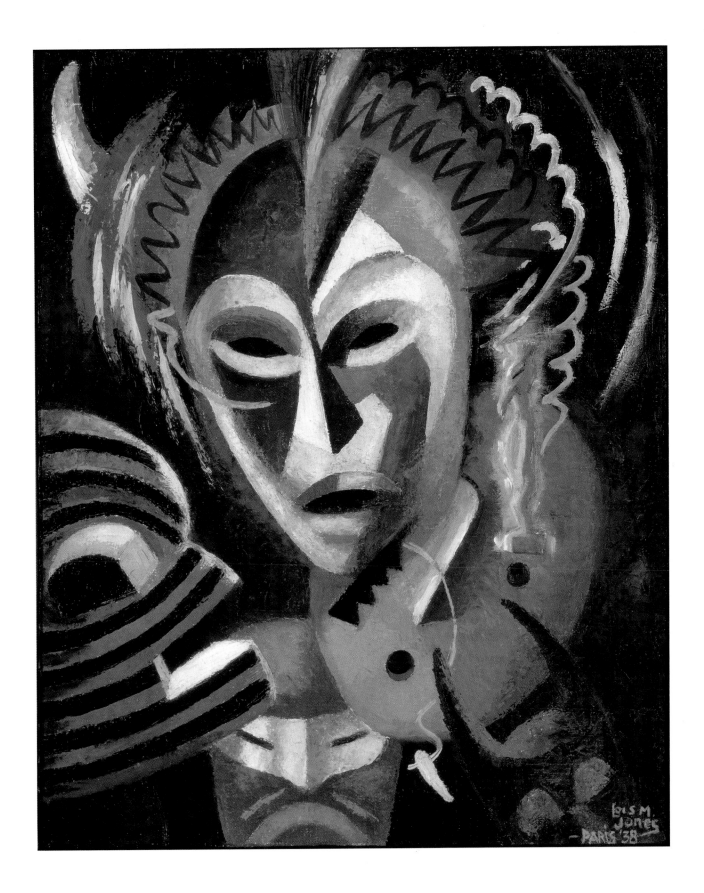

# LEE KRASNER

(1908 – 1984)  *Cornucopia*  1958

THE POST-SECOND World War art world witnessed a seismic shift from Europe to New York as the epicentre of the avant-garde. There the self-absorbed prosperity of the Eisenhower years and the influence of many refugee artists from Europe produced a climate conducive to the development of that quintessentially American style — Abstract Expressionism. The artists who broke new ground in fusing traditional abstraction with Surrealist automatism and emotive Expressionism included women like Elaine de Kooning, Grace Hartigan and Lee Krasner. Long overshadowed by her husband, action painter Jackson Pollock, Krasner nonetheless from the beginning worked at the frontier of this new movement.

Raised in a Russian-Jewish immigrant family, in Brooklyn, NY, Krasner decided at an early age to be an artist. Her studies at Cooper Union's Women's Art School from 1926 to 1929 included endless studies from plaster casts; she had difficulty getting promoted to the Life class. Further studies at the National Academy of Design were also traditional, but during this period she discovered at the recently opened Museum of Modern Art the joys of Picasso, Matisse and Mondrian. She supported her studies as an artist's model and by waitressing in the bohemian milieu of Greenwich Village, meeting art critics like Harold Rosenberg.

The Federal Art Project established in 1934 offered her work for a time as a muralist. She also began to work in modernist painter and theorist Hans Hofmann's studio, and became involved in American Abstract Artists, a group exhibiting non-representational work. They invited Léger and Mondrian to show with them, and Krasner recalls Mondrian's response to her work: "You have a very strong inner rhythm. You must never lose it." In an interview she contrasts his opinion with Hofmann's barbed remark, "This is so good that you would not know it was done by a woman."[1]

In 1941 Krasner participated in a group show at the MacMillan Gallery, where she discovered Jackson Pollock's painting. "It was like a force, a living force ..."[2] She promptly tracked him down and introduced herself. They were married in 1945, and sustained one another through creative crises, through psychoanalysis, and through Pollock's debilitating alcoholism until his death in a car crash in 1956. Although she tended his brilliance, she struggled to work out her own different responses to the vicissitudes of life with force and originality. For several years she piled canvases with grey paint, finally to discover her "Little Image" series breaking

through. Small, densely worked calligraphic gestures filled these thick canvasses with energy. With their "frenetic visual rhythms, these were quintessential examples of Abstract Expressionism."[3]

Throughout her career, Krasner would develop a way of working only to find it 'break' into new revelations, new configurations of abstract line, form and colour. By 1951 she was exhibiting larger, more open organic forms at the Betty Parsons Gallery. (She was actually asked to leave when Pollock chose to go elsewhere because she was 'Mrs. Jackson Pollock.') Many of these paintings were then literally torn apart and reworked in collages. Pollock's death precipitated a more anthropomorphic style; forms became fuller, exploding with colour and energy, until the next 'break' metamorphosed her work into sombre compositions slashed with splintered strokes. Her sense of gestural rhythm never failed to infuse her work with a wild intensity which even a critic of Clement Greenberg's monumental stature found compelling. He became a friend, but such was her confidence in her own vision that his criticisms of the direction her work was taking in 1959 actually led her to cancel the show he had planned for her.[4]

In "Cornucopia" we find a tension between explosive forces, an exuberant play on forms which might suggest a traditional cornucopia of abundant fruit or be read as sheer form. The lyrical tracery of the artist's hand laces the disparate colours and forms together energetically, suggesting movement, growth, change. She works a few nuanced warm colours freely and openly to enrich each another within a shallow picture space. Her biomorphic forms often derive from nature and have echoes of the archetypal; her method is to work "spontaneously and free of preconceived images,"[5] open to the unconscious. Krasner shares with other Abstract Expressionists the conviction that "the physical process of painting is inseparable from the artist and is an act of self-revelation."[6] "Cornucopia" reveals her with visceral immediacy, with the confident inner rhythms of life and nature.

Krasner worked over her lifetime in both large and small scales, though never in acrylic, which she described as "dead as a door nail."[7] Many of her works were finally given the critical attention they deserved in a major exhibition at the Whitney Museum in 1973. Slowly her reputation is emerging as the major force in the Abstract Expressionist movement that it really was. ✑

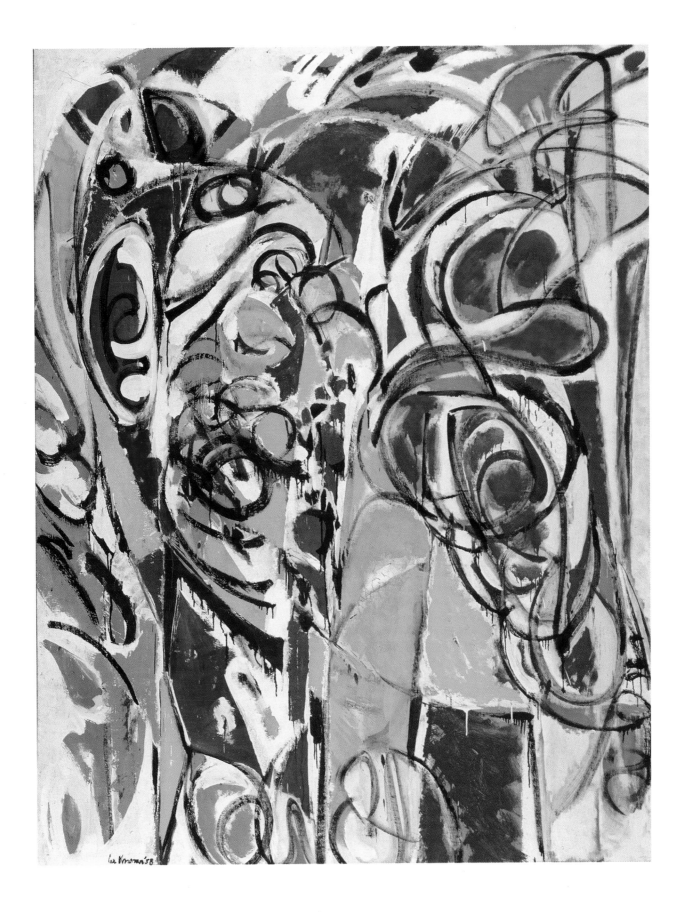

# FRIDA KAHLO

(1910 – 1954)   *Self-Portrait with Thorn Necklace and Hummingbird*   1940

ANDRÉ BRETON, the 'high priest' of Surrealism, described Frida Kahlo's painting as "a ribbon tied around a bomb."[1] Through a body of work of uncompromising personal honesty, Kahlo's legacy is one of searching self-portraiture, the product of a life of riveting self-scrutiny.

Born to a Mexican Roman Catholic mother and a German Jewish photographer father, Frida Kahlo suffered a catastrophic bus accident at age fifteen; her pelvis was crushed and her spine fractured. Her injuries, which required a series of some thirty-five operations, were to haunt her for the rest of her life. Although doctors did not expect her to live, she slowly recovered; teaching herself to paint on a specially constructed easel became part of her convalescence. She had met painter Diego Rivera at age thirteen. After her recovery, a stormy courtship ensued and they married in 1929. Kahlo's headstrong nature combined with Rivera's infamous egocentricity resulted in a tempestuous relationship; separations, divorce and remarriage marked the course of their lives together. Nevertheless, Rivera supported and admired her work, claiming that Kahlo was the "only artist who tore open her chest to express the biological truth of feeling."[2] The psychic strains of the relationship were recorded with passion and brutal frankness in Kahlo's work, as was the searing physical pain which was her constant companion.

Kahlo was known throughout her life for her flamboyant spirit. With her broad black eyebrows, theatrical dress and striking presence, she presented a compelling and unconventional figure. She hid her heavy braces beneath the flowing dresses, ribbons, and bright embroideries of her much loved Mexican native dress. Her painting also was influenced by Mexican folk customs. Largely self-taught, she admired local religious ex-votos, *retablos* painted on tin, and kept the small scale, inscriptions and use of tin in many of her own works.[3]

In the early 1930s it became difficult for progressive artists to find work in Mexico, so Kahlo and Rivera travelled to California and New York, where he obtained various mural commissions. Back home in 1938, the couple were visited by Leon Trotsky and André Breton; their household had become a gathering place for many of the leftist political and artistic figures of the day.

Kahlo had her first exhibition in New York that year. Breton's essay for the exhibition's catalogue described Kahlo's use of imagery as Surrealist. In "Self-Portrait with Thorn Necklace," the unsettling juxtaposition of animal imagery with Kahlo's psychologically powerful gaze can be construed as influenced by Surrealism. The cat, monkey, bird and luxuriant, vascular vegetation conjure up archetypal associations with the earth's fertility. But Kahlo herself said that Breton "thought I was a Surrealist but I wasn't. I never painted dreams. I painted my own reality."[4] This devotion to her own inner realities distinguishes all Kahlo's self-reflective work. The painting also relies on Christian symbolism — the circle of thorns, the redemptive red drops of blood, the mortification of the flesh. It is 1940, the year of her remarriage to Rivera, but the necklace of pain is with her nonetheless; she challenges us with a gaze full of the knowledge of the turbulence of passion. As in many of her works, Kahlo uses a frontal, and confronting, pose, creating a compressed picture plane to thrust the foreground inescapably towards the viewer. Her characteristic use of red, white, black and green, with all their powerful symbolic resonance, is also present. She takes liberties with scale as well, as evidenced by the over-sized insects crowning her head — ornaments or incessant tormentors? Is she a force of nature, or its victim?

The allusions to a strenuous inner life may indeed have Surrealist overtones, but the courage with which Kahlo reveals herself through her own image forges a new kind of portraiture. The subjects she addresses so critically — the trials of intimacy, the agonies of an invalid body, the obsession for a child and the despair of miscarriage and abortion — were unconventional and daring for her time, and expressive of a woman-identified vision.

In 1953 Kahlo was honoured with a major exhibition in Mexico City; although ill, she received her guests for the opening from a bed brought into the gallery. She died the following year at the age of forty-four. Today her work, with its powerful self-imagery, has become increasingly popular as women search out new ways of representing the emotional and physical experiences of their personal lives. ✆

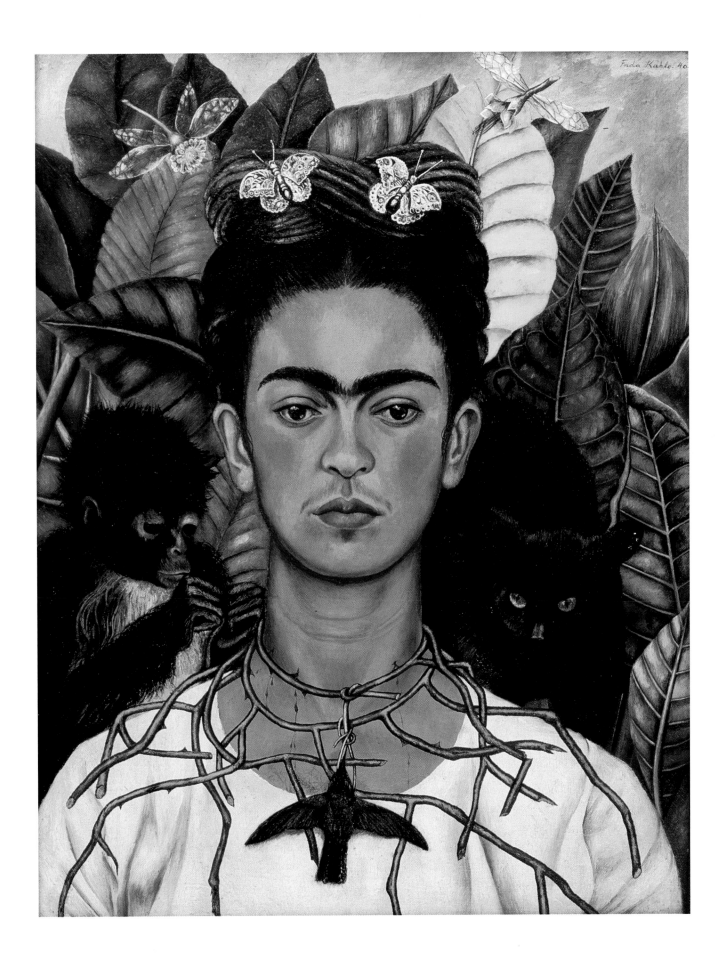

# DORIS MCCARTHY

(1910 – )  *Iceberg Fantasy # 24*  1976

... I've found that working with dedication towards an end that you believe in is abundant life, happiness enough for anyone. My talent or lack of it is not my responsibility. What is my responsibility is to use what I have to the full.     — Doris McCarthy[1]

DORIS MCCARTHY'S life as an artist and teacher is a testament to the joys of the creative life. McCarthy grew up in the Beaches in Toronto's east end. Although her family expected her to follow her dream of becoming a writer and English teacher, a stint at Arthur Lismer's art classes at the Art Gallery of Toronto led to her being offered a full-time scholarship to the Ontario College of Art. Once there, she was caught up in a whole new world. The tradition of painting trips into the countryside, with group critiques at the end of the day's work, started in these early years and deepened McCarthy's love of nature and the land.

When she had finished her four years at art school McCarthy was offered a job in the art department at Central Technical School. Her painting, confined to weekends and holidays, continued unabated through the next four decades of teaching, crowded into every available corner of McCarthy's life. Teaching was exhilarating and exhausting, leaving her 'bone weary'; she also deeply held the belief that an art teacher must be a practising artist to teach well. Weekends were spent painting with friends and colleagues in Haliburton or Muskoka; summers were often spent at Barachois Harbour on the Gaspé coast. For McCarthy, these were solid work sessions, "wonderful periods of renewal and mutual inspiration and stimulus."[2]

McCarthy's public exhibition at the Royal Conservatory of Music in 1929 was the first in a long career of putting her work before the public wherever possible. In the early days this required ingenuity and perseverance, since commercial galleries were largely non-existent. However, she found a willing audience in universities and community centres, and her entries to the annual juried shows of the Ontario Society of Artists led to her membership from 1944 on. The OSA, the Royal Canadian Academy and the Canadian Society of Painters in Watercolour were pre-eminent artists' organizations in the 1940s and 1950s, drawing upwards of two thousand people to their openings at the Art Gallery as late as 1964.[3]

McCarthy became the first woman president of the OSA in 1964, and saw the organization through the period of its isolation by the contemporary art world as too staid and traditional a body. Nonetheless, as President, she testified on behalf of Toronto art dealer Dorothy Cameron when Cameron was charged with obscenity in 1965 for her group show "Eros '65." "... there's nothing obscene about sex or the human body, necessarily," says Miss McCarthy in "light ladylike tones" in a newspaper account of the trial.[4] Doris McCarthy knew when to wear gloves; she also knew when to take them off.

Throughout her career, McCarthy took the opportunity to travel whenever she could, spending a year studying and painting in England in 1935 and again in 1950, and journeying completely around the world on her own in 1961. On her retirement from teaching, she made the first of many trips to Resolute Bay and the Canadian Arctic, which she continued into her eighties. Home was "Fool's Paradise," the house and garden she had lovingly built, often with her own two hands, next to the Scarborough Bluffs in Toronto. A search for the spiritual infuses McCarthy's artistic vision which, despite occasional experimentation with the artistic currents of the day, remains dedicated to her exploration of the Canadian landscape. Her apprehension of the natural world is not an imitation of it so much as an incarnation in paint, an incarnation informed by her involvement of mind, senses and emotion to interpret the perceived world. "Each [landscape] ... is a visible document of Miss McCarthy's inward apprehension of what it is to stand on the very edge of the world."[5] Each image selects and distils the essence of perceived form and colour and gives the land back to us with fresh eyes and understandings.

"Iceberg Fantasy #24" reveals many of McCarthy's concerns as a painter. The circling composition draws us into the cold but mystical embrace of these rhythmically repeating majestic forms. The lyrical and compelling circle of form we step into is set against the frieze of a distant background of glowering sky and dark, unknown mountains, a compositional scheme to which she is often drawn. To the Group of Seven's compositional motifs and treatment of stylized form she adds her own: this circling invitation to be a part of the larger cosmos which we see so radiantly illustrated here. Colour symbolism and the monumental purity of form of the north combine to produce a meditation on the spiritual aspects of this land we take so much for granted.  ☯

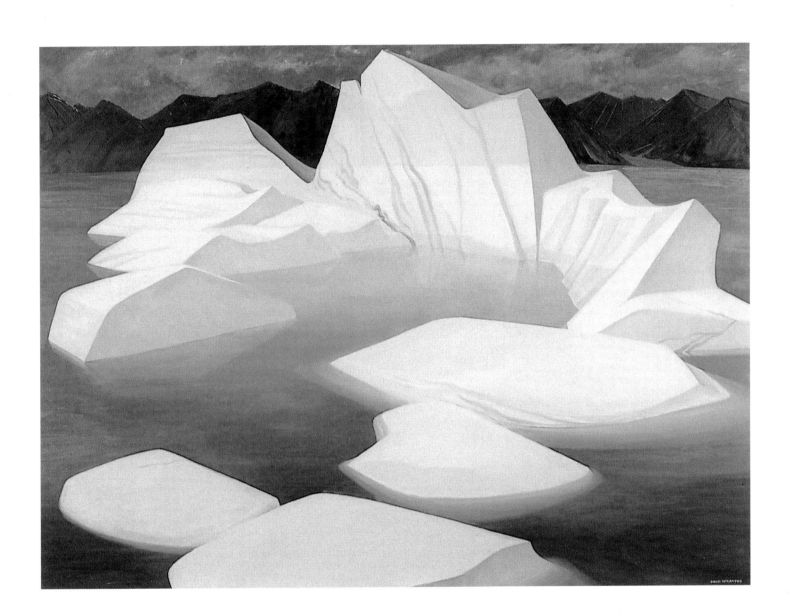

# AGNES MARTIN

(1912 – ) *Falling Blue* 1963

> When people go to the ocean, they like to see it all day ... It's a simple experience, you become lighter and lighter in weight, you wouldn't want anything else. Anyone who can sit on a stone in a field can see my painting. I want to draw a certain response ... an experience of simple joy, the simple direct going into a field of vision as you would cross an empty beach to look at the ocean. [1]

AGNES MARTIN'S gridded canvasses glow with an inner life, like musical tone poems. In them, she hopes to reawaken our purest understandings of happiness and beauty. Martin was born in the town of Macklin on the plains of Northern Saskatchewan, to Scottish immigrant farmers. After the death of her father in 1914, her mother took the family to live with Robert Kinnon, Martin's grandfather, who impressed the children with the Presbyterian virtues of devotion to work, humility and egalitarianism. When Martin left home to help out a pregnant sister in Bellingham, Washington, she found herself attracted to what she called the "American character"[2] and became an American citizen. She studied education in Bellingham and later at Columbia University in New York in 1941, where she found her courses in Fine Arts most compelling. She then taught in public schools in Washington, Delaware and New Mexico, finding time off for painting without distractions when she could.

Studying in New York City again in 1951–52, she was impressed by the work of Abstract Expressionists Barnett Newman and Mark Rothko, whose search for transcendent experience through painting paralleled hers. By now, her own painting had developed from early portraits and landscape to more experimental, abstract biomorphic forms floated on washes of pale, translucent paint — forms inspired by the natural world.

Martin returned from New York to make her home in Taos, New Mexico. In the early 1950s she gave up teaching at the age of forty and turned to a life of painting, choosing to live alone in austere simplicity in a converted goat shed. In 1957 New York dealer Betty Parsons purchased enough work to enable Martin to move to New York. By 1960, Martin had found the six-foot square format — the size of the human body — which came to characterize her work for the rest of her life. Though critics claimed that her spare compositions were Minimalist, her aims were "metaphysical rather than physical"[3] — her meditative paintings were about feeling. She lived and painted in New York for ten years; then she abandoned painting for writing, and roamed the country in a camper van, finally settling in New Mexico. In 1974 Martin returned to her square canvasses, adding shimmering colour to her search through painting for a physical manifestation of beauty that could evoke "the fleeting passages of the spirit through the mind."[4]

Martin's search for a radiant art had its roots in her readings of Taoism, spiritual sources like William Blake and the Bible, and in the Zen interpretations of Buddhism attracting interest in North America in the 1950s. Her method was to strip away the unnecessary, to focus the viewer's mindful attention on the ineffable and essential beauty of the world through images of pure colour and form. Turning her back on the ceaseless chatter of modern life and the hectic daily pressures of society, she chose in her art and in her lifestyle to pare down, to be still, to simplify until nothing was left but essentials. Her efforts towards "self-effacement through the act of self-expression ... a practice in humility, [are] for Martin 'the most important response to life.'"[5]

"Falling Blue" is a variation on the theme of linear grids Martin evolved to express her vision. Her own hand has brushed lines of blue pigment across a warm ochre ground to the edges of a perfect square. Each line steadily marks out the order and constraint of the grid, and yet each bears the traces of the vagaries of the human hand. When one stands back, the accumulation of lines settles into a humming surface, alive with a tremulous, quiet energy. Martin invites us to participate in "Falling Blue" as an event; with the act of concentrated looking, our distractions fall away. The ocean of vision she has created draws us into a new place where strength belies the apparent fragility of the gossamer tracery of line. As critic Lawrence Alloway has said, "An artist like Martin can fill the house with a whisper."[6] And the moments of perfection to which she recalls us are reminiscent of those flashes of awareness of true beauty which we carry with us as touchstones all our lives. "Beauty illustrates happiness; the wind in the grass, the glistening waves following each other, the flight of birds, all speak of happiness."[7]

Now in her eighties, Martin continues to live a rigorously spare and ascetic existence, reserving all her energies and attention for the intense focused commitment her vocation demands. Now considered one of the pre-eminent artists of our time, her work was recently honoured with major retrospectives at the Whitney Museum of American Art and the Stedelijk Museum in Amsterdam. ✍

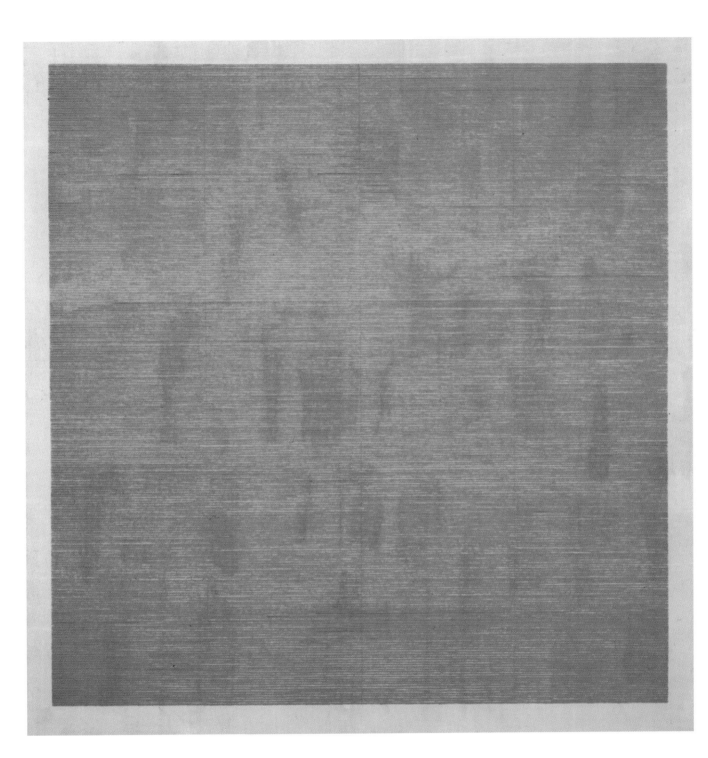

# ELIZABETH CATLETT

(1919 – )  *Sharecropper*  1970

> Art for me now must develop from a necessity within my people.
> It must answer a question, or wake somebody up, or give a shove
> in the right direction — our liberation.     — Elizabeth Catlett[1]

BORN IN WASHINGTON, DC, Elizabeth Catlett felt an early affinity for drawing, and did well in art in high school. Catlett's application to study at Pittsburgh's Carnegie Institute of Technology was refused on the basis of colour; undeterred, she went on to study art at Howard University. Here she was influenced by Lois Mailou Jones and others interested in the question of Black heritage. Her political understanding deepened in the atmosphere of debate at Howard, and Catlett became drawn to the idea of an art which spoke to Black people of both their ancestral legacy and their contemporary lives.

After teaching high school in North Carolina, Catlett did postgraduate work at the University of Iowa in 1939. Blacks were not permitted to live in the dormitory there, but she persevered at her studies, becoming the first student ever to earn the degree of MFA in sculpture. She studied with American realist painter Grant Wood, whose dedication to painting 'what you know' she admired and took to heart.[2] In addition to painting, Catlett had begun to explore the potential of three dimensional form, winning first prize for her thesis sculpture "Mother and Child," a recurring and powerful theme for her.

Upon graduation, Catlett became head of the art department at Dillard University, and then studied briefly at the Chicago Art Institute, where she married painter Charles White. Then came a stimulating period in New York City, where the couple moved to Greenwich Village. Romare Bearden, Langston Hughes and Paul Robeson were among their circle of friends; they were caught up in the excitement of the legacy of the Harlem Renaissance, and debated the questions of Black identity and creativity with passion. To Catlett's disappointment, sexism prevailed. "Though I was part of this group ... as the female half of a husband/wife artist team, I was not taken as seriously as an artist as my husband."[3] At this time she studied with the Cubist-influenced sculptor Ossip Zadkine. Catlett was also teaching evenings at the George Washington Carver School, a people's school in Harlem. Teaching students who were "working people, like domestic workers, people that were hungry for some kind of education and culture," immigrants from all over the world,[4] Catlett's conviction that art must not be elitist, that it must speak to ordinary people, deepened.

In 1946, a Rosenwald Fellowship allowed her to travel to Mexico to work in the Taller de Grafico Popular, a collective printmaking workshop where she came into contact with artists who were dedicated to producing art which would contribute to the struggle of working people. The prints she developed from this period show her profound commitment to documenting the plight of her own people. A portfolio of fifteen linocuts she did in 1946/7 on the subject 'The Negro Woman' shows Black women at work as labourers, artists, farm workers — women strong in their own right rather than portrayed as the supporting and background figures of past imagery.

"Sharecropper," done later in the artist's career, shares this continuing concern for representing the strength and dignity of Black women. Catlett has used the technique of woodcut to add a bold, graphic pattern of line to this powerful portrait. The broad planes of the woman's face show the same angular simplicity of form found in Catlett's sculpture: a paring down to basic volumes in order to strengthen their character. The composition is pyramidal, with the central gaze of the subject encircled by hair, hat and pattern to bring us constantly back to the proud brow and unwavering gaze. Catlett's work here, as always, is in the figurative tradition, a self-conscious decision on her part to reach ordinary working people with politically conscious art and to by-pass the elitism of more mainstream abstraction.

Catlett divorced in 1946 and then settled in Mexico, where she married Mexican artist Francisco Moral. She became a Mexican citizen in 1963 when her activities on behalf of the civil rights movement in the United States led to her harassment by the House Un-American Activities Committee. It was not until 1971 that the American State Department responded to pressure from the arts community and granted her a visa.[5] Since then, her work has been shown in many exhibitions in the US, both in mainstream museums like the Museum of Modern Art in New York, and in art spaces like libraries, where ordinary people would have greater access to her work. Her work continues to combine "social as well as aesthetic, political as well as physical, emotional as well as intellectual [concerns] ... When I physically transform a raw material — wood, clay or stone — into an aesthetic expression of the life of my people, I feel complete as a human being."[6]  ✑

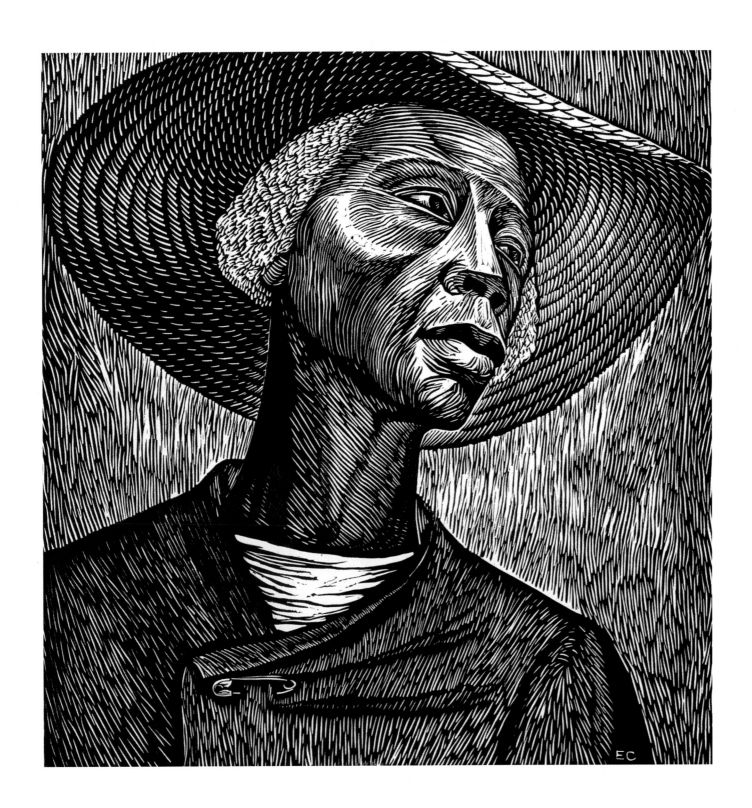

# DAPHNE ODJIG

(1919 – ) *Beauty in Transition* 1990

THE STRUGGLE TO be accepted as a person and an artist has been a long one for Daphne Odjig. Born on the Wikwemikong Reserve on Manitoulin Island of a Native father and English mother, Odjig grew up in a close and supportive family. Her early years were a relaxed mix of cultures and Odjig's interest in art was encouraged. After her mother's death, Odjig was removed from her father's care. Her mother's relatives were ashamed of her Native background, and for the next few years Odjig found she had to deny her own roots.

> After mother died I went into the White community to look for housework. I soon learned that to say I was an Indian resulted in the door being shut in my face. In order to survive I lied and said I was part French and English. I hated this lie, but I was desperate.[1]

At the start of the Second World War Odjig left Parry Sound for Toronto. At the Art Gallery of Ontario she found the works of 'old masters' and of contemporary Canadian artists, teaching herself by observing and reproducing techniques which she had seen. In 1945 Odjig married and moved to British Columbia. Her husband, a former service man, cut up his old tents and stretched the canvas for her to use for her painting.[2] As with many women artists, Odjig's time for art was restricted by domestic demands. In addition, the racism she encountered was discouraging. "I always tried to walk proudly and keep a good appearance ... I projected security, I projected that I was master of myself. But actually, inside, it was another story ..."[3]

Following the death of her first husband, Odjig became more involved in her art, experimenting with different media and techniques such as printmaking. In 1963 she remarried, and it was also around that time that Odjig was invited to join the British Columbia Federation of Artists. Odjig became increasingly involved in recording Native struggles. She began to sketch the passing traditional ways and to paint images of some of the legends she had heard in her youth, drawing from a modernization of the pictograph style. In her paintings and prints she often used the expressive form line now common in the work of Norval Morrisseau and other contemporaries. "I do it. All Indian artists do it ... we all feel comfortable with this, working within the framework. You'll find it even in my soft pastels. If you took all the colour out of my painting you would see a line drawing. So you work within that line. Do not all artists work within a line?"[4]

Odjig became the first Native person to own her own gallery and control print production. She was part of a three person exhibit of works at the Winnipeg Art Gallery in 1972, the first time a public gallery devoted a show to Native art. In 1975 her erotic illustrations for the book "Tales From the Smokehouse" electrified the community. Her large mural "The Indian in Transition" was commissioned for the Museum of Man in 1978.

Odjig's 1990 work "Beauty in Transition" demonstrates her mature style and the ease with which she blends traditional legend with her personal vision. The mythic creature who metamorphoses here from human to creature is reminiscent of other treatments Odjig has done from the legend of Thunderbird Woman.

> The Thunderbird Man was a young Indian who courted the Thunderbird Woman when he encountered her in human form. A jealous older brother shot her with an arrow. Torn with grief, her lover wandered through the woods. Nanabozho* advised him to go to a tall mountain that reached into the clouds, and there the lovers met again. Thunderbird Woman was now part Thunderbird and part woman ... She said, "If you wish to stay with me you must come to see the chief of the Thunderbirds who will change your body as ours," and the young Indian followed her and was transformed.[5]

The image shows us a woman/bird who fills the entire foreground. The form line defining shape is dark and flowing, while filled with rich primary colours. The abstracted figure is in motion, carrying us across the canvas with the life force of transition. A background of fluid mountains organically enfold the figure; nature is a protective and healing force. The entire work is imbued with an atmosphere of power and mystery. Odjig has effectively drawn the viewer into the ecstatic experience of transition, capturing the legend at a pivotal moment when the connection between the two worlds of mortal and spirit is at its strongest.

Now in her late seventies, Odjig continues to explore personal themes. Her experiments with colour vary now, but the themes of Native and personal enlightenment remain. She continues to feel strongly about the importance of her art: "I believe I used to paint considerably for emotional escape, but in recent years I feel I've found my place in life, I feel more content and most of the time I paint more for enjoyment and expression. I feel fortunate I have a medium through which I can speak to non-Indians and Indian people alike. I feel I have a job to do ..."[6] ꆛ

*A spirit who is helpful or a trickster and can be found in many Native stories — an ambiguous or paradoxical character.

# GATHIE FALK

(1928 – )    *Theatre in Black and White and Colour: Alberta Spruce and Streamers*   1984

GATHIE FALK'S work ranges from ceramic sculpture to performance art to painting. Her adherence to often surprising personal imagery and refusal to 'explain' her work have made her path difficult at times, but Falk's tenacity and confidence have gained her recognition as a prominent Canadian artist, with a major retrospective of her work shown at the Vancouver Art Gallery in 1985.

Falk was born in Alexander, Manitoba on January 31, 1928 to parents who were recently immigrated Russian Mennonites. Her father died soon after her birth and, in order to survive during the Depression years, the family was forced to move from relative to relative in Ontario, Saskatchewan and Manitoba. Despite these difficulties, Falk's mother encouraged her daughter's interest in the violin, singing and the visual arts, which she felt particularly drawn to. Falk was forced to leave school at age sixteen in order to help the family financially. Her first jobs were dull, repetitious factory positions — sewing pockets into suitcases or packing boxes for Safeway. She finished school by correspondence, then trained to be an elementary school teacher. For twelve years she taught school in British Columbia.

While teaching, Falk had taken some art courses at the University of British Columbia. She was able to fully pursue a career as an artist when she cashed in her pension and left teaching. Pension fund in hand, she began a year of painting and making ceramic sculptures. She experienced quick success with her glossy, organic ceramics and was able to sell enough to continue her new career.

Although Falk has experimented with various media, her use of repetition, of symbolic objects and intimate personal images has been a constant. She consistently uses everyday, personal objects and experiences in her work. "The word personal is a better one than domestic, I think. Everyone deals with the domestic. But personal, that's something different ... You're never going to be able to see things in detail unless you can look at your kitchen table, see it and find significance in it ... seeing the detail around you makes you able to see large things better."[1] Falk has experimented with the expression of her vision through performance art, installations, ceramic sculpture and painting. Although reluctant to discuss the meaning of her work, she has indicated that her style often relies on the unusual juxtaposition of seemingly unrelated objects that is reminiscent of Surrealist art.[2]

Much of Falk's imagery and work style relate to her religious background; a practising Mennonite, the joy of sharing rituals and experiences with her community of friends is central to her. "There was the loveliness of cherishing ordinary things — from cabbages and eggs to old songs and old friends — as an act of religious gratitude and blessing, and the beauty of dwelling on the earth in the bonds of kindness."[3]

It is through the repetition of objects or through changes in scale that Falk celebrates the quotidian. Her performance pieces also subtly play out the repetitive actions of everyday life — eating an egg, reading a book — often injecting a note of surprise or dreamlike absurdity. "I know what I put into the work and I can read it on many levels. I can sometimes find humour in it, but I can also see other things ... I never try to put a message into my work, but I very often get one out of it."[4]

"Theatre in Black and White and Colour: Alberta Spruce and Streamers" echoes many of Falk's recurring themes. Here again is the veneration of the ordinary, the repetition and the careful formal balance so often seen in her work. There is a richness in contrast between the textured detail and sun-lit colours of the spruce trees and the flatness of neutral paint applied to the background. For this series, Falk treated the same subjects in both black-and-white canvasses (often a painterly deep brown or blue rather than black) and in colour, exploring the difference as a photographer might. Each painting uses orderly grids — of kitchen chairs bestrewn with flowers, of stakes in the ground, of thin young trees. Her spruce trees are potted and carefully ordered, aligned in a grid and illuminated with bright auras of light which cast strong shadow-selves of the pots. Shadows are "... always attached to you, so I make much of shadows. In my paintings I treat shadows as if they were things."[5] Above the trees are festive streamers, returning us to the repetitions of the grid, and the ordering hand of the maker.

In "Alberta Spruce and Streamers" Falk continues her wry and sensitive exploration of the mysteries of ordinary life and continues to return to her touchstones of personal experience, attention to process, detail and repetition. ☙

# HELEN FRANKENTHALER

(1928 – ) *Before the Caves* 1958

HELEN FRANKENTHALER'S invention of the soak/stain method of Colour Field painting has influenced a generation of painters and propelled her to the front ranks of critical attention in American painting. The single-minded drive with which she has pursued her goals has been noted by painter Grace Hartigan, who describes Frankenthaler's work as "the core of [her] life ... an all-consuming thing."[1] Throughout her career, Frankenthaler has refused association with feminism and dismissed gender as an issue,[2] insisting on a strong-minded individualism and on evaluation of her work through the lens of the artistic milieu in which she has lived and worked, rather than in relation to the social movements of her time. Her search, as with other women abstract painters, has been for a unique voice among her male contemporaries, defining something different that could not be reduced to the difference of women,[3] in contrast to critical assessments of her work at the time as 'feminine' and 'sweet.'

Frankenthaler's early influences were teachers Paul Feely and Hans Hofmann as well as the work of Kandinsky. In 1950 she absorbed the impact of Jackson Pollock's large Abstract Expressionist paintings. Both the huge, expressive scale of the work and the unmediated, direct and 'automatic' brush-stroke of the technique impressed her, as did the evocative, associative aspects of Abstract Expressionism. "By Pollock I was touched by the surrealist ... associative quality. It's what comes through in association after your eye has experienced the surface as a great picture. It's incidental but enriching."[4] Abstraction could tap into the rich veins of subconscious and dream imagery. In 1952 she brought the spontaneity of automatism together with a new way of letting turpentine-thinned oils soak directly into raw, unprimed canvas; the painting had become embedded in the canvas in a new way. Following Pollock's method of working with canvas on the floor and from all four sides, she developed the large scale "Mountains and Sea"; it became a landmark work. No longer was painting a thick skin of oils on top of a cotton or linen support. Drips, splatters, floating veils of colour, subtle biomorphic shapes suggest associations with natural forms, a new landscape of the imagination.

Frankenthaler's work was taken up enthusiastically by critic and friend Clement Greenberg, whose writings were instrumental in the eventual success of Abstract Expressionism and the more lyrical Colour Field painting which followed, as heroic new 'American' styles. The stain method which Frankenthaler had developed was adopted by such Colour Field luminaries as Morris Louis and Kenneth Noland. Despite the male-identified, 'macho' milieu of Abstract Expressionism, Frankenthaler's work went on to attract considerable attention; in 1960 she had her first retrospective at New York's Jewish Museum, and by 1969 she was accorded a major exhibition at the Whitney Museum.

In 1958 Frankenthaler married painter Robert Motherwell. That same year, she produced "Before the Caves," nearly nine feet square and full of the energetic fields of colour which so characterize her work. Semi-transparent and opaque washes of thinned oils in complementary hues of mauves and oranges flood into the canvas, becoming part of the canvas support itself and yet shifting us through planes of colour-induced atmospheric space. This surface/depth ambiguity is a constant feature of Frankenthaler's work. Movement is also splashed vigorously through the painting by means of gestural colour lines, drawn out, splattered, both containing forms and exploding edges at the same time. We can almost feel the dance of the hand across this surface. Her method is to let things happen, to begin and let the forms "answer back"[5] in an unfolding journey into the unknown controlled only by her own artistic sensibilities. Patches of unbleached canvas allow colour its clarity and brilliance, creating both 'breathing space' and a ground on which the figure can work its magic. The rich exuberance of line, form and colour elicit our first, sensual response, as Frankenthaler uses paint as almost its own manifestation of the physical world. But the allusion to the cave we stand before, the beckoning opening to mystery and adventure, resonates at second glance also as, through its title, Frankenthaler locates her image in an evocation of the natural world. Indeed, much of Frankenthaler's work can be said to fall within the modern landscape tradition, with its concerns for the processes of nature and its parallels with these processes in paint. "Before the Caves" exemplifies the powerful allusive aspects of her work as well as her unstinting, celebratory abstraction.

In the 1960s, Frankenthaler began to use thinned acrylics rather than oils for her stain paintings; she found the paint flooded into and became part of the canvas differently, and was adaptable to her intuitive pouring and dripping methods in new ways. She continues to be one of the leading proponents of Colour Field painting, conveying an intensely personal vision of "space, light and energy ... an American art ... ample and forceful as the land itself."[6] ℘

# BESSIE HARVEY

## (1928 – 1995)  *Tribal Spirits*  1988

> Trees is soul people to me, maybe not to other people, but I have watched the trees when they pray, and I've watched them shout and sometimes they give thanks slowly and quietly.
>
> — Bessie Harvey[1]

BESSIE HARVEY has been described as "one of the most spiritual and versatile forces among contemporary African-American self-taught artists."[2] Born in 1928 in Dallas, Georgia, Harvey came from a very large family. She lived in Tennessee most of her life. A self-taught artist, she began her artistic career in 1972 at the age of forty-four after mothering eleven children. A deeply religious and spiritual woman, Harvey saw her work as the result of divine inspiration. Although she had never travelled to Africa, she had read widely on her ancestral home and culture, and experienced a strong inner link to her African ancestry.

Often her sculptures began with the particular shapes of the wood she had found, whether driftwood, tree trunks, branches or limbs. She studied the wood and worked with the existing shapes to draw out figures and meaning, a dialogue between artist and material to release the spirit within. She would see forms in the wood and enhanced them with paint, beads, feathers and inlaid marbles. Harvey expressed her vision via many media: painting, drawing, making quilts, dolls, clay figures, and metal sculptures. She believed that the visions she sculpted in wood were spirits who revealed themselves to her, "children of trees, or soul people, a family or tribe that goes back to a legendary Old Africa."[3] The figures often have staring, all-seeing eyes that draw the viewer into the mystical spirit world of the sculpture. Harvey's work blends her link to her African ancestry with deep religious feeling.

> When I was a child I had these strange things I'd see and feel and now I'm putting them in wood ... and just about everything I touch is Africa ... I must claim some of that spirit and soul ... To me Voodoo is just like Methodist and Baptist.[4]

In traditional African cultures, trees possess great spiritual powers and represent a kind of life force.

In "Tribal Spirits" we are presented with a group of mask-like faces with inlaid teeth and eyes growing from the base of a broad tree trunk. While the natural texture of the wood remains evident, Harvey has enriched and interpreted the existing forms by adding paint and small inlaid found objects. For Harvey, "spirit represents a different tribal group and the potential for internal and external strife within that group."[5] These figures are painted with a thin wash of warm glowing greens, browns, reds and yellows. The mix of colours gives us both the darkness and the light that can be said to be within each person, and also calls to mind the elements of earth and fire, of the mysterious natural world from which we spring. The birdlike figure at the top of the sculpture emerges in much cleaner tones, as if to draw the purity from the middle of the mass of life in the work. Harvey has said "the soaring bird represents the removal of conflict from the midst of humanity."[6]

"Tribal Spirits" exudes a raw beauty and retains the warm naturalness of wood, while evoking an almost ceremonial presence. It is a powerful and celebratory example of Harvey's affinity for and connection with her materials. This work, which combines her interest in her African ancestry with the universal theme of unity and love conquering conflict, testifies to her spirituality and creative force.

During the mid-1980 and 1990s, Harvey's work was shown extensively in group shows throughout America, attracting increasing attention with the haunting and natural energy of her sculpture. ❧

# MARISOL

### (1930 – ) *Women and Dog* 1964

REACTING AGAINST the explosive popularity of Abstract Expressionism, several artists in the early 1960s in Britain and America reclaimed the tradition of figurative representation, reinterpreting it through the prism of 'Pop' (from popular culture) Art. The mass-produced icons of contemporary consumer society, from celebrities to soup cans, paraded across canvasses in both send-up and celebration of a society whose central mythology was the nirvana of advertising and mass production. Marisol's satiric collaged and painted sculptures were well received as an important critical variation on the themes of Pop Art.

Born to a wealthy Venezuelan family who supported her artistic ambitions, Marisol Escobar received her early training in 1948 at the École des Beaux Arts in Paris and the Art Students League in New York City. The early 1950s found her in Greenwich village with the 'Beat generation,' thriving on the friendly and fertile environment, and drawing in Hans Hofmann's studio. Marisol has said that her "main influence has been the street and bars, not school and books."[1] Other influences were Pre-Columbian, Mexican, and early American folk art. She began to make small figures out of clay, finding an affinity for sculpture that soon developed into larger tableaux of figures. New York dealer Leo Castelli visited her studio in 1957, prompting her first solo show and establishing her as a force within the art world.

Marisol's method was to start with a large block of wood, perhaps carving it away slightly, but never losing touch with the feel of her source, the wooden cube. Then she would add on plaster-cast heads, arms, feet. The surface was painted, collaged or drawn on, with found objects or metal or fabric added if needed. Often she would use casts or paintings of her own face, hands and feet, leading to speculation about probings of self-identity. The juxtapositions of materials and forms she arrived at were startling reworkings of how contemporary society has constructed the figure, the modern persona.

Her originality was not confined to her sculptural method; the narrative content of her tableaux was often a biting commentary on the preoccupations of contemporary America. Her piece "Babies" (1962) showed "a huge baby monster taking over,"[2] — the American dream gone wild. From "Family from the Dust Bowl" and its migrant workers she crosses class lines to comment mordantly on "The Party" and its socialite women, and "LBJ Himself," Johnson revealed as a macho power broker carrying tiny figures of his wife

and daughters in his paternalistic hand. Marisol has said that she wanted "to work for everybody, because I saw that art had become such a highbrow thing — just for a few people."[3] Ironically, the early 1960s art world was hermetic enough that her critics discussed aesthetics, her use of materials and technique, rather than the satiric social criticism she felt she was making of American institutions.

"Women and Dog" shows Marisol typically slipping back and forth between two- and three-dimensionality. Clothing is painted on with flat patterning, including a playful rendition of painter Frank Stella's geometric forms. A real handbag and leash fade into representations of bag and leash. The handbag is made of pony-skin, evoking with the dog the natural world which has been 'reined in,' controlled by the same forces rigidly constricting how these women present themselves. Their multiple mask-like faces — Marisol's — search in all directions for other existences, locked in their prim and proper prisons of dress and social roles. Hints of sexual imagery subvert their propriety; all is not as it seems on the surface. As with so many of Marisol's pieces, we begin to fill in the story of her relational narratives, finding the group's sense of restless unease a metaphor for the times.

In the 1960s, Marisol herself became somewhat of a myth, famous for her enigmatic silences, her mystique and her personal beauty. The glamour industry decided she was 'chic' and made an icon of her. Andy Warhol called her "the first glamorous girl artist,"[4] consigning her to the role of a 'star,' the exotic Other. She did indeed like parties and dressing up, but her comment on her treatment was that "it's a way to wipe me out,"[5] to disregard the seriousness of her work and achievement, of her satiric social commentary. The 'party girl' was a mask to be enjoyed at the time and retreated from in the studio, an echo of the dialogue between superficial appearances and larger realities which much of her work addressed.

By the late 1960s the social malaise she sensed deepened into personal disenchantment with the North American way of life, and she began a series of travels through Asia, Central and South America to explore other cultures. Her work since then has taken on a new emphasis, investigating a more inward-looking exploration of beauty and the dangers that can accompany it. ✆

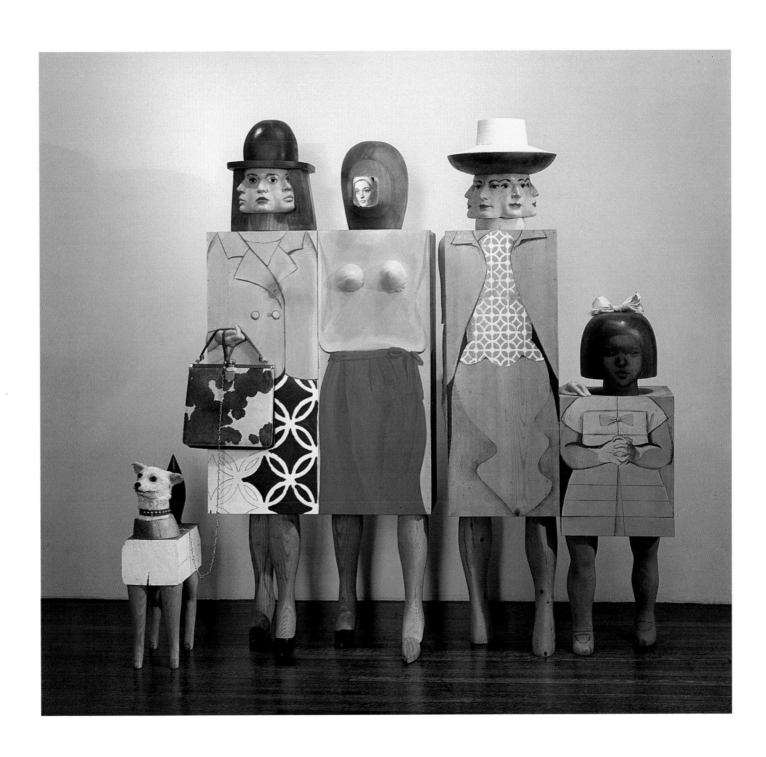

# FAITH RINGGOLD

(1930 – ) *Tar Beach* 1988

> After I decided to be an artist, the first thing that I had to believe was that I, a Black woman, could penetrate the art scene and that I could do so without sacrificing one iota of my Blackness, or my femaleness, or my humanity. — Faith Ringgold.[1]

ONE OF THE DILEMMAS faced by contemporary artists is the question of reaching out to a wide audience. To do so Faith Ringgold breaks down traditional barriers in subject matter and between the arts themselves. Employing unusual materials and approaches — sculpture, material arts and performance techniques — she redefines what it is to be a woman and Black in America.

Born and raised in Harlem, New York, Ringgold decided to pursue a career as an artist after finishing a Masters degree and teaching art in the New York school system. Her early work in the European tradition soon gave way to a search for African artistic sources and for political themes. Ringgold's 1967 mural "Die" from her solo show "American People" shows an interracial street riot surging around a Black and a White child huddled together in bewilderment. It is full of the social concern which led her to become active in such groups as "Women Artists and Students for Black Liberation" and "Where We At," a group of Black artists which she co-founded in 1971. Her commitment to raising public consciousness about minority artists in the face of the indifference of the mainstream art world has led to a body of art fully engaged in social commentary. Her piece "Atlanta" presents us with rows of twenty-eight cloth figures, which commemorate the twenty-eight Black children murdered in that city in 1981.[2] Such work involves an instant engagement on the viewer's part in the political issues raised.

Ringgold also challenges traditional notions of form, reclaiming the 'subversive stitch' of women's handiwork for fine art purposes. Her use of sewing, quilting, weaving and other material arts grew out of the increasing affirmation by feminists of these 'decorative' arts as valid fine art approaches. Her mother had been a clothing designer, so Ringgold grew up with sewing. However "it wasn't until the Women's Movement that I got the go-ahead to do that kind of work."[3] Along with artists like Judy Chicago and Joyce Wieland, Ringgold brings women's 'crafts' into mainstream art-making. In the early 1970s she constructed a series of soft sculpture figures entitled "Family of Woman." Sewn, stitched, braided and beaded costumes and masks have been assembled with the aid of performers to convey a powerful social message about the strong

mythic female figures Ringgold has known since her youth in Harlem.[4]

Through the 1970s, Ringgold showed and lectured in both the United States and Europe, curating shows, serving as artist in residence at Wilson College, participating in workshops and panels at small galleries across the country. Her perseverance in putting her work and concerns about race, gender and class before the public finally resulted in attention by the mainstream art world. In 1984, she had a twenty year retrospective at the Studio Museum in Harlem. The 1980s brought further recognition: a Soho dealer, the Bernice Steinbaum Gallery, and a full professorship in San Diego. Her distinguished career has led to honorary degrees and a major travelling exhibition in 1990–92. In 1991 Ringgold published her first book for children, based on "Tar Beach."

In the 1980s, Ringgold developed 'story quilts.' Using the traditionally female, and often anonymous, form of quilting (which her great great grandmother had practised as a slave), she began to work colour and soft texture together with images and words in a new kind of commentary on her own life and the issues of her community. "Echoes of Harlem," "Slave Rape Story Quilt," "Who's Afraid of Aunt Jemima," ... the titles of her work are touchstones for her exploration of the dilemmas faced by the Black women, men and children who are her central characters. "Tar Beach" is from Ringgold's series "Woman on a Bridge." The George Washington bridge fills the view from Ringgold's New York studio window, and arches across the background of "Tar Beach." Over it flies Cassie, the narrator of the story, claimed by the magic of a starry night and by that familiar dream in Black literature of flying to freedom. Cassie also lies beside her baby brother on the tarpaper rooftop in the warm summer night as the grown-ups enjoy a sociable hand of cards. "Usually people write very negative things about Harlem. My experience growing up was positive and uplifting. I had a wonderful childhood and "Tar Beach" actually comes from that experience. It's not an autobiography but we often went up on the roof at nights when it was hot."[5] Here Ringgold's voice is added to the rich oral story-telling tradition of her family and culture. She brings to life new folk-tales using an old folk form — the quilt — and a bold, stylized approach to her treatment of the figure. Framed by lush, warm pattern and text, her particular vision vividly affirms the everyday lives and dreams of a Black family and the development of a new vehicle for contemporary art-making.[6] ✎

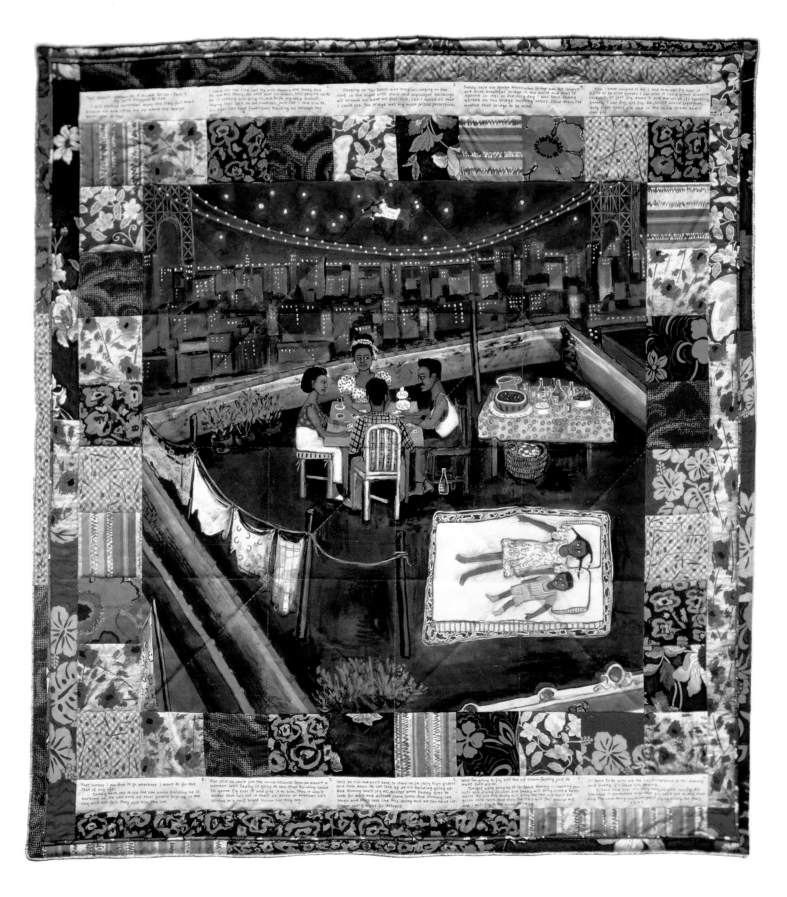

# AUDREY FLACK

(1931 – )  *Marilyn (Vanitas)*  1977

WOMEN ARTISTS have felt torn between the often conflicting roles of creative artist and dutiful daughter or wife. A New Yorker from a 'proper' middle-class family, Audrey Flack was determined from an early age to venture beyond the security of conventional roles to forge a career in the arts. Her studies in the early 1950s at Cooper Union and Yale confirmed her sense of the current view of women artists as either 'one of the boys' or sex objects. "For the most part, women art students weren't taken seriously."[1] Abstract Expressionism was the order of the day, with its wild gestural abstraction and its attendant bohemian, macho style. "Unless [women] played the game, they were not allowed into the inner circle."[2] Turning away from the powerful mythologies of Abstract Expressionism, Flack began to explore that heretical subject, the human figure, at the Art Students League. To fly in the face of mainstream opinion in the art world takes considerable inner vision and confidence, but with a small band of like-minded artists, Flack continued to pursue a realist course. Despite the courage this took, she still signed her work 'A. L. Flack,'[3] as so many women artists and writers had felt the need to do before.

Flack took a special interest in the tumultuous political events of contemporary American society, choosing subjects from nuns on a civil rights march to anti-Vietnam War demonstrators in a style that she termed 'social protest realism.' In 1965, her painting "Kennedy Motorcade" caused a furor even among her realist friends. Always interested in photographs as source material, for the first time she had worked directly from a colour photo of the famous moment in Dallas just before Kennedy's assassination. The horrified reviews confirmed for Flack the power of this method of working, in spite of the taboo around the charge of copying. Her rejoinder was "One learns through imitation. Originality will always come through."[4]

Flack's use of photographic sources as a springboard for her art and as a tool for her interest in illusionism defined the direction her work now took. She chose ideas from black-and-white snapshots, 8x10s, colour photos, and finally, slides. Always interested in questions of surface and scale, in 1970 Flack found using a slide projector a major breakthrough for her painting. Projecting slides directly onto the canvas made preparatory drawings unnecessary; now she could concentrate, with the aid of a spray gun and pure primary colours, on mixing colour directly to achieve maximum brilliance. Light, reflection, layers of pure colour became the means through which she translated form. The arrangement of objects, how they were lit and organized into a composition *before* the slide was taken, provided the opportunity for an inventive, original vision. Her place as a Photorealist was now confirmed. The sensuously rendered surfaces and huge scale with which she worked dramatically confronted the viewer, forcing an intimacy between the viewer's space and the illusionistic picture space intruding into it.

Many of Audrey Flack's subjects have been women of character and feeling treated with empathy and authority, whether in her Photorealist painting or her later sculpture. There are two prominent concerns in her work: one with the beauty of material reality, the other with subjects which are powerful, emotive cultural symbols. "Marilyn (Vanitas)" weaves these two strands together in an opulent, seductive painting which echoes the power the icon of Marilyn Monroe holds. Her image has almost become kitsch, reproduced as it is on everything from T-shirts to postcards. But Flack wants to reclaim kitsch when it concerns an image that millions of people have invested with feeling and meaning.[5] For all its painstakingly rendered, gorgeous surfaces, shapes and colours, the painting is demanding on emotional and intellectual levels; it is rife with references to the transience of time and mortality, a true *vanitas*. Marilyn Monroe has become a deeply understood symbol for the tensions between beauty and anguish, between the myth of success and the reality of exploitation, between sensuality and death. In the manner of seventeenth century Dutch *vanitas* painters, Flack sprinkles her composition with reminders of the immutability of time passing: an hourglass, a watch, ripe and cut fruit, a full-blown rose, the suspended mask of make-up, the melting distortions of a mirror, a candle flame, the frozen tear of blood-red which casts a shadow over Flack's construction of a powerful eulogy to this tragic figure. The table top tilts towards us, the objects fall into our space at varying angles; but always we are brought back to the frozen, perfect black and white smile framed with its halo of sumptuous decay. ♡

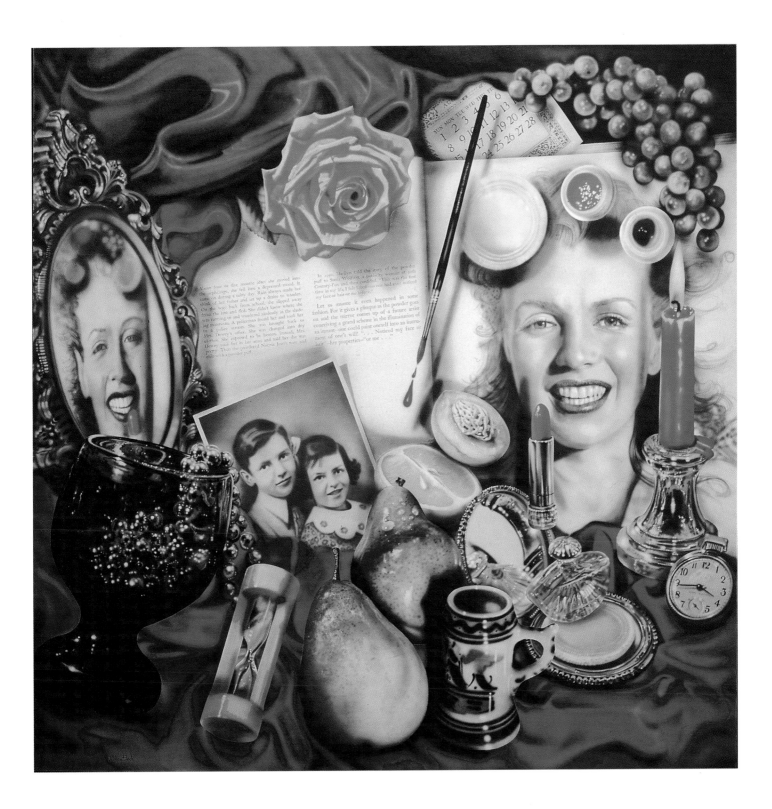

# JOYCE WIELAND

(1931 – )  *The Water Quilt*  1970 – 71

DOMINANT ART discourses have traditionally denigrated as lesser arts or 'craft' those media that had often provided avenues of creativity for women. Joyce Wieland, the best-known contemporary female artist in Canada,[1] consciously chose to work with 'feminine' media such as embroidery and quilting. Weiland used whatever was necessary to enter into dialogue with her viewers, ignoring the boundaries between craft, art and the various media. Wieland also worked to promote collaboration in the creation of art. Although her vision at times resulted in works deemed political, ecological or feminist, Wieland refused to be boxed in by labels. As she synthesized her ideas in order to communicate through art, her media and subject matter changed.

Although Wieland was interested in a career as an artist, both parents had died by the time she was nine. Thinking she might have to choose a more 'practical' route, she enrolled at Central Technical School in Toronto to take dress design and sewing. The teachers in the art department, however, were so encouraging that Wieland switched to the art program. Doris McCarthy, then teaching at Central Tech, was an inspiration to Wieland. "She was my first woman artist ... She changed my life."[2] Following graduation Wieland found employment at a commercial art firm.

Wieland always had tremendous energy for her art, and thus found time outside of work to pursue her interest in the history of film and filmmaking. At Graphic Films, a group of artists and filmmakers interested in experimental film, she met Michael Snow, whom she married in 1956. The couple moved to New York in 1962, thinking it would be good for their artistic future. While there, Wieland pursued her interest in filmmaking and also created works incorporating Pop Art styles. Wieland's images incorporated an exploration of human eroticism and her own sexuality, a cool look at the American fascination with disaster, and her own burgeoning interest in nationalism, politics and ecology.

While in New York, Wieland was struck by the competitive, hothouse nature of the art scene, dominated as it was by male artists. "I was on my way in a sense to becoming an artist's-wife type artist until I got into looking around in history for female lines of influence. I read the lives and works of many, many women, salonists, diarists, revolutionaries, etc. I started to invent myself as an artist. I saw only gradually that my husband's artistic concerns were not mine ... Eventually women's concerns and my own femininity became my artist's territory."[3] In 1969 she returned to Toronto, feeling a social responsibility as an artist to "strengthen the idea of Canada against the encroachment of American [values]."[4]

Through Wieland's work run currents of concern over Canada's sovereignty, love of the environment and identification with women's issues. These themes coalesced in 1971 in *True Patriot Love*, the first solo exhibit of a living Canadian woman artist to be held at the National Gallery of Canada. The exhibit also addressed Wieland's efforts to "combine aesthetic components with current problems without turning the work into propaganda."[5] She attempted to resolve this by collaborating with other women and working her designs and messages into quilts. Eight years before Judy Chicago's monumental "Dinner Party," Wieland challenged the conventions of high art through women-created works that were accessible and brought greater recognition to textile artists. "I wanted to elevate and honour craft, to join women together and make them proud of what they had done."[6] Although she retained full artistic control, Wieland made sure that she paid the knitters, embroiderers and quilters, mainly from the Maritimes and Quebec, and fully recognized their contribution to the exhibit. Downy quilts like "Reason Over Passion" (a theme oft-quoted by Pierre Trudeau, Canadian Prime Minister at the time), embroidered hangings such as "O Canada Animation" (a series of lips silently singing the words to Canada's national anthem) and rambunctious works in other media (for example, knitted Canadian flags, a cake, and beaver perfume — the perfume of Canadian independence) attested to Wieland's humorous and passionate use of art as an engaging means to give Canadians a sense of their nation and culture.

"Water Quilt" also uses textile techniques; sixty-four embroidered muslin flaps hang lightly over fabric 'pillows' printed with text. The piece undercuts the exquisite, delicate beauty of Arctic flowers and grasses with quotes from James Laxer's book *The Energy Poker Game*, a comment on the ravaging of natural resources like water and delicate ecosystems of tundra to satisfy energy 'needs.' The layered pillows are grommetted and lashed together in rows into an almost filmic sequence of 'frames' to make a quilt with a message — passion and reason together.

Wieland's style and imagery evolved to include works in coloured pencil and oils; impressionistic, erotic fantasies of sexuality and goddesses in nature, and expressionistic personal mythologies. She continued to actively promote equity for women artists. Sadly, she has been claimed by Alzheimer's disease; it cannot dim her legacy of committed and sensuous art. ✿

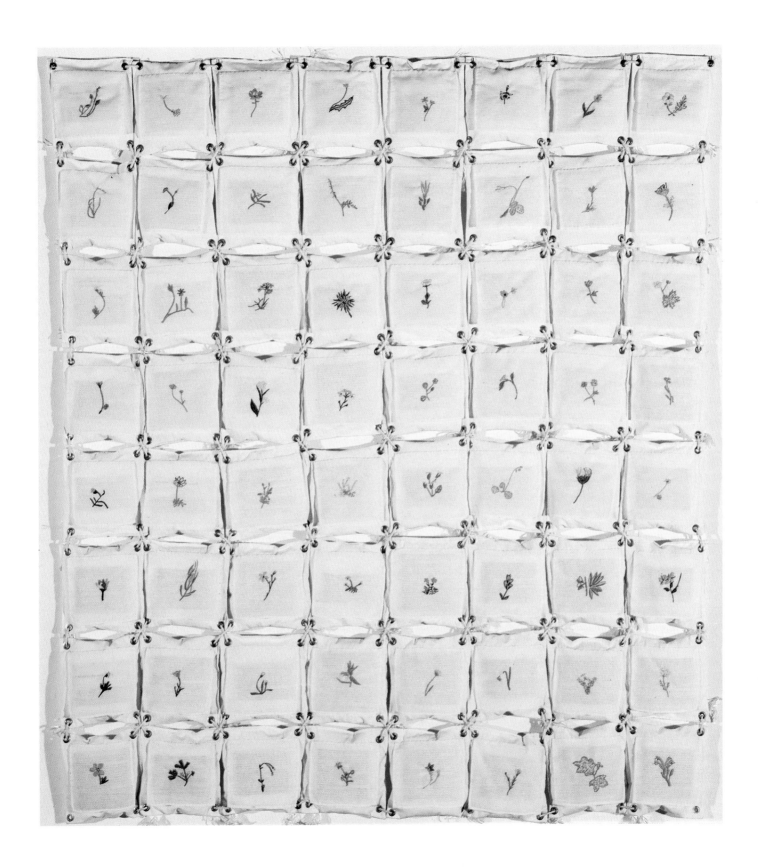

# MARYON KANTAROFF

(1933 – ) *Daughter of the Moon* 1977

I used to be disgusted with my body. I was born a woman in a sexist society. I was trained to think of myself as inferior. My marriage to a man who had no respect for women deepened my feelings of inferiority. Art instructors persuaded me that male was strong and female weak. Straight lines and hard edges were regarded as 'tough' while curves were seen as indolent, effeminate and sentimental. The only way that a contemporary woman can fight free of ancient myths and damaging images of herself is through participation in the women's liberation movement. Now I'm happy to be lyrical. I've discovered I have a lot to sing about.

— Maryon Kantaroff[1]

AN ARTIST WHO creates sculptures of great formal beauty, Maryon Kantaroff's sensuous bronzes articulate a world swelling with balance, grace and harmony. Through forms which seem to grow from within, Kantaroff celebrates the origins of creation, the complementarity of forces in the world.

The visual language Kantaroff inherits is that of Brancusi, Hepworth and Moore, the environment to which she became attuned when studying art in England for eleven years in the 1960s. Born of Bulgarian immigrant parents in Toronto, she grew up interested in both art and music. She obtained an Honours Degree in Art and Archaeology at the University of Toronto and then continued her search for a personal artistic language with studies in the UK. Married and divorced while there, Kantaroff also found her vocation as a sculptor while in England.

Returning to Canada in the late 1960s, Kantaroff found her professionalism taken less than seriously; in effect they said, "no beard, no muscles, she can't do the work."[2] Her baptism by fire came with the discovery of the women's movement, then in the throes of rebirth. With feminism, Kantaroff found a new pride in herself as a woman artist and began to reclaim forms traditionally associated with 'feminine sentimentality' — curves, ovoids, spirals. Deriving strength from the lost mother-goddesses of history, Kantaroff rooted herself in mythology as a wellspring of sources for her own formal vocabulary. She began to use both 'male' and 'female' attributes in a dialogue of mutual co-operation and respect. "Masculine characteristics are human; feminine characteristics are human; we need access to all human characteristics."[3]

"Daughter of the Moon" states many of Kantaroff's themes. A beautifully cast and highly polished bronze, it both pleases the senses and invites symbolic interpretation. In mythology, Diana is the moon-goddess, representing "the three aspects of woman — virgin, sexually mature woman, and crone. Each is destined to aid and follow the other. So the crone as midwife attends the birth and the cycle begins again."[4] The inter-relationships, the flow and interchange of life, the fecundity of creation are integral to a vision which looks not to the splits which force us apart, but to a healing balance of spiritual interconnections. The work is contained yet suggestive through its free-flowing line and budding forms of continuation and growth. "Just as sound can be understood only because of the silence between the words, so material requires space in order to be articulated."[5] "Daughters of the Moon" quickens the space around itself, inviting us to follow its curves and imagine their continuation in space.

Kantaroff's dedication to feminism led her to join the Toronto New Feminists in the early 1970s; here she found the strength to pursue her ambitions. In 1974 she opened the Art Foundry for casting her own and others' work in bronze. She began to exhibit across Canada and internationally. She has received many sculpture commissions and shows in Canada, the United States and Britain, her work is often commissioned as environmental sculpture, displayed in civic spaces and accessible to the public. Kantaroff was honoured with a Zonta Award and in 1982 as YWCA "Woman of Distinction." Though her work has been critiqued as being traditionally formalist, her vision of spiritual wholeness has struck chords with many. Her important commissions include sculpture for the Canadian Embassies in Mexico and Japan. The 1997 retrospective of thirty-five years of work at Toronto's Kinsman Robinson Gallery shows her work to be an affirmation of our potential for harmony and beauty. ℘

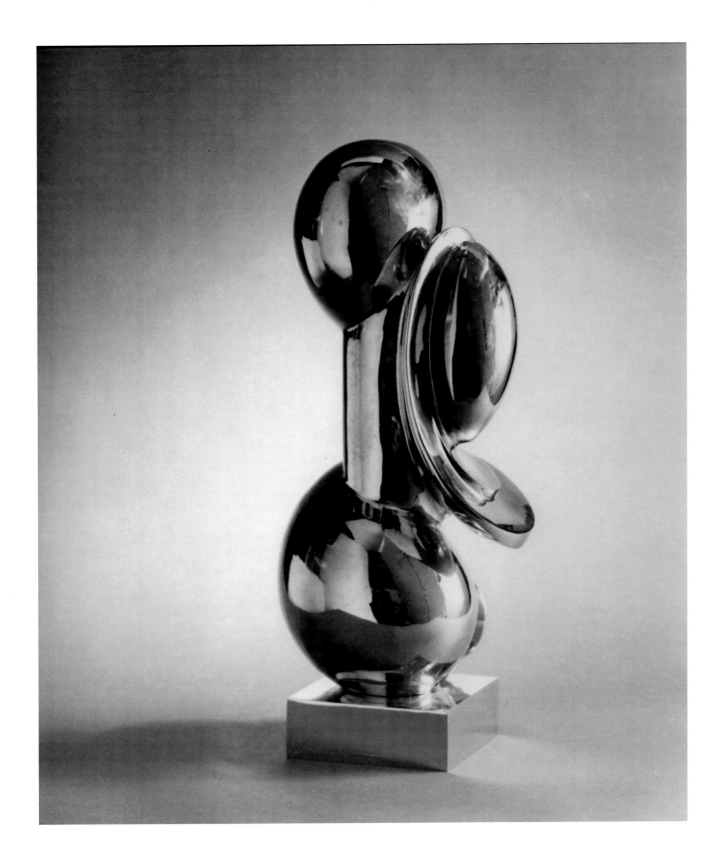

# MARY PRATT

(1935 – )  *Salmon on Saran*  1974

BORN IN FREDERICTON, New Brunswick in 1935, Mary Pratt grew up in a "genteel and protected environment"[1] in which her interest in art was encouraged. She studied Fine Art at Mount Allison University in Sackville, New Brunswick. This early training soon gave way to a busy domestic life with painter Christopher Pratt and their children. Until her early thirties, Pratt lived in rural Newfoundland leading what she calls "a fairly normal housewife pattern" and limiting her art to drawing objects around her. Then one day Pratt was struck by the image of the morning light shining on her unmade bed. "I began to see other ordinary things in the same way and painting on small boards, I tried to catch them all, but I couldn't. I had to work too fast."[2]

The inability to capture the shifting light quickly enough led Pratt to use slides. "At first I felt badly about having to resort to slides. All the spontaneous delight with my subject seemed to be gone, and the calculating way I was able to discard, plan and design was foreign to me. However this new method of working allowed me to paint things I couldn't have attempted before, because of light and time. And so I decided to let other people worry about the validity of using slides. I didn't know in those days that other people used them."[3] Pratt came to develop a Photorealist style which described her subjects with consummate painterly skill, almost effacing the hand of the maker.

Pratt wove time to paint around the responsibilities of family life. "... when a floor shone, or the bread was hot and golden from the oven, or the sheets were folded neatly in ordered piles, I was happy ... That they eventually led me to do some paintings that also made me happy seems 'right' for me. My ordinary life is so mixed up with my painting that I'm seldom aware of any imbalance. It's a very good way to live."[4] Although Pratt is ambiguous about the relationship of her work to feminist theory, she speaks strongly about her vision as a woman artist. "I think of myself quite consciously as a woman painting, and I have quite strong feelings about the women's movement without really being a part of it. I have a lot to thank it for, but not the origin of the work, not the impetus to paint. I do think it's important for a woman to work within her own frame of reference, and not feel it is inferior to feel the way a woman feels."[5]

At first glance Pratt's work can seem a sensual and analytical exploration of the play of light over textures and surfaces seen close up. Are there other dimensions to the images than the attractively presented surface reality of the work? Her work can also conjure up questions of change and mortality, of the momentary transience of light and beauty. "I see these things, and suddenly they become symbolic of life."[6] Luminous jars of jelly can indeed suggest rivers of wine, gutted bodies of fish and fowl symbols of human domination over nature.

In "Salmon on Saran" Pratt adeptly explores the surface of gently undulating cloth on which a gutted salmon on crinkled Saran wrap lies. The cloth is white, but softly muted with blue and rose tones that echo the iridescent reds, silver and blues of the inert salmon. Although luminously painted, this salmon's brilliant reflective surfaces can seem almost as synthetic looking as the crisp Saran. "The things that turn me on to paint are the things I really like. Seeing the groceries come in for instance ... and suddenly I look at the cod fillet spread out on tinfoil and I think, 'that's gorgeous, that's absolutely beautiful.'"[7]

For some time, her subjects have also included the figure; she has applied the same keen sense of detail illuminated by glowing light to many studies of the women in her life. Her treatments of her daughters and of Donna Meaney (her husband's model) show women caught up in everyday moments or rituals. Here again we sense ambivalence, unease, mystery, a sense of stories/meanings lurking beneath beautiful surfaces. Lately her light-imbued Photorealist style has given way to semi-abstract images of waves and fire, achieving a "looseness she has sought for decades" with new mixes of scintillating watercolour and crayon. Her domestic arrangements have changed; she and her artist husband Christopher Pratt now live companionably but separately. "Both of us feel that our work will be better if we are alone. You can't have two strong people doing the same thing living together. Inevitably, one has to give it up."[8]

Mary Pratt has had a life into which she has been able to incorporate the radiant intensity of her art. Her success will undoubtedly encourage others to celebrate ordinary domestic life as a valid subject of painting. ◌

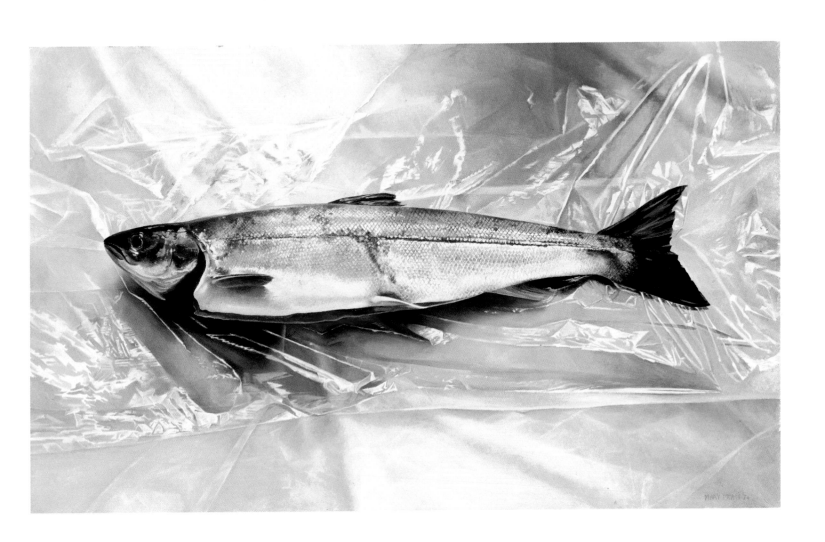

# EVA HESSE

(1936 – 1970)  *Contingent*  1969

BORN IN HAMBURG, Germany in 1936, Eva Hesse came from a Jewish intellectual family forced to flee Hitler's Reich. In the ensuing chaos, the two year old Hesse found herself separated for a time from her parents and siblings. Although eventually reunited with her family, who went to New York, Hesse's anxiety over abandonment was to remain with her throughout her life. Her mother, driven mad from her wartime experiences, was institutionalized and committed suicide. As a result Hesse identified closely with her father; he, in turn, encouraged and supported her interest in art.

An ambitious and brilliant student, Hesse studied briefly at the Pratt Institute in 1952, then at the Art Students League and the Cooper Union in New York. In 1959 she received her Bachelor of Visual Arts from Yale where Josef Albers was an influential teacher. Though her works at this time — mainly drawings — were wildly coloured, Hesse did not feel they sufficiently expressed her emotional turmoil. Nevertheless, drawing was to remain a significant form of expression throughout her career.

In 1961 Hesse married sculptor Tom Doyle. During her short marriage Hesse struggled to balance the roles marriage implied. "I cannot be so many things. I cannot be something for everyone ... woman, beautiful, artist, wife, housekeeper, cook, saleslady, all these things."[1] In 1964 the couple's year-long stay in Germany came to be a form of pilgrimage for Hesse in which she searched out her roots and the fate of lost relatives. This painful journey reignited anxiety that she sought to illuminate in her artworks. Her drawings developed into collages and then sculptural reliefs, incorporating materials found around Doyle's studio-warehouse.

Soon after her return to New York, Hesse's marriage dissolved and her father passed away. Faced with renewed feelings of abandonment, she threw herself into her art and began a breakthrough body of work. She continued to explore the use of unusual materials begun in Germany: rope, rubber, fibreglass, cheesecloth, latex and cloth. Rigorously planned, her works demonstrated a blend of formal balance with evocative organic shapes. Use of colour became subdued, a distinct change from her earlier, riotously coloured, drawings. This new direction brought Hesse support and recognition from like-minded artists like Sol LeWitt who were interested in the geometric austerity of Minimalism; indeed, at this time her work was often discussed by critics in purely formal terms.

The many notebooks she kept indicate that Hesse worked over a piece in her mind, on paper and in maquette form before arriving at sculptures that were at once abstract, beautiful and hauntingly uncomfortable. Hesse's works developed into a kind of "ugly beauty,"[2] touching the viewer with their reminders of mortality, vulnerability and the absurd. Many of her later pieces suggest a concern with her place as a woman and an interest in materials and forms traditionally related to women's work. Suggestions of breasts, organic shapes, viscera, carefully laced and grommetted forms, draped and looping fabric all surfaced in her sculptures. The women's movement was becoming a major force in society, and many younger feminist artists found in Hesse a role model: she had introduced personal issues into work considered tough and serious by the art world.

From 1966 to 1970 Hesse alternated between exhibitions and work in her studio. She began teaching at the School of Visual Arts in New York as well. In 1969 Hesse collapsed and was diagnosed with a brain tumour. She would undergo three surgical interventions before succumbing in 1970 at age thirty-three. During this time Hesse continued to complete her large-scale process pieces; she also returned to a more mature version of her earlier drawings. These layered drawing-paintings containing Abstract Expressionist brush work were reworked in layers of smouldering colour; they seemed to emanate light. "In her last works, drawing, painting and sculpture alike became all but incorporeal. Like the watercolours of Turner, who worshipped light, they are both life affirming and transcendent."[3]

"Contingent," completed in 1969, is one of Hesse's final sculptural works. Eight gelatinous, irregularly rubberized and fibreglassed cheesecloth sheets are suspended from the ceiling. These glowing composites in dramatic scale are reminiscent in texture of skin and bring Hesse's reference to the body into play. They appear fragile and diaphanous, huge membranes catching the light in different ways; yet the rubberized coating strengthens them. "Contingent" was, for Hesse, a blend of the beautiful and the unexpected with its careful balance, radiant quality and visceral texture.

In her short career Eva Hesse was able to achieve both critical acclaim and personal success. Her images and choice of unusual materials helped to move abstract sculpture beyond Minimalism to expressive and tactile associations with the body. Hesse also provided a profound connection to her inner self — her fragility and her strength — through her work. "In fact, the core of her art was the core of Eva's self; the two were inseparable for her and for anyone who knew both the work and the artist ... to reach out to her work, or to be reached by it, was to be in touch with Eva's most profound aspirations."[4] ✑

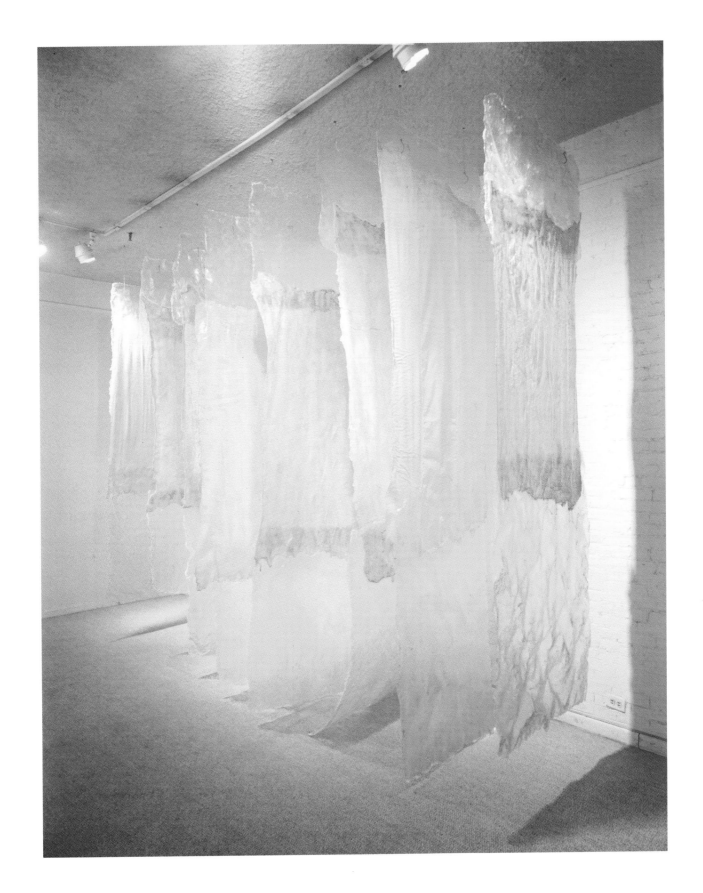

# CHRISTIANE PFLUG

(1936 – 1972)   *Kitchen Door With Esther*   1965

Realism is simply the tool I use to make my vision visible.
— Christiane Pflug.[1]

THE SENSITIVE and richly detailed work of Christiane Pflug goes beyond straightforward realism to reveal a neat and ordered world that is at the same time silent and brooding, making visible Pflug's own inner world of anxiety and insecurity.

Born in Berlin in 1936, Pflug had a difficult and lonely early life. Her mother, a widow, was forced to board Pflug in Austria during the war years with a strict elderly widow. This lonely child began to cope with her isolation by drawing and creating her own private world. In the early 1950s Pflug left Germany for Paris to study fashion design. She married in 1956 and her husband, a young medical student who was also a budding painter, encouraged her to continue her art. Stimulated by the city's art galleries and life, Pflug painted mostly still lifes, exhibiting her work at the Alliance Française, as did her husband. Pflug was insecure about her painting, plagued by indecision, low self-esteem and a stormy relationship.

The couple moved to Tunis in 1956 where Michael Pflug worked as an intern and Pflug had her first daughter. At first Pflug found it difficult to adjust to the move. In Tunis she began to paint more interior scenes, experimenting with tempera "to convey the softness of the light inside an Arab house."[2]

In 1959 Pflug moved to Toronto with her two young daughters while her husband remained in Tunis to complete his internship. On her own with two young children, she again found it difficult to adjust to her new home. Her inability to immediately resume painting caused Pflug great anxiety; she was afraid that she would never paint again.

> I had to learn here that I would never find the same landscape, the same quality of life which we had left behind in Europe and North Africa. What I saw around me at first seemed banal and often ugly. Only slowly I saw it differently, the very sharp light here (which has something of the light of Tunis), the landscape much larger and more chaotic. In pursuing it one can bring a different tension into one's painting. I have changed only very slowly, but now I feel that I would like to paint more in the city ... from an apartment window over a snow landscape ... at night ... [3]

When she began to paint again, the household came to be organized around her work. She would "paint from dawn until 8 am, get the children off to school and continue painting."[4] Pflug was meticulous. She would work on a small section of a painting, applying the oil paint one careful stroke at a time. She would usually paint what she saw from her window or inside her studio, trying to portray the weight of objects, distilling form into a dense materiality. When she did put people into her work they were tenderly portrayed, but always very still or silent, alienated from the unsettling objects surrounding them. Although her exhibits were popular, very little sold. The Pflugs had rigid standards about who could purchase the work. Michael Pflug's resistance to selling to private collections in hopes of international interest would often dominate a decision on this issue.

"Kitchen Door with Esther," which is representative of Pflug's work from the mid-1960s, took seven months to complete. The painting is a quiet portrayal of her daughter Esther's back as she sits in the doorway of the kitchen, facing a lush garden. Given Pflug's troubled state of mind at the time, it is tempting to read this work on a variety of levels. The careful composition, the attention to detail, the sensitive rendering of the young Esther raise the larger question of Pflug's own feelings and intentions. The interior of the austere, slightly ominous kitchen is painted in muted, carefully rendered tones. The thin back of the young girl in the open doorway gives one a sense of her innocence and vulnerability. The luxuriant, highly detailed garden-forest outside is reminiscent of Henri Rousseau's dreamlike jungles. Does this contrast of interior and exterior reflect Pflug's own sense of isolation and lack of connectedness with the outer world? Has Esther become her intermediary between these two worlds, or does the child's turned back indicate that she has already lost that contact? Are we trapped inside or is there a way past that little being in the doorway? Perhaps this is rather a quiet observation of the contrasts in Pflug's world: her bouts of depression, her love for her child and her close and Spartan observation of life around her.

Pflug said that she was "attempting to reach a clarity that does not exist in life."[5] This thought-provoking and complex work reminds us of her potential and of the great loss of the artist when she committed suicide at age thirty-five. ✂

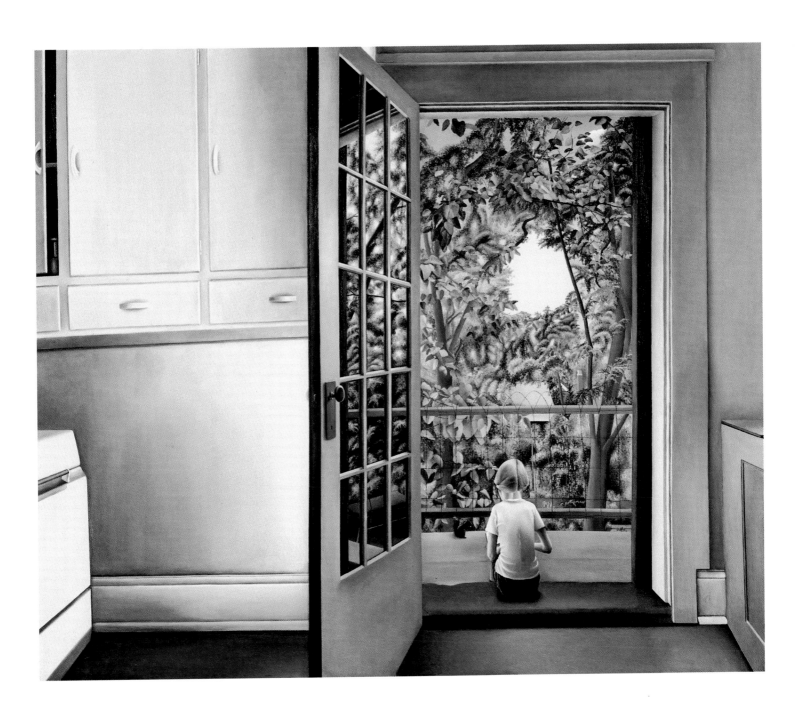

# AGANETHA DYCK

(1937 – )  *The Wedding Dress, The Extended Wedding Party*  1995

What is absurd, the work or the world I point to?

— Aganetha Dyck[1]

AGANETHA DYCK'S sculptural installations are both playful and provocative. A "housewife whose equilibrium has snapped,"[2] she asks us to explore the nature of social constructs such as the balance between decay and preservation or the struggle for individuality within the collective.

Aganetha Dyck was born in 1937 near Winnipeg and raised on a grain farm in a closely knit and liberal Mennonite family. The necessity of making do with what was available meant that the family placed an emphasis on creative self-sufficiency. "Art would have been regarded ... as sinful, frivolous, yet the shapes and forms and textures at the farm were natural and organic and I work from them today."[3]

Dyck married in 1958 and for fifteen years was preoccupied by the roles of housewife and mother. In 1972 she moved with her family to Prince Albert, Saskatchewan, where she began volunteering with the local arts council. She began to study intensively at the Prince Albert Art Centre.

After some experimentation with weaving, Dyck happened on a new technique by chance. She had accidentally shrunk some wool fleece, and, intrigued by the appearance of the wool, began shrinking woollen sweaters and garments *en masse*. Dyck transformed hundreds of garments into miniature forms and set them up in installations on rocks and marching down a country road. Their shrinking rendered them both absurd and dense with the implications of former wearers. Dyck had merged home economics and art; drawing from her own experience, she had found a unique form of commentary on the inane repetitions and frustrations of domestic drudgery like laundry.

After moving to Winnipeg in 1976, Dyck turned her talents to canning. Her new studio was in an old button factory complete with a windfall of buttons. After much contemplation, she decided to 'preserve' the buttons. Dyck's art asserts that "to use things in a culturally inappropriate way is to challenge the stranglehold of convention."[4] Her rows of jars also draw satiric attention to the repetitive tasks of the household. Still, her work struck a responsive chord with viewers; when in 1984 she displayed three hundred jars of canned buttons for "The Large Cupboard," people left small jars of jam on the shelves.

From preserving buttons, Dyck moved to preserving books and pocketbooks (handbags) — collections of "all the non-history we have as women and all the stories," stories embedded in the pairs of gloves, handkerchiefs, address books, dress shields, lipsticks, and in the big black handbags which are "the last things women clutch in old-age homes." The beeswax in which Dyck covered these objects lifts them into metaphor; they become "reliquaries, not of saints but of the experiences of ordinary individuals. Every life is extraordinary and mysterious."[5]

Chance was again a motivating factor in her work when Dyck began her work with bees. She had noted with interest how bees would form honeycombs over foreign objects in the hive. Chance, order, communal structures, collective behaviour, sensuality and natural process are all part of life in a hive. Recognizing the metaphoric potential of the bees' behaviour, Dyck began to place objects into seventeen hives and observed the bees' reactions.

"The Extended Wedding Party" consists of a series of honeycomb-encrusted wedding clothing and footwear arranged for display and to hang inside metal hive racks. They represent the groom and attendants arranged around a central piece, a glass wedding dress 'embroidered' by the bees' honeycomb. The entire work is redolent with the heady perfume of beeswax.

> There's a tremendous power in a hive. It's like a pulsing intelligence. I just allowed chaos and chance to happen. In the beginning when I started the dress, I wanted the bees to make a ruffle but they still haven't done it. And while I feel warmly towards bees, it's a cruel world in a hive. They don't have senior citizens' homes in hives.[6]

The empty bridal party stands eerily silent. The wedding dress is intensely sensual as the bees have abstractly arranged the wax in folds resembling a fantasy landscape of cascades and mountains. At times the dress is displayed with the bees inside and oozes with honey. While visually beautiful, the work poses the question of whether marriage is a decaying institution preserved in elaborate ritual. "The difference between us and the bees, ... is that the bees just are — programmed totally. And maybe we are too and I just can't see it ... I think we are being watched all the time — and laughed at. Hilariously."[7] Dyck's ironic subversions of housekeeping and social convention rest on her wry sense of humour, her openness to chance, and her understanding of the resonant symbolic power of the rituals of homemaking. ❧

# EVELYN ROTH

(1937 – )  *Shell Knit*  1974

WEST COAST artist Evelyn Roth has been an active presence in the Vancouver art world since the mid-1960s. Her sense of humour, her delight in recycling materials and her desire to broaden people's understanding of different cultures have impelled Roth's continuing creation of lively and unusual works.

Roth was born Evelyn Yakubow in 1937 on a farm outside the town of Mundare, Alberta. She married at seventeen, living first in Edmonton and then in Vancouver. In the late 1960s Roth left her husband and quit her job at the library at the University of British Columbia. Roth's early interests in fashion and dance grew into investigations of the body and movement. Her interest in the new performance art and multi-media experimentation of the lively Vancouver art scene led to active involvement with Intermedia, an avant-garde artists' collective.

Roth began to use recycled materials to make costumes and as part of other collaborative works. Roth's flamboyance — she "crocheted a videotape canopy for the old Vancouver Art Gallery, and posed in a videotape miniskirt against a car that was wearing a videotape tea cozy"[1] — went against the grain of an art world concerned with high seriousness. Whether she is crocheting recycled videotape, knitting leather or fur, or building large inflatable and colourful 'zoos,' Roth's intention is to get people physically as well as mentally involved. The 'play' required of her viewers has led some to speak of Roth dismissively as a "toymaker."[2] Perhaps it is Roth's ability to strip away some of the art world's mystique that has caused such disapproval.

Her works often pass through a long process of evolution. Large and colourful inflatables often figure prominently in her work. In "Meeting Place," Roth created an interactive structure; her large inflatables serve as passages and settings for children costumed as creatures in Northwest Coast Native legends. Dancers and Native storytellers assist the children in this collaborative piece.

Roth continues to create her own works and to encourage artists to participate in their community. Jo-Anne Birnie Danzker, a director of the Vancouver Art Gallery, notes that "Vancouver has always balanced three cultural traditions; the western European, the Asian, and the indigenous Native. Emily Carr was the first to recognize this cultural hybrid, and artists like Roth show an instinctive grasp of Vancouver's history in their attempt to combine all three traditions."[3] While Canada at times has been slow to recognize her achievement, artists in Australia have been interested in her efforts. She has been seen as "an incredible catalyst and inspiration to artists throughout Australia. She insists on an interaction of artists in their society, and her real talent is in making that work."[4]

Roth continues to work with inflatables, to collaborate on other multicultural performance works and to run the Evelyn Roth Moving Sculpture Society. "I am still, twenty-five years later, trying to find a pocket, an agency, a place to gain support — a country which will recognize my work and make use of it ... After twenty-five years, I'm still an independent artist with a cupboard *full* of stuff."[5]

"Shell Knit" is an example of Roth's wearable sculptures from the early 1970s. Recycled and 'found' materials are combined to create a piece evocative of the West Coast environment. The solid stance of the wearer combines with the graceful lines of the Shell Knit to produce an elegant half human, half sea-creature set against the shoreline. Movement is an essential part of the realization of the piece, which comes alive for the view's investigation only when worn.[6] Roth has created an effective tactile contrast between the sharp shells and slippery kelp-like substance against skin. We feel ourselves slipping into the mythic world of this creature, suspended between our human selves and nature. Roth's work is at once simple, graceful, playful and a challenge to the boundaries of traditional art. While difficult to categorize, Roth's work continues to engage our senses and to challenge our concepts of what constitutes art. ಬಿ

# AIKO SUZUKI

(1937 – )  *Lyra*  1981

> For me a sculpture must be light and quick. You can see right through these pieces. They trap light and modulate it. They move in the breeze.
> — Aiko Suzuki[1]

AIKO SUZUKI, a third generation Canadian of Japanese descent, was born in Vancouver, British Columbia in 1937. Although she experienced the same prejudices and internment as other Japanese Canadians during the Second World War, early family support and a clear connection with her roots have allowed Suzuki to evolve an inner strength and belief in her work. Suzuki's confidence and flexibility have allowed her to move from hard-edge paintings early in her career, to powerful fibre sculptures which she calls 'suspensions,' to work in film and video.

Suzuki studied art at the Artists' Workshop in London and in Toronto, where she now lives. Although her early work involved hard-edged acrylics, she was never really satisfied with this style. In 1969 she began to design dance sets in Toronto. They were often comprised of three-dimensional fibre hangings that the dancers would work below, around or within. The hangings provided the starting point for Suzuki's desire to share her ideas in a technical collaboration. "It is a kind of reaching out to artists who would never have a chance to work on such a big concept or to show one's work to a built-in audience. Artists tend to work alone in a studio. That's so lonely. Here is the delight of collaboration with a team."[2]

The experience of working with fibre on the dance sets led Suzuki to discover a new style and medium. Her hanging fibre sculptures or 'suspensions' allow for a blending of modern high-tech materials, abstract themes and a vision of simultaneous simplicity and subtlety. Suzuki avoids extra frills, details and colour, anything extraneous. She usually spends a great deal of time contemplating each step in the development of a piece, often placing one strand of fibre at a time.

> I feel like a dancer when I make these pieces. The trouble with paintings is that they limit you in the ways you can move through space. For me, these suspensions don't even assume their final shapes until I'm up on a ladder poking at them and twisting them into the spatial form I want for them.[3]

The work that Suzuki is probably most well known for — "Lyra," a large fibre suspension in the foyer of the Metro Toronto Reference Library — is named after the Greek goddess of the harp. Suzuki won the competition to provide a sculpture for this site, but it was four and a half years before the work would be unveiled, due to problems raising funds for installation of the piece. As a result of this time lapse Suzuki's original conception developed somewhat; the finished work is even more fluid and meditative than the original design. Over a period of eight months, Suzuki walked an estimated two hundred and fifty miles in her studio to place and shape and to physically enact a 'drawing' with 'lines' of over a million feet of white fibres, enlivened with the odd earth-toned strand.[4] The resulting 'waves' of line catch the light and arch and fall in ever-changing vistas as the viewer moves through the space.

Raymond Moriyama, the architect of the library, envisioned this space as a transition from the bustle of Yonge street to a quiet working atmosphere. His plans called for "a sculpture which would resemble 'a gently rising mist' above the water."[5] "Lyra's" cascades of cream-coloured fibres hang vertically from the ceiling to just above a reflecting pool; in the background are the sounds of softly falling water. The verticals are interspersed with lifted scoops and arcs of fibres, reflected in a mosaic wall of mirrors and dramatized by gentle air currents and the natural light streaming through adjacent windows. This forty-five by thirty-three foot sculpture creates an atmosphere of serenity and contemplation in a foyer passed through by some three thousand people daily.

Since the completion of "Lyra," Suzuki has been pursuing her work in many disciplines. She has continued to collaborate on dance sets with airy scrims and fibre hangings, and has experimented with differing media, including film animation and video. Since 1984, she has as well pursued an interest in working with young people, participating as a teaching artist in Toronto school programmes. ☙

# VERA FRENKEL

(1938 – ) *Body Missing* 1994

> The truth is always in the interstices between things. A piece of evidence is always a manifest ambiguity; what is stated masks what isn't.
> — Vera Frenkel[1]

TORONTO ARTIST Vera Frenkel's work is poised at the forefront of today's information age. Using the Internet as a creative medium and collaborating with other artists, Frenkel creates an art with a global reach. Frenkel was born in Bratislava to Jewish Czech parents; the family escaped during the Second World War to England, and then settled in Canada. She studied art in Montreal. After teaching at the University of Toronto, she moved to York University, where she taught until 1995, when she decided to focus on her studio practice.

While Frenkel's early work consisted of prints sometimes published with her own poems, her printmaking soon grew more three dimensional, extending off the wall and into the viewer's space. First apertures, mirrors and then video became means of increasingly involving the spectator. Her series of multimedia works "No Solution — A Suspense Thriller" invited the viewer to take an interactive role in examining evidence and unravelling a 'mystery.' Exhibited as an installation, "Signs of a Plot: A Text, True Story & Work of Art" (Part Five of the series) included back-to-back video monitors replacing the proscenium arches of a puppet theatre and a reconstruction of the set for the video narrative shown, with props and clothes worn by the 'personae' in the video (Frenkel and friends).

Frenkel draws on and juxtaposes the conventions of various disciplines — fiction, film and theatre — to reveal their contradictions and make new connections. The complexity of the layers of meaning Frenkel asks us to sift through bring her installations into the realm of a type of interactive, avant-garde performance. In "The Secret Life of Cornelia Lumsden: A Remarkable Story," she reconstructs the life of a little known but brilliant Canadian novelist who lived in Paris between the wars and disappeared mysteriously in the early 1940s, a fictional and archetypal 'lost Canadian.'[2] "Her Room in Paris," an installation from the series, invites viewers to enter a room redolent with the presence of its occupant, to look at her chaise-lougue, her clothes, the view from her window, her TV set ... Though Lumsden is absent and mysterious, we are convinced of the truth of her reality, however elusive. But all is not as it seems; through many subtle clues Frenkel has made her artifices clear. Paradoxically Lumsden is revealed in the interstices between her absence and the means of declaring it.

In "... from the Transit Bar," (a six-channel videodisc installation and functional piano bar) which originated at the Documenta 9

exhibition in 1992, Frenkel also uses props, sets and texts to create a physical setting, a contextualizing site for video. Frenkel created a bar with the transient look of an airport or train station bar — a waystation to drift into between 'real' destinations, a place on the border between coming and going. "Body Missing," which existed first in Linz, Austria, as a photo, text and video work, was developed futher as a web site (http://www.yorku.ca/BodyMissing), in which video footage of "... from the Transit Bar" serves as an integral part of the site. The bar's 'regulars' — artists and writers, taxi-drivers and locals — come and go at the bar, where we can follow their conversations. Their 'discussion,' through text links, video clips, current and archival images, explores another absence. In this work, the 'body' in question concerns the body of up to six thousand works of art stolen by Hitler during the war and hidden away in salt mines near Linz, his boyhood home. There Hitler wanted to build a monument to himself, a Führermuseum, his own art museum of the world's treasures. After the war, these hiding places were looted, causing huge black market activity in the art market. The paintings have 'gone missing'; but then, the avant-garde and political works condemned by Hitler as decadent had also been 'banished.' What is 'missing' — "the theft, transportation and loss of works of art, is grafted onto the human displacements of ... *from the Transit Bar.*"[3]

Frenkel and the other artists extend their examinations of the presence/absence of these works and their meanings through many dimensions; it is a conversation with "different eras: during the war, after the war and now; at a time of international debate about appropriation of the cultural properties of other countries and cultures."[4] The many types of loss examined in "Body Missing" are often documented as lists (so beloved of scholars). Frenkel has drawn up a 'master list' of categories which dissolve into layers: "... what was collected; what was stolen; what was hidden; what can only be shown privately; what is heirless; what is still in dispute in the courts; what was unsuccessfully claimed; what is still missing ..." All these lists "lead back to Hitler as master of genocide, failed artist and would-be curator."[5]

The complexity of layers of shifting meanings in "Body Missing" raises many questions: "Where do we stand? What did we do? What do we do now?"[6] Through her characters and the objects of their contemplation, and in a stunningly contemporary medium, Frenkel has presented us with a way to investigate the complex web of how we assume what is truth and what is invention; how we decide what to keep and what to discard, how to make memories, how to make history. ✂

# Storage Spaces

Maikäfer flieg,
der Vater ist im Krieg,

die Mutter ist im Pommerland,
Pommerland ist abgebrandt,

Maikäfer flieg.

Ladybird, ladybird,
fly away.

Your father is in the War,
your mother is in Pomerania.
Pomerania is **burnt** down.
Ladybird, fly.

# JUDY CHICAGO

(1939 – )   *The Dinner Party*   1973 – 79

To reclaim our past and insist that it become a part of human history is the task that lies before us, for the future requires that women, as well as men, shape the world's destiny.

— Judy Chicago[1]

IN 1981, JUDY CHICAGO'S monumental installation "The Dinner Party" came to the Art Gallery of Ontario through the efforts of the AGO Women's Committee, sparking furious debate. Critics trivialized the work as second-rate, but the public flocked to see this collaborative work which called into question conventional divisions between art and craft, and which celebrated women's history and creativity so joyously.

Judith Cohen, who conceived this ground-breaking work, was born in Chicago. She studied there and at the University of California at Los Angeles, developing a minimalist style of work in the mid-1960s. Chicago says that her early work was 'neutralized' by her connection with the male-dominated art world.[2] She felt blocked by the gap between her "real concern as a woman and the forms that the professional art community allowed a 'serious' artist to use."[3] She had become that 'serious' artist, but disentangling an authentic vision of her own from the prevailing trends of the art world — in this case Minimalism — proved a challenge.

In 1969, Cohen took the name of her native city. It was an auspicious year; the women's movement was finding its voice, and Chicago found the new feminist critiques applicable to the art world. Without strong female role models in the arts, it was "easy to believe that we were incapable of ever accomplishing important work."[4] When she confronted Judith Leyster's self-portrait of 1645 at the National Gallery, Chicago felt deeply moved. "I felt I was seeing an echo of my identity as an artist across the centuries."[5]

Chicago dedicated herself to the task of developing an environment where women artists could form their own communities and recover their history. In 1972, Chicago with artist Miriam Schapiro and their students from the first feminist art programme in the United States, formed the "Womanhouse" project, taking over an entire house and developing installation art which reflected on the domestic roles typically assigned to women in each room. The "Menstruation Bathroom" and other rooms tackled traditional taboos head on and ignited heated debate about feminist ideas in art.

The communicative function of art was always a primary concern for Chicago. Her work during the 1970s was often accompanied by texts which made explicit her intentions. Writing and audio-visual resources also accompany "The Dinner Party," connecting its audience as fully as possible in its celebration of the lives of women heroes.

One of Chicago's aims in "The Dinner Party" was to assign value to the 'hiddenstream' tradition of women's traditional crafts, as well as to valorize areas of women's experience such as female sexuality. The question was how to bring these all these concerns together: the answer was a dinner party! A dinner party, where "family traditions are passed down like the carefully preserved tablecloth made by a beloved grandmother,"[6] where the family of women down through the ages could rejoice in one another's company and nourish us all. The dinner party centred around a triangle of three tables, each with thirteen place settings (there are thirteen witches in a coven, thirteen participants in the Last Supper). The great early Goddess figures, Sappho, Artemisia Gentileschi, Sojourner Truth, Virginia Woolf, Georgia O'Keeffe — the names of the thirty-nine ring notes of recognition and accomplishment. Each is represented by a sculpted hand-painted ceramic plate, circular and utilizing sexual imagery as a vehicle to suggest the character and times of the 'guest.' Each sits on a needlepoint runner executed in the style and technique of the period. The floor is tiled with more names emblazoned in gold. Further documentation brings the number of lives researched and commemorated to over three thousand, a monumental affirmation of Western women's history and heritage.

Such an ambitious project required the talents of researchers, embroiderers, weavers, ceramicists, fundraisers and many others. "The Dinner Party" rapidly became collaborative in nature, with countless volunteers working out of Chicago's Santa Monica studio. Although she was criticized for not paying for their labour, they shared Chicago's dream of a symbolic history of women's achievements and struggles. The results of five years of the efforts of some four hundred people can be seen in "The Dinner Party," a testament to the strength of women's work. The project had an enormous impact on public awareness of feminist issues; in New York alone, over 75,000 people saw the exhibition.

Chicago has since gone on to other large projects like "The Birth Project" which have continued to foreground women's concerns. ○

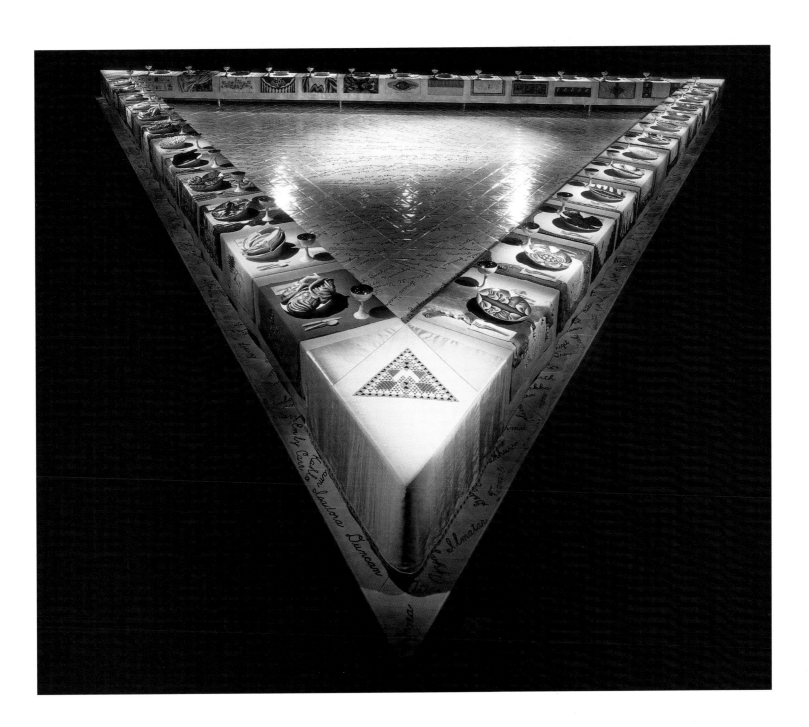

# June Clark
(1941 – )  *Untitled*  1984

"THE CREATION ... of the African-Canadian Odyssey," showing at the Power Plant in Toronto in the summer of 1992, exposed visitors to the work of seven African-Canadian artists. June Clark's installation "Family Secrets" was a quiet but powerful presence in the exhibition, the work of an artist whose pursuit of the question of Black identity has unfolded over the past decade and a half. Each small black box in the installation holds cherished personal mementos reworked to suggest new versions of old stories. One contains a cross made of human hair overlaid with a wishbone, a personal re-visioning of Christian themes. Fragments of bone figure prominently, as do remnants of an American flag, old lace, a latch-key from childhood, clothes pegs — not "heirlooms," the artist comments, "but things I've squirrelled away" in the empty wooden cigar boxes her uncles would give her as a girl.[1] Says the artist, "growing up in Harlem on 118th St. and 8th Ave., I lived an intense and vital community life where little could be hidden and much was shared. I continue to live with sights, sounds and emotions from those early years — they reverberate in me, shaping the intuition and insights which are found in my art."[2] Old presences, old identities are evoked in these small treasure chests, each reflective of moments in the passage of Clark's life as an artist, as an immigrant and as a woman of colour. What survives, what is disclosed, what is layered with hidden memory and meaning is part of the dialogue between viewer and artist.

June Clark studied art at York University in Toronto, receiving her Masters of Fine Art in 1990; she went on to teach at York and at the University of Guelph. Her early interest in photography and women's issues led to her co-found the Women's Photography Co-op, curate photography shows, and participate in photography exhibitions in community and university galleries. While her work is rooted in photography, she has had an increasing interest in printmaking, collage and sculpture. Clark has also participated in numerous public and private curatorial and jury assignments through which she has extended her teaching and creative roles in helping to shape exhibitions for the public.

In "Untitled," Clark uses the medium of photo-etching, choosing an archival photograph and juxtaposing image with text, both found and of her own making. Her inscription across the bottom reads "Wedding portrait of R. J. Clark. Upon his death (May 12, 1984) this clipping was found in his top dresser drawer, having been preserved by him." The clipping details the savage racism of the cold-blooded shooting of a Black man by two White youths in California in 1979. The artist weaves this raw text together with two other elements: her own terse marking of Clark's — her father's — passing and his preservation of the clipping, and a photograph (actually the wedding portrait of Clark's parents), with its powerful projection of all the hopes and joy of a couple beginning a life together, a life where anything is possible. The newspaper article so potently undermines the promise that shines from the young couples' eyes that we are left with devastation and sadness. The artist has drawn these pieces together into an explosive statement of what is and what must not be.

June Clark works both with found pieces and with her own photographs, which she has been making since she came to Canada in 1968. Her photographic work has taken her to New York, Montreal and Europe. Drawing her own images into the printmaking process has allowed her to overprint image with text, to soften or sharpen, to juxtapose and re-fashion images, to layer other meanings. "For me, photo-etching suggests rather than reports, blurring the sharp distinctions between reality and imagined possibility."[3] Such a process is evident in a large photo-etching from 1987, also called "Untitled." It is a close-up portrait of a woman's navel and belly, creased with the wisdom of childbirth and overprinted with a text questioning men's difficulty with such images of "perceived ugliness." "I had the need to show another definition of beauty," she said when confronted by reactions that ranged from shock and horror to blatant revulsion.[4] Such reclaiming of images which have been hidden away, which society prefers not to look at, invites us into new understandings of the power of images to undermine the status quo. "I am drawn to photographing fragments that I believe suggest and reveal larger truths. Through close examination of frequently unnoticed gestures and traces, I invite the viewer to supply a narrative and fill in the larger picture. With images that I make I do not intend to preach, teach or admonish. I am attempting, according to my knowledge of the past and present, to call forth archetypes into the realm of consciousness."[5]

## 2 hunters stalked murder victim

Oroville, Calif. (UPI)—Two white men who stalked and killed a black man because they failed to find a deer or even a cow to shoot on a hunting trip, pleaded guilty yesterday to first degree murder.

James T. McCarter, 20, and Marvin D. Noor, 19, both of Oroville, told a Butte County Superior Court judge that they murdered Jimmy Lee Campbell, 22, of Chico, with a .30-30-caliber deer rifle as he walked along railroad tracks in Chico. Sentencing was set for Feb. 27. The two could face life imprisonment. Their guilty plea allows them to escape the possibility of a death sentence.

McCarter and Noor said they were hunting on Jan. 13, 1979, the day of the slaying, but failed to find a deer near Oroville. They then looked for a cow, but again failed, they said.

Public defender Robert Mueller then asked: "You decided to go to Chico. Why?"

"To shoot a black man," McCarter responded.

McCarter said he was driving the car when they saw Campbell walking along the railroad tracks. He said he made two U-turns and drove up from behind while Noor shot Campbell from the car.

# YOLANDA M. LOPEZ

(1942 – )  *Portrait of the Artist as the Virgin of Guadalupe*  1978

THE MID-1960S witnessed the development of a flourishing cultural and political consciousness on the part of Mexican Americans. Yolanda Lopez came of age as an artist during this heady period, developing an artistic vision which expressed both the anger and the pride felt by her people. A politically engaged artist, she uses mixed media to expose stereotypes, to look critically at how Chicanos are represented, and to celebrate the contribution women have made to Mexican-American culture.

Born in San Diego in 1942, Lopez grew up in a Spanish-speaking household. Her grandmother, who had come from Mexico, looked after the family; her mother worked in a hotel laundry. The strength of these two women in sustaining the family was to become a touchstone for Lopez's art. As a child Lopez loved to draw; by the end of high school, teachers were encouraging her to consider college studies. At San Francisco State University Lopez found a highly politicized atmosphere; Chicanos, inspired by the civil rights struggle and the grape workers' strike led by union organizer Caesar Chávez, were speaking out. Murals and collective projects exploring Chicano identity and history were springing up in public spaces. Determined to find out more about her heritage, Lopez became involved in community organizing, eventually dropping out of school and moving to San Francisco's Latino Mission District. Working with neighbourhood clinics, settlement houses, journalists and artists, she found that "My art, politics and personal history all came together." She found "a sense of audience, who I was doing my art for. The streets were my gallery ... [for] posters, leaflets, lapel buttons, and graphic art for neighbourhood newspapers. I saw my work everywhere, and unsigned."[1] Later, Lopez was surprised to find that many had assumed her unsigned work was done by a man. Eventually, nine years of intense community activism led to burn out, and a return to San Diego and her family.

Resuming her university studies, Lopez struggled against her professor's view that "ethnic art is dead, corny and a rehash,"[2] claiming entitlement to express her own vision of the relationship between Chicana women and mainstream society. For her graduate art project, she 'reclaimed' the women of her family, working against negative media stereotypes of Mexicans to portray them as strong, compassionate and confidant, "demanding acceptance on their own terms."[3] "Portrait of the Artist as the Virgin of Guadalupe" is from this period, and completes the trio of family portraits in oil pastel Lopez did to assert the full dignity and humanity of these working women. The Virgin of Guadalupe is a revered traditional icon in Mexican-American culture, a symbol fusing religion and nationalism. Lopez, critical of the conservative image of the Guadalupe as an instrument of the church and of social control, claims her as "America's first syncretic figure ... a transitional figure who emerged only 15 years after the [Spanish] Conquest as the Christianized incarnation of the Aztec earth and fertility goddess Tonantzin,"[4] an adaptive, transformed goddess. Within this trio of paintings, Guadalupe's divine sun ray aura radiates from Lopez's mother at her sewing machine, the starry deep blue cloth of Guadalupe's robe spilling from her weary but resolute fingers. Guadalupe's aura radiates again in the second painting in the series from her bespectacled grandmother, seated resplendent on the Guadalupe's deep blue robe and holding a snake skin and knife — she has skinned the snake of knowledge, wisdom, respect and sex/regeneration.[5] And finally the sun rays frame Lopez's self-portrait, seen here. She jogs triumphant, from the warm embracing flow of the aura into the viewer's space, into the contemporary world, strengthened by the starry cloak and snake of tradition. In this portrait, Lopez uses Surrealist juxtaposition to remake the old myths. "I feel living, breathing women also deserve the respect and love lavished on Guadalupe ... It is a call to look at women, hard-working, enduring and mundane, as the heroines of our daily routine."[6]

In the 1980s, Lopez continued her questioning of the stereotyped representation of Chicano culture through mixed-media installations, performance and video pieces. "Cactus Hearts/Barbed Wire Dreams: Media Myths and Mexicans," displayed commercial knickknacks and kitsch such as cactus cut-outs, intercut with statistics exposing the exploitation of Chicanos, in an installation at the Galeria de la Raza. As educational director for the Mission District Cultural Centre, Lopez has been involved in many festivals and multimedia events involving socially committed and progressive art. Art which takes risks like these is not without its price; Lopez's cover image for *Fem* magazine in 1984 showed a modern Guadalupe in high heels and short skirts, a 'transgression' which elicited bomb threats against the magazine's offices.[7] But for Lopez, producing powerful art which provokes redefinitions of old stereotypes, activist art which exposes and undermines the status quo, art which is "driven by love, rage, and a sense of irony,"[8] is imperative. ✆

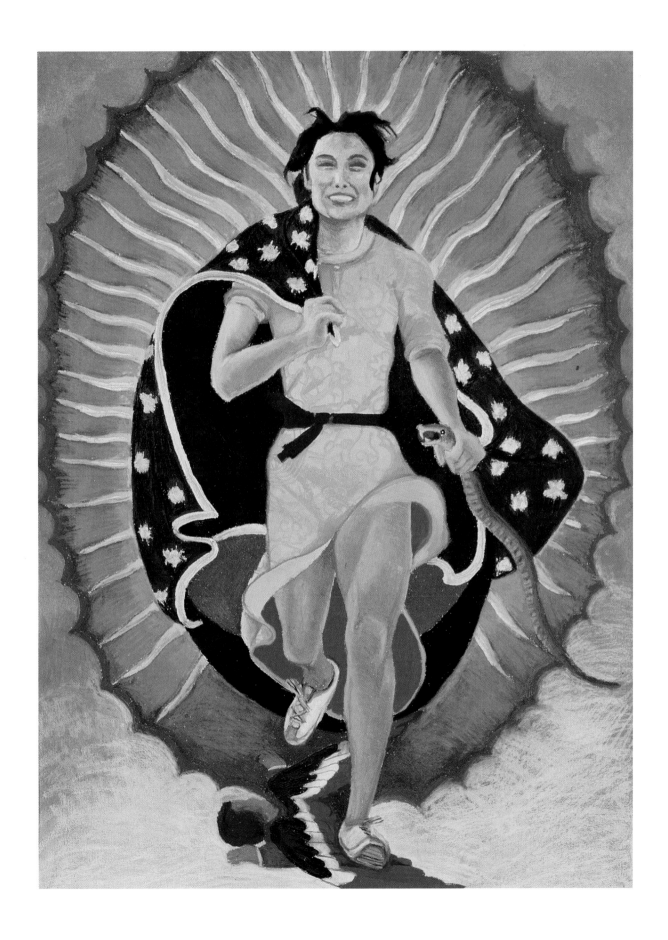

# MILLY RISTVEDT

(1942 – )  *After Rameau's Nephew*  1978

> Central to [my work] is the idea of the artist as a transformer of energy. Central also is the constant awareness of the importance of dynamic tension.  — Milly Ristvedt [1]

MILLY RISTVEDT is from Kimberley, BC. From 1960 to 1964 she studied at the Vancouver School of Art, where she found artist Roy Kiyooka an important influence in her understanding of colour. Determined to pursue a creative career, she found work as a legal secretary to finance her artistic ambitions. Early on she recognized the additional barriers women face: "When you say you're an artist, men kind of look at you as though you're the type who takes out her little canvas on Sundays and paints roses." [2] "There has always been a prejudice to be met by any woman who takes her work as an artist seriously. The pressure is heaviest just when a woman comes to the realization that her own need to make art takes priority over the needs of the men in her life — fathers, teachers, lovers and husbands ..." [3] Balancing these pressures is something faced by any woman venturing into the arts. Ristvedt's choice to follow her own path as an artist is deeply felt: "Painters are essentially hasslers ... It's a responsibility of the painter to hassle people's spirit, soul and their anxiety for material gain." [4]

Ristvedt's early work involved large repeated simplified forms which allowed the viewer to focus on her lyrical use of stained acrylic colour. Exploring the canvas as a flat surface with its own integrity, her art has been an engagement with the formalist worlds of colour, structure, surface texture and gesture within the modernist abstract tradition. Her interest in how various hues affect one another led her to develop large scale, shaped canvasses with geometric, soaked-in areas of colour. Although Ristvedt's palette in the late 1960s explored pastel hues (so often demeaned as 'feminine,') the huge scale and hard-edged mystical presence of these paintings gave fresh power to the interplay of pale colours, proclaiming their strength. Her works can be seen as meditations on the construction of a work of art as an event, an end unto itself, rather than a referent to the observed world.

Developing in series, her paintings then moved to explore scrubbed, flat grounds with 'bites' of brilliant colour at the edges or boundaries, a strategy employed by Jules Olitski and other American abstract painters. Gradually the bites and 'figures' at the boundaries moved to a more central space on a densely textured ground. They assumed the sprightly, rhythmic inflections of calligraphic strokes, her painter's 'handwriting' animating the shallow planes of the canvas. "After Rameau's Nephew" is an exuberant example of this dance of painterly gesture and vibrant colour across a grid and flat, subtly textured ground.

Her concern here is with boundaries played off against the energetic voices of colour and texture which bring the surface to life. 'Messy' gestures and surfaces are given backbone by the unrelenting geometry of the grid, which reasserts the essential flatness of the canvas. But this flatness is in turn challenged by her sensuous saturated colour and intense movements, whose energy undermines the strict, inexorable grid. This is form for its own sake, rather than for the sake of representation. Or is it? Perhaps it may also trigger dreams of emotional space, as we are drawn into an animated world in flux, then calmed by the rational logic and rhythmic order of the grid.

Ristvedt has gone on to explore the visual energy of gesture and touch further, using clusters rather than grids as a basis for a looser sense of composition, and developing an even freer feeling of spontaneity and virtuoso colour sensibility. Paint was rolled, scrubbed, sponged, scraped, stroked or brushed; whatever approach was necessary to achieve the density of paint required. The results were further reflection on an exploration of colour and form. "Ristvedt's grids are neither neutral or arbitrary, but rather distillations of deeply felt experience, responses to the specific meditations in place. Within a rational, legible format she [now] suggests landscape forms without making images that look anything like landscape." [5]

Ristvedt's challenging canvasses have been called part of the 'Zen-via-America' tachiste tradition, a tradition which emphasizes a "scrupulous discipline of intuition, wrist and sensibility" [6] of touch. They explore colour, texture and form, the eternal dialogue of figure and ground, solid and void, giving us new insights into the interactions of these basic elements of the visual world. ᴗ

# HELEN HARDIN

(1943 – 1984)  *Changing Woman*  1981

Painting is my job: and it's my life. I don't want to be rich and famous: I want to be best ... I'm categorized as an Indian and then I'm categorized as a woman. So I have to try harder.

— Helen Hardin[1]

HELEN HARDIN was born into a family where painting was all around her; her mother, Pablita Velarde, was one of the most important Native artists in America of her time, and a prodigious worker, given to painting far into the night. Velarde is known for her detailed paintings of Pueblo Indian life; she devoted her career to work based on the traditions of her people, the Santa Clara Pueblos. Helen Hardin spent her first years at the Santa Clara Pueblo, steeped in the tribal traditions and Tewa language of the people. She showed an early interest in drawing, winning her first art competition at the age of nine. In high school in Albuquerque she took a drafting class, which introduced her to compasses, templates and other tools she was to make use of later in her career. After a year at the University of New Mexico studying art and anthropology, Hardin struck out on her own course to develop a unique style and vision, one which was to prove quite different from her mother's.

Hardin's rebellion against traditional ways began early — "drinking, shoplifting ... living with a reputed mobster who beat her and her new daughter."[2] The escape she was to make from these difficulties came partly through her dedication to painting. In these turbulent early years, her personal artistic vision emerged. Rather than the descriptive, figurative style her mother had helped popularize, Hardin turned to an original fusion of cultural and contemporary concerns, dealing with the tension between her Native heritage and the dominant culture in the United States. Her work was influenced by the Cubist aspects of paintings by Native artist Joe Herrera, and by Pueblo pottery designs and rock paintings.[3]

A visit to her father in Bogotá, Columbia in 1968 resulted in an exhibition of her work at the American Embassy; twenty-three of the thirty paintings she showed sold, and her career was on its way. In the early 1970s, Hardin was 'discovered' by the local media as "a darling of the hippie movement."[4] This did not translate into financial security, but it did bring attention to the strengths of Hardin's unique vision. She went on to win many awards at group shows; solo shows followed. In 1976, her work was well enough known that a PBS television documentary about her was made.

Helen Hardin's work utilizes a strong sense of pattern and geometric form. Her subjects are often the *kachinas* (spirits from a higher world) or *kokomo*, masks or figures drawn from Pueblo legend. But these traditional subjects were freely and imaginatively interpreted through the prism of a modern sensibility as Hardin experimented with new forms. She used acrylics, airbrush sprays and inks to layer on washes of rich colour and textures like desert sand or sun-bleached rock; pens and the drafting tools of her school days were used with great precision to rule in detailed pattern and design. Often the designs played on the motifs and themes of Pueblo weavings, pottery and rock art. The affinity between Hardin's painting style and printmaking eventually led her to experiment with etching at the El Cerro Graphics Studio. In her "Changing Women" series, done from 1980 to 1982, the carefully inscribed geometric patterns and layerings of colour build up strong close-up portraits of women. "Changing Woman," "Listening Woman" and "Medicine Woman" move beyond documentation of what the eye sees, presenting us with an abstracted sense of the spiritual aspects of Hardin's subjects.

"Changing Woman," an acrylic painted in 1981, again illustrates Hardin's abstraction of form and clear use of geometric design in a visionary interpretation of the motifs of her forebears. "Rather than painting a subject, I am inspired by that subject to paint what I feel from the idea, the song, the ceremonial, the mask. I paint it as I feel it, rather than as I see it."[5] Her departure from the pictorial style of her mother is complete; she uses vivid abstraction to summon the spiritual power of women caught in the winds of change and struggling to forge a strong sense of self.

When she was thirty-eight, Hardin learned that she had breast cancer. Undaunted by surgery and chemotherapy, she continued her quest for the spiritual in painting, working daily from seven till five. She died in 1984 at the age of forty-one. Her husband, photographer Cradoc Bagshaw, writes: "Helen lived her life as a bridge between two cultures. When I look at her art, I stand on that bridge and see, if only for a moment, into another world."[6] Her legacy to us is a body of work which speaks eloquently of old and new together, a testament to the strength of contemporary Native vision. ℘

# COLETTE WHITEN

(1945 – )  *Family 1977 – 78*

COLETTE WHITEN'S challenging art, both her early sculptures and her more recent multi-media works, pushes the boundaries of personal expression. Born in Birmingham, England in 1945, Whiten came to Canada when she was nine. She studied art at the Ontario College of Art from 1968 to 1972. Although her works have evolved in form over the years, the underlying theme of human relationships and interaction remains a constant. In her early work the processes of conception, construction and completion were documented and made part of the finished piece. Her early sculptures, all without applied colour, often incorporated men 'locked' into various confining structures of wood, plaster and chain. From the various moulds in plaster completed at that time, Whiten became intrigued with the interplay of positive and negative three-dimensional space.

In the late 1970s Whiten began to create negative moulds and casts of people: serene, silent works imbued with illusion and mystery. She began also to use elements of colour, as bits of material and dye from the models' clothes remained embedded in the plaster. These sculptures done as negative spaces contained a tension, the implied illusion of positive form. Although the forms were negative casts, the images can 'flip' visually and appear to protrude outward.

In "Family" Whiten has used members of her own family as models. A sense of the presence of the individuals is clear as the "white faces seem to look back at you through closed eyes and the heads turn as you move from side to side or up and down."[1] Each model was cast twice, once from the front and once from the back. The two forms were mounted on easels which were constructed so that the figures can be presented with both sides visible in either a vertical or horizontal angle. The sculpture shown in this image is in progress. In the background one can view the back of one of the easels with two cast backs protruding. The three figures still in progress stand one behind the other in front of the easel. The male figure already demonstrates the illusion of positive protrusion.

When one views the raw casts with the fabric and dyes embedded inside, the drama of the casting process is very immediate. One can feel the implied energy of the individual whose body was used for the form. "My recent work, using negative images, makes this vital aspect more direct. One is aware of the enclosing space that a person occupied and becomes conscious of the person and how the space was defined."[2] The silence and serenity of the forms and the small touches such as the mother's arm around her daughter's shoulders give us a sense of the ties among the family unit, a warmth of representation which makes this work unique.

Whiten continues to explore new ideas and relationships in recent two-dimensional multi-media works and in finely detailed embroideries which probe women's absence in the media. This relates to her examination of the dissemination of power through newspaper media. Her exhibit, "New Needleworks" supports her "conscious decision to ally herself with the vast history of largely uncredited women's work that makes up so much of art's history."[3] In choosing forms such as cross-stitch and samplers, she joins feminist artists such as Joyce Wieland and Judy Chicago in claiming the power of women's traditional textile work for fine art purposes.

When she first began her career as an artist, Whiten described the emotional nature of striking out on one's own, the fear, the exhilaration and the "frightening freedom."[4] The struggle continues. Whiten is now a full-time teacher at the Ontario College of Art. One of the few full-time female staff members, she believes that it is important for students to see strong women in the faculty as role models. She was involved in drafting the "OCA Equity 2000 Plan," which is an affirmative action policy aimed at increasing the number of female teachers at the art college to a position of equity by the turn of the century. The plan has been controversial; its existence signals the determination of artists like Whiten and other faculty and students to work for fairer representation of women in today's institutions. ॐ

# NICOLE JOLICOEUR

(1947 – )   *Étude de JM Charcot (a)*   1988

NICOLE JOLICOEUR is a Quebec artist whose work traces out some of the key social and historical forces influencing contemporary society. Looking back to the roots of psychoanalysis in the nineteenth century, she explores how the *terra incognita* of both Woman and Nature became charted, labelled and thus circumscribed as mysteries tamed by Civilization. Since the early 1980s she has focused her attention on the work of Dr. Jean Martin Charcot's theory of hysteria as an example of how patriarchal forces have kept women 'in their place.' Using mixed media superimpositions of drawings, photographs and text, she questions and undermines the documentation of 'female hysteria' set up by Charcot in the nineteenth century.

Charcot, seen in this image teaching in the hospital amphitheatre in Salpêtrière, France, was a neurologist with a great interest in exploring the newly discovered domain of psychology. A teacher of Freud, Charcot had a penchant for drawing and photographing examples of his chief object of study — the female hysteric — for his students, even diagramming patients' 'fits.' Jolicoeur begins her piece with a photograph of a painting from 1887 by André Brouillet, "Une leçon clinique à la Salpêtrière." Brouillet has portrayed Charcot at work as he holds up as 'Exhibit A' — a woman in the throes of a fit — for his students' inspection. The patient is Blanche Wittman; in Brouillet's painting (and Charcot's theories) she is reduced to a symbol for a particular aspect of 'Woman.' Wittman's face contorts, her body swoons; her convulsion is viewed with seriousness and fascination by the roomful of young gentlemen. Charcot was known to have drugged and manipulated his patients into the 'performance' of fits of madness for his lectures.[1] Overlaid on the photograph Jolicoeur places a drawing etched out in white line. It is a tracing of a work by the Italian painter Andrea Del Sarto, of "St. Philippe of Neri Healing a Possessed Woman," a work known by Charcot. Jolicoeur thus reaches back to the Renaissance to find roots for this template of the representation of man as healer and woman as ill; woman as a swooning, unstable figure liable to seizure by demonic forces. The use of perspective, a device for organizing space (and the world) into a containing grid, for setting down and systematizing and thus 'possessing' worlds ripe for exploration and conquest, began with this period, the Renaissance. Rational man thus orders, names and categorizes the 'chaos' of Nature, of non-European cultures and lands, and of Woman. Knowledge becomes power. Women have often been constructed as frail, irrational and emotional: victims of their nerves and fantasies, prone to hysterics, witchcraft and madness. Madness is a kind of refusal of control; such 'dangerous' behaviour could be tamed through classification, through diagnosis as disease. The patients Charcot exhibited demonstrated his notion of the weakness of female character, and the need to contain this weakness through the classifications of medical science. Jolicoeur has brought together two images from two distinct historical periods to underline this continued, persistent positioning of woman as ill/man as healer.[2] Thus she makes visible this particularly male representation of women throughout history, and challenges as fantasies notions of 'objective science' rooted in ideas of social control.

Jolicoeur studied at the École des Beaux Arts de Québec, Laval and Rutgers University in New Jersey. She lives and works in Montreal, and since 1980 has worked on explorations of Charcot's theories on female hysteria. Since the early 1980s there has been intense interest among feminists in how the legacy of psychoanalysis has named and restricted the feminine condition. Using scrolls, text, drawings, photographs, images extended in gouache drawings and bookworks as her media, Jolicoeur has scrutinized the work of Charcot as well as that of his son, Jean-Baptiste Charcot. Jean-Baptiste explored and mapped Antarctic polar regions — unknown territory — in ways that paralleled his father's charting of female hysteria. For father and son, "hysteria and *terra incognita* were represented, codified and formalized by a system whose most recognizable features are unquestioned authority and territorial ownership."[3] Jolicoeur shows us how Charcot's representation of women is "a story of mastery, domestication and ownership," a conquest of the 'wild.'[4] But the map is not the territory; women will no longer be defined and contained by such 'authority.' Through art Jolicoeur has illuminated a particular tradition of power relations between men and women.

Nicole Jolicoeur's work is rooted in the world of ideas and how they have been and are represented. It raises the question of work which can be fully appreciated only within its context, as some background knowledge of Charcot and his work is essential to understanding her work. But the demand made on the viewer to look further than the visual image to the ideas behind it, though a cerebral one, shows us an art that is rich with possibilities for opening new windows of understanding. ✀

SAINT PHILIPPE DE NÉRI DÉLIVRANT UNE POSSÉDÉE

Groupe dans une fresque de André del Sarto, dans le cloître de l'Annunziata, à Florence.

# JANA STERBAK

(1947 – )   *Remote Control, I*   1989

JANA STERBAK grew up in Czechoslovakia. Her parents participated in the liberal 'thaw' experienced by Czech society in the mid-1960s; like many others, they fled the repression of the Russian tanks which rolled into Prague in 1968, emigrating with their family to Canada. In Czechoslovakia, Sterbak was influenced by the culture of scepticism and dark humour which the authoritarian communist regime engendered; later in Canada, the excesses of capitalism led Sterbak to cultivate a similar scepticism. Educated in Vancouver, Toronto and Montreal, Sterbak has tended to reject labels, preferring to acknowledge the complexities of life, whatever the system. At the same time, works like "Remote Control, I" challenge us to reflect on questions of power and control. "What Canada and Czechoslovakia both offered was an experience of colonized identity ... Through this experience, Sterbak developed an acute sense of the conflict between dependency and self-determination that exists both on the personal level — and therefore on the political plane ..."[1] And it is the body which becomes the site of Sterbak's investigations of dependency, self-determination, constraint, desire, contradiction.

"Remote Control, I" was used in performance for the opening of Sterbak's show at Galerie René Blouin in Montreal in 1989. A female actor was positioned by two men into the metal crinoline which Sterbak had fabricated; an external hand-held control device was then manipulated electrically by a man. As the skirt wheeled about, the woman encased in it, whose feet did not touch the ground, tried in vain to try to find a position of comfort. The hooped skirt, a familiar symbol for the physical constraint of women's movement, here immobilizes the actor; she is literally trapped. Yet when "Remote Control, I" is seen in isolation, as a purely sculptural piece, it can offer other possibilities to the viewer. One might read the cage/skirt as a sign of social control; one might also imagine operating the device, assuming the role of controlling agent either inside or outside the skirt, changing the power relations. Such layered meaning is a central aspect of Sterbak's often controversial work.

Sterbak came to wide public attention in 1991, when another piece, "Vanitas: Flesh Dress for an Albino Anorectic," attracted the attention of two hostile Members of Parliament who denounced it in parliament. The piece was defended by the National Gallery, where it was on display, but a huge flurry of publicity in the national media ensued. On a suspended tailor's dummy, Sterbak had sewn and shaped in the form of a dress three hundred dollars worth of salted meat. With time, the meat became dried and desiccated, changing colour and odour, aging as does our own flesh. The 'dress' can be seen as a garment to put on, but it can also be read as a raw metaphor for the body itself. The piece became a lightning rod for heated exchanges between vegetarians, animal rights activists, those concerned about hunger and food banks in the face of such art world 'excesses,' and those who defended the artist's right to use whatever materials necessary in her work. Sterbak's response was that there is no meat shortage in Canada; there is a money shortage.[2] Her work does not create waste, rather it illuminates it — the waste of anorexia, and the image-obsessed society which spawns it. That a woman should feed others ideas instead of food was clearly a transgression to many. Feminists, who had long decried society's commoditization of women's bodies — of women as meat — found in the piece an expression of this concept that spoke volumes. Art historians found an apt contemporary version of the *vanitas* — a time-honoured genre, usually of still lifes of flowers and fruit, which symbolizes the transience of life, the passage from ripeness to decay. As with "Remote Control, I," the piece offered layered readings. Critics like Sarah Milroy found "the intensity as well as the nature of the public's response are a testimonial to the work's commendable defiance, and to its effectiveness as social intervention."[3]

Fluent in the history of western art, Sterbak first wrote art theory and criticism. When she found this got in the way of making art, she concentrated her energies on making her ideas concrete as artworks. Although she occasionally draws text into her pieces, often drawing on classical allusions,[4] her materials — meat, wire, electricity, metal — provoke a visceral response from the viewer. But closer contemplation brings out the complex interweaving of references to both history and to contemporary dilemmas. What distinguishes Sterbak's work is a powerful combination of the emotional and the intellectual, manifested in a dense physicality; her work engages people immediately.

Sterbak has shown her work widely across North America and in Europe. "We need to talk to more people than just ourselves,"[5] says the artist — and her work indeed provokes much talk which helps us look through the everyday reality of the body to the markings of society encoded on and through it. ☙

# JAMELIE HASSAN

*(1948 – )  The Oblivion Seekers  1985*

Do not live only for yourself, so that you do not live for no one.[1]

JAMELIE HASSAN was born and brought up in London, Ontario, of Islamic parents from the Bekaa Valley in Lebanon. She studied art in Windsor and abroad in Italy, Lebanon and Iraq. As a teenager, she travelled in Europe and then went to school in Lebanon "not so much searching for my roots as attempting to locate those cultural elements that had been such a strong focus for me as a child."[2] The atmosphere of political tension of the Middle East was a radicalizing influence, and led to extensive travels in Europe, Latin America and the Middle East.

Back home in London, Ontario, the process of making sense of experiences in other places led to Hassan's 'actualization' of those experiences and feelings through art. Often these works would involve found or made objects, texts, or installations as well as picture-making. "... it is as if I have a dialogue with the object as I form it and then it speaks in turn to those who encounter it. In other words, there is a language that is embedded in the way people do things that communicates as well as the spoken language."[3] From a dossier left in London by three visiting women from Argentina, Hassan fashioned "Los Desaparecidos" (1981), an installation of porcelain handkerchief shapes. Each was inscribed with the name of a 'disappeared' person from the dossier, as remembered by the mothers and grandmothers of the Plaza de Mayo who had dared to demonstrate on behalf of their children, victims of terror.

During her 1979-80 visit to Iraq, Turkey, Syria and Lebanon, Hassan found herself in Beirut, "caught up directly into the nightmare of urban warfare. Under surveillance, in a climate of final betrayal and violence, Jamelie felt directly, bodily, the same forces which had historically ravaged the Latin American countries she had visited ..."[4] Her art took on a new political urgency; she began to examine the fractures colonialism and oppression wreak on society. In a Forest City Gallery installation back in London, Ontario, she violently dismantled one brick wall of the gallery, to uncover photographs and documentation of the devastation she had just witnessed, forcing our attention to the cataclysms of war.

Works such as this are to be moved through by the viewer, to be experienced and reflected on; meaning is clarified for each of us as we become familiar with the elements of the installation. For the artist, "knowledge occurs when one unravels things for oneself and arrives at an understanding independently."[5] At the same time, Hassan wrests our attention away from the predictable and everyday expectations of the role of art and confronts us with the torn fabric of social reality, giving us new keys for understanding.

Although Hassan's art involves a passionate engagement with the social world, it is intensely personal. In "The Oblivion Seekers," she weaves together elements with autobiographical resonance, using the personal to build a positive image of a whole community. "The Oblivion Seekers" is a performance piece which celebrates the security of a warmly remembered childhood within the bosom of Arabic family life. Hassan's home in London was a gathering place for many newly arrived immigrants from the Middle East. "There were always relatives and people who were displaced entering into a familiar environment where Arabic was spoken. They always brought messages. It was almost like a caravan in a way ... foodstuffs [they had brought] would be cooked and consumed and the music would begin, and there would be dancing."[6] To recreate this strengthening sense of community, Hassan tracked down images of herself as a child of five, dancing at an Islamic event, and juxtaposed them with home movie images, a specially commissioned musical score (by Gerry Collins) and a reading from the texts of artists Mona Hatoum and Isabelle Eberhardt (by Lillian Allen).

Hassan sees this performance piece as a way to give Canadians new perspectives on different ethnic groups, to 'mediate' the stereotyping which so often exists in our society, to "find a ground somewhere for the mainstream culture to be exposed to another culture ... You can't, say, refer to one ethnic group as being responsible for terrorist acts within the world, if you're looking at a family that embraces and has children."[7] The personal journey reaches out to become a political journey as well. "Because ... there was and there wasn't a city of Baghdad," a text emblazoned across a photograph of a magnificently decorated mosque on her billboard artwork (1991-92), echoes this humanizing theme, and stands as a reminder to us all of the price of the Gulf War. In Hassan's view, "the motivating principles of war ... are absurd and irrational ... whether at the beginning or end of the century: the rhetoric remains the same."[8] Her work is a challenge to that rhetoric, and to the evils of stereotyping. ℃

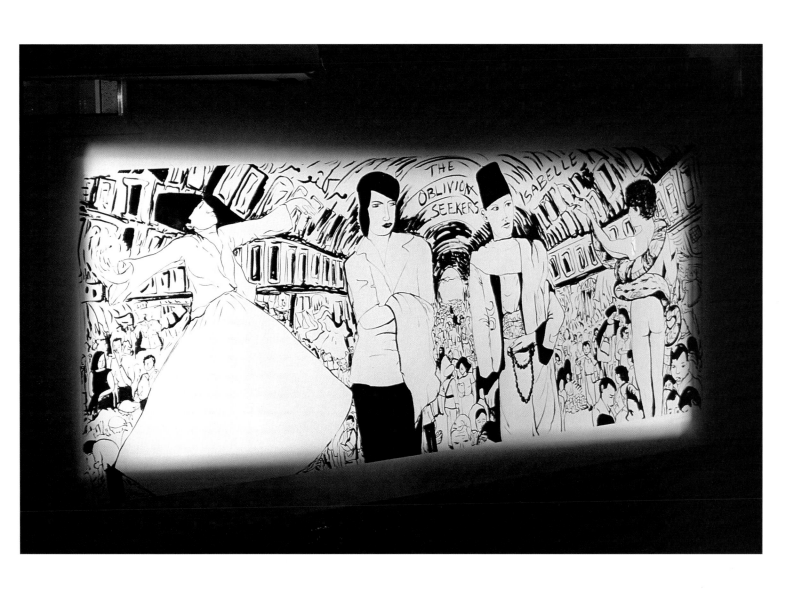

# LIZ MAGOR

(1948 – ) *4 Boys and a Girl* 1979

I am always looking for comfort in a world disturbingly subject to change ... sometimes I find it in objects, things that sit still for a while and slowly gather, then release their history. I wanted to do work that would objectify some history of a life or at least the life of a body and the process of change that affects that body.

— Liz Magor[1]

LIZ MAGOR's conceptual installations investigate questions of personal identity. Her highly organized and structured pieces include collections of images, objects and natural materials subject to decay, reminders of the fragility of human life. Her explorations of "the cultural influences and individual distinctions that account for identity are set against the inevitability of the natural processes that govern existence."[2]

Magor was born in Winnipeg in 1948. She lived in Vancouver and studied at the University of British Columbia, then continued her studies at the Parson School of Design in New York and the Vancouver School of Art. Magor has worked and exhibited steadily since 1971. Following her move to Toronto in 1981, she has taught at the Ontario College of Art and has been vocal in expressing her concern for the current climate for younger artists. She now lives and works in both Toronto and British Columbia.

Magor has in her work sought to find a balance between the emotional drive to produce and the critical, intellectual aspects of planning and analysis. "There is a way in which you can implicate yourself, continue to produce and criticize at the same time. That's a very small space. And my work wants to be in that tiny space."[3]

Although her interest in the elusive nature of identity and how it is established and maintained has remained constant, Magor's work has evolved from a concern with 'production' of objects with special presses she has constructed as part of her art works, to an inclusion of more manufactured materials, to a concern with 'reproduction' using photographic imagery. From her earlier West Coast works like "Compost Figures" or "4 Boys and a Girl" which included wood, rags, mulch and other natural materials, she has moved to "Regal Decor," made from linoleum, sono tubes and photographs, and to installations of photographic re-enactments of historic events like "Lethbridge Telegram."

Identity is both fixed and fleeting. Magor's 1979 installation, "4 Boys and a Girl," explores the question of what remains when we die. Five compressed rectangular blocks of brown material are arranged around a wood and metal 'machine' which the artist had devised to press them out into coffin-shaped slabs. The title refers to the artist and her brothers; it was, in fact, the death of one brother that impelled Magor to create the piece. She has "introduced a mixture of old clothes, grass clippings, water and white glue into a large steel tray meshed at either end. It fits into a machine ... its lid pierced by enormous screws, it becomes an instrument of torture. From it Magor has squeezed out human slabs placed like cakes on cooling racks/like bodies on cots."[4] Each slab "releases its history," marking "4 Boys and a Girl" in relation to each other and to the metamorphoses of nature. The compressed layers of sediment evoke allusions to archaeology, death, coffins; a suggestion of a return to the earth through decay, a metaphor for individuals cut from the same cloth, sharing the same mold/mould and history. For Magor this allusion to composted material is specific to the wet world of the West Coast with its cycles of decay and regeneration.

"Lethbridge Telegram," a work from 1994, draws on the history of Lethbridge, Alberta, a town which sent proportionally more young men overseas during the Second World War than any other town in Canada, and where 12,500 German prisoners of war were interned between 1942 and 1946. Magor's fascination with the act of returning to history has led her to reconstruct and then photograph these re-enacted events from the daily lives of soldiers — moments of reprieve, in infirmaries, reading the news — and juxtapose them with images of those fallen in bullet-ridden death. She combines these 're-enactments' in an installation that helps us remember, through the lens of this particular 'small history,' the larger history of war. Magor here constructs narratives of personal identities to embody larger social truths. Her work has been noted as "a solemnly beautiful commemoration in a society populated by amnesiacs and sleepwalkers,"[5] a call to remember, through objects and the individual lives they call forth, identities 'released by history.' ❧

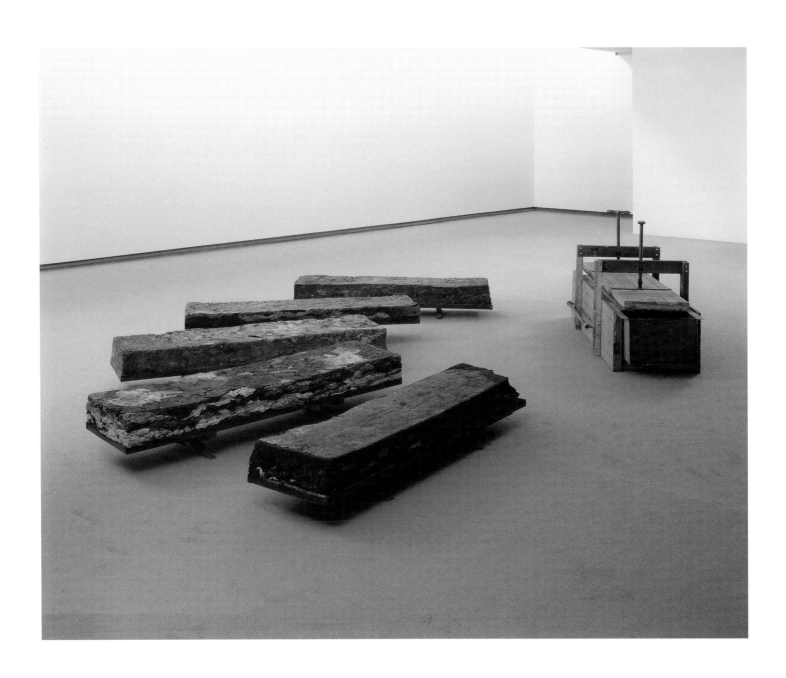

# JANICE GURNEY

(1949 – )   *Searching Black Miners for Hidden Diamonds*   1987

JANICE GURNEY'S art is one of engagement with her audience; she opts for a stance of careful questioning, and incorporates the work of others as part of her artistic statement. "Searching Black Miners for Hidden Diamonds" is one such piece. A first reading of this collection of images and text brings us to reflect bitterly on the human price of the West's fetishizing of diamonds, those coveted status symbols. Behind the wedding bands of the top left corner of this work and their dream of harmony lie the corrosive chains of racism and servitude to the power of capitalism. On this level, the relevance of the piece to our questioning of modern life is inescapable.

But what are the stories behind these different images Gurney has threaded together? Following her usual strategy of refashioning meaning by assembling disparate fragments, the artist conceived of this piece in ways that challenge the conventional notion of 'authorship' of a creative piece. The title is drawn from an archival photograph of Black miners at the De Beers diamond mines in South Africa. The price of waged work for these men is clearly shown as they suffer the indignity of being strip-searched after work. Gurney splits the photo in two, using it to frame three paintings she has commissioned from other artists. The left central panel is by artist Joanne Tod, patterned on a sports magazine photo of American boxer Aaron Pryor. The right central panel is by Gurney's husband, artist Andy Patton, also taken from a found source: a newspaper photo of South African miners. David Clarkson was commissioned to paint a fractured diamond over the adjoining edges of both. Below the side panel, Gurney places text drawn from Pryor's rambling interview,[1] which is given fresh overtones in this new context.

Thus Gurney draws others into a conversation relating parts to whole, recognizing the inevitable back and forth, the interplay of ideas which continually informs our thought processes. How does this relate to the question of 'originality' in an artist's work? Andy Patton speaks of Gurney's work as inhabiting a "civil space," a place of public dialogue. "The actual incorporation of others' work is fundamental to that space; it becomes impossible to acknowledge the artist's subjectivity ... without at the same time acknowledging the subjectivity — and the subjection — of others."[2] The artist is present as the producer of new visual meanings through the juxtaposition and commissioning of images, and as a participant in the conversation produced. The work becomes a site of visual dialogue, drawing the viewer into varying levels of meaning. The resulting whole thus brings differing voices and shifting meanings, both personal and social, together to make a statement that is emphatic at one level, fraught with complexity at others.

Gurney has been an active contributor to the arts community through the 1980s, serving on the board of *YYZ Artists' Outlet*, a cooperative artist-run gallery, and exhibiting her work across the country and at the Wynick/Tuck Gallery in Toronto. Born in Winnipeg in 1949, she received her BFA from the University of Manitoba in 1973. She has taught at various arts institutions such as at the Ontario College of Art, and has been a visiting artist at the Emily Carr College of Art and Design, York University, and the Nova Scotia College of Art and Design. Her early work concerned itself with the relationship between family and identity, with the ways in which society scripts our understandings of the body and psyche. Pieces like "Portrait of Me as My Grandmother's Faults" (1982) used old family and archival photographs combined with a commissioned portrait of herself, traced over and ruptured with white markings. A complex image, it touches on family relations, on the burden of history, individual responsibility and the victimization of women and minorities.[3] "Emphasis Mine" (1988) reflects on the blistered, scarred surfaces of the body, the faults of our physical selves which serve as the vessel for the anxious psyche of the accompanying text by author Anne Truiit. Gurney adds to a punctured image of physical surface/skin, combining text and image in a disconcerting reminder of our fears of how inner and outer selves reflect one another. "The Surface of Behaviour" also involved Gurney's commissioning a portrait of herself by painter Sheila Ayearst, in a work concerned with similar themes.

Thus Gurney puts the body 'into the picture.' Uncovering the truths of the particular experiences of the female body is a common theme for many women artists today. Traditional male-defined ways of representing both the world and female experience — the 'male gaze' — are challenged as artists like Gurney incorporate feminist theory into a 'female gaze,' a self-identified representation of reality. In the face of patriarchal history, Gurney's work "bring[s] the female body to speech, in and of its multiplicity, in its unknowness ... in and of its dance, song, speech and its torture."[4] And in works like "Searching Black Miners for Hidden Diamonds," Gurney trains such a consciousness on the social questions of our time. ✍

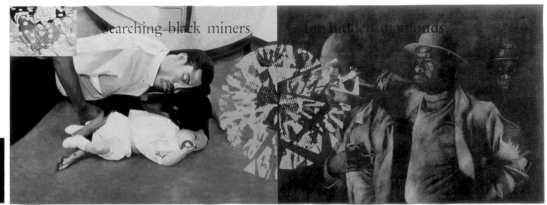

searching black miners for hidden diamonds

Everybody
They take my
I had
I wanted to shoot

robs me.
machine gun.
an M16 . . .
my way back home.

# SHIRLEY WIITASALO

(1949 – )  *Black and White*  1986

PAINTER SHIRLEY WIITASALO lives and works in Toronto. After studying briefly at the Ontario College of Art in the late 1960s, this largely self-taught artist moved into a loft on Yonge Street, right in the heart of the city. Her early works explored questions of self-identity and relationships with nature, moving from abstraction to references to the observed world. In 1975, International Women's Year, her work was included in the National Gallery exhibition "Some Canadian Women Artists." "My lakes, birds, and plants imitate nature in order to understand its spirit. They are images that reassure me that all things have some essential energy and strength. I bypassed their structure and processes to grasp a basic principle."[1] As her work developed, Wiitasalo's vision of the essential energy of the observed world came to embrace a concern with how we perceive and represent this world and with the role that the media plays in this process.

In the 1970s and early 1980s, Wiitasalo's studio became a vantage point for observing the changing face of the city as old buildings were torn down to make way for the glass towers of 'progress.' Wiitasalo's painting from this period is an angry commentary on the wanton destruction of place and history. "Facade," painted in 1987, takes as its subject "the handsome nineteenth century building opposite [the] studio which had been stripped to a shell in order to accommodate an office tower. I was so pissed off that they had ruined this beautiful building."[2] The painting's angry, searing reds are a study in the mutability of form. Her critical reflections on change in the built environment continued after her eviction in 1987, when she moved to the suburbs, where 'monster homes' were swallowing up older neighbourhoods. Throughout this period, Wiitasalo's work is marked by lush, painterly surfaces, by the sensuous touch of hand and brush.

In "Black and White," this emphasis on touch is spare but still evident in the application of paint, but Wiitasalo's work in the late 1980s has deepened, including the touch of the cerebral as well as the sensual. A figure looks out from the mouth of a cave to a second seated figure shadowed by a harsh light, and to two yawning caves beyond. Suddenly, as we look, positive flips to negative; the far caves become eye sockets and a bleached skull emerges to look back at us — a *memento mori* or *vanitas* image. But this skull also has

aspects of a mask — hiding what is truly there in the picture, or hiding our own watching face? On the edge of these advancing and receding readings, we perceive the image of an atomic blast as the human form flows into the unseeing eye socket; the unspeakable menace of nuclear annihilation lurks behind whatever screens of meaning we are puzzling out. Meaning shifts, resettles, assumes new ambiguities and distortions, dissolves into our shadow selves, transforms from cave to skull to mushroom cloud. We are "looking in and looking out, seeing and being seen" in this "standoff, face to face ... between the living and dead, between the living or dead."[3] Is the frame of the canvas inside the cave or outside the skull/mask? Does it help us see out into the picture space — or to be seen by the skull?

The richness of layered readings "Black and White" evokes is typical of Wiitasalo's work of this period. Her work explores 'frames' or enclosures which shift our gaze inside, then outside, as she incorporates into her painting symbols from various media — photography, TV sets, mirrorings of the illusions of contemporary life. These frames also mediate "public and private, personal and social, and thus stand for a broader social framing of our experience."[4] "Black and White" confronts us with our own mortality, framed as it is in our time by the threat of nuclear holocaust.

In the 1990s, Wiitasalo has turned from these ominous, intense commentaries on the nature of perception and representation to a more spontaneous, direct view of the world around her. Working with veils of vibrant colour and a painterly touch, she has "renewed herself by returning to the well of direct observation."[5] In her new work she has forged paintings which open up the interplay between organic and inorganic forms — the worlds of nature and culture — with a new mood of transcendence. Her work, shown for many years at the Carmen Lamanna Gallery in Toronto, is now exhibited across North America and in Europe. ℘

# BARBARA KLUNDER

(1949 – )  *MonkeyBusinessMen Medicine Chest*  1994

> Art is love, and if it isn't love, it ain't art. That's my theory, but it's not everybody else's theory.　　　— Barbara Klunder.[1]

BARBARA KLUNDER'S source of inspiration is what she calls 'real art,' by which she means the "folk arts found in native cultures of Canada, Mexico, the Caribbean, and Africa."[2] Klunder has developed a funky, colourful style of art that she hopes is more easily accessible to carry her lively messages about our society to a wide audience.

Klunder was born in Toronto. Her artist parents encouraged her natural interest in art: "I drew from the time I was born."[3] Always a bit of a prodigy, Klunder completed grade twelve by the age of fifteen. She attended the Ontario College of Art and then left school to pursue an independent career. Klunder now lives on the Toronto Islands, which allows her to be close to the city and at the same time to pursue a "semi-rural life" with a "closely knit community of very original people ... It is paradise. The whole neighbourhood cares for the environment and for each other."[4]

This concern for the environment is of central importance in Klunder's work; while her playful and exuberant images and strong sense of design catch the eye, a deeper message also emerges. Combining natural and human forms, Klunder creates images of modern mythology. It is the balance between humans and nature that she believes we "*must* achieve to save the environment — to deeply realize [that] if we are careless with nature — we don't survive."[5] Klunder recognizes this same concern — our interdependence with the natural world — in the philosophies of many indigenous cultures.

Proof of the accessibility of Klunder's imagery and broad appeal of her work lies in the many posters and T-shirts for social and political activist groups such as Tools for Peace and Oxfam that she has designed. Klunder's images often mix a sense of fun with her message for our survival. Truly eclectic, she has turned her strong design sense to many projects, from the creation of a typeface to rugs to murals which have become an integral part of the downtown Toronto streetscape. For her, art should be everywhere.

"MonkeyBusinessMen" brings Klunder's populist folk art style together with a subject of strong political concern for women: the issue of breast cancer. In 1993 Toronto philanthropists Barbra Amesbury and Joan Chalmers, having lost five friends in the space of a year to breast cancer, decided to turn to the transformative power of art to raise public awareness about this issue. They commissioned twenty-four artists to investigate and develop art pieces about breast cancer, introducing them to one hundred 'survivors' who were willing to share their courageous experiences. Klunder's response, after a year of "soaking up information and statistics," was outspoken fury at the "politics of avoidance"[6] of our society. "MonkeyBusinessMen" juxtaposes a symbolically empty brassiere embroidered in red with the ironic phrase "hope springs eternal" with an iconic box/shrine. The box, or medicine chest, is emblazoned with a painting of three monkey business men who "see, hear and speak no evil," oblivious to the tragedy of breast cancer. The factories which despoil the land and air and feed the self-absorption of the money men lurk poisonously in the background. Inside this astringent reliquary a second painting is revealed: an image of a woman, hands crossed protectively over breasts, rising above the menacing devil-figure below.

The exhibition "Survivors: In Search of a Voice" includes this and twenty-three other powerful artworks, displayed alongside personal testimonies by thirteen 'survivors.' It has been seen by almost a million people, and has travelled widely in North America and internationally, fulfilling the mandate of Amesbury and Chalmers's Woodlawn Arts Foundation to "lift the veil of silence and get people talking about this disease,"[7] to "spur fundraising for research and treatment, and honour the women and their families confronted by this disease."[8] "MonkeyBusinessMen" exemplifies Klunder's keen interest in an art connected to the social world in which she lives, an 'act of love' which sharply rebukes injustice, a call for healing, restoration and balance. ༄

# GRACE CHANNER

(1959 – )   *The Women Before*   1994

> Black people and Black women in particular represent something dark and strong in the world which is looked upon very negatively. This through no accident. Black women are more often than not placed at the bottom of everyone's value list, yet everyone eventually turns to her for her help through physical labour to political activism.[1]

GRACE CHANNER is an uncompromising Black lesbian artist whose work often reflects her passionate belief in the creative potential of women and of Black women in particular. Her paintings are usually large in scale; the power in her subjects resonates as they fill the space provided. Channer's thoughtful work delves into the experience of the African diasporic community.

Channer has worked actively in the arts in Toronto since she completed her BAE at Queen's University in 1978. She values community involvement as a means of educating people about Black women's issues in particular, as well as about the effects oppression has on all people. Channer also underlines for her students what has been achieved thus far in the struggle against racism and sexism. She has participated in Toronto school programmes and children's workshops as well as workshops for educators on how African-rooted images can be utilized in the school curriculum.

Channer has shown her work in many group and solo exhibits, and continues to work as a feminist and an advocate for Black rights. In 1991 she travelled to Ghana in order to connect with the community of African women there. Channer's lesbian identity is central to her creativity,[2] informing her art and imagery. "To be a woman is [to be] unequal; to be a Black woman is to be more unequal; to be a Black lesbian is to be the most unequal."[3] The burdens of inequality are challenged in Channer's work; she confronts them with the strengths of Black women so affirmed in her images.

Channer is concerned also about the context in which her work is presented. In a 1987 painting, "Black Women Working," five large panels portray Black women at various tasks: labouring, nurturing, protesting, learning. This dynamic work is dedicated to "all Black women all over the African diaspora whose contributions to this human society remain unrecognized and deliberately ignored and who still struggle on with the fight that is for all people."[4] It was shown in the public space of the Parkdale Public Library, readily accessible to the local Black community in Toronto.

"Who Will Fight For Our Liberation," exhibited in 1992 at the Power Plant Gallery, is a large multi-frame semi-sculptural painting which incorporates branches, collage, sewn pieces and images of the Black female form intensely involved in Channer's ethos of struggle. In this work Channer again explores the African roots of Black women in North America with an interwoven text which comments powerfully on the sexism and oppression they experience. "What is there for our young women now?" Channer seems to ask by juxtaposing her "three ancestral forms [who] witness the activities of their progeny in the 'New Land'"[5] in the adjacent works of art displayed.

Channer's methods have changed over the past decade, incorporating sculpture, painting and construction; the underlying themes have been honed and clarified. However, she consistently employs the stylistic device of a frame of some kind within the composition in which she surrounds her characters. The 'embrace' of the frame has the effect of presenting the subjects, often women, in intimate spaces that seem comforting, even womb-like. "Channer's compositions reflect a keen sense of spatial arrangement, which is a result of different ways of assigning significance, of seeing, of valuing women, and of being."[6]

Although she is grappling with social evils, Channer's works are often surprisingly celebratory. Despite the challenges and struggles facing Black women, Channer also presents her figures as "Amazons who stoically and steadfastly hold up their families and communities, regardless of the cost to themselves."[7]

"The Women Before," a strong painting produced in 1994, continues the celebratory, intimate nature of Channer's work. It depicts the powerful, muscular figure of a woman, arms upstretched, within a protected space, framed and supported by other women. The figure is slightly stylized, with exaggerated forms that dynamically fill the space. The nude figures intertwine in mutual support, creating a composition of fluid forms resonating with courage and power as "The Women Before" pass on their strength to the women of this moment. Channer's work, whether an outraged cry against racism or a celebration of Black lives, continues the challenge to traditional Western artistic practice that her North American predecessors such as Lois Mailou Jones began. Despite her awareness of the hardship of her people's lives, Channer affirms the indomitable will and spirit that gives the strength to continue to fight for change. ℘

# REBECCA BELMORE

(1960 – ) *Artifact 671B* 1988

I have with me the influence of my Kokum (grandmother) and my
mother.

I can see their hands at work. Hands swimming through the
water, moving earth and feeling sky: warm hands.

I can see their hands touching hide, cloth and bead, creating
colour, beauty: work hands.

I look at my hands and I am aware of their hands.

That is how I wish to work.

— Rebecca Belmore[1]

ANISHINABE ARTIST Rebecca Belmore was born and raised in the small Northwestern Ontario town of Upsala and spent her summers with her grandparents. She did not speak Ojibway, they did not speak English; nonetheless it was a time of intense and rich communication. The lasting impressions of these times together were to prove a source of strength as Belmore encountered the full force of White culture and institutions. As a girl, Belmore saw tourist-trade birchbark canoes made in Japan and plastic chiefs dangling from key-chains at the Upsala gas station, and wondered where they came from. "Who made the souvenirs? It wasn't Indians ... her family wasn't a souvenir ... they were alive, living ..."[2]

When she moved to Toronto to study at the Ontario College of Art in 1985, Belmore found a curriculum which marginalized the artistic practice of Native and other cultures. Her first exhibited works were images of Native grandmothers, an exploration of her own identity as a Native woman. She had returned to Thunder Bay, where a community of artists and storytellers offered a richer context for her ideas about the relationship between art and Native expression. Though her drawings were circulated throughout Northwestern Ontario through a public gallery extension programme, she found mainstream channels were not enough; to reach a Native audience, different approaches were needed.

One artistic strategy Belmore went on to develop was to show her work as a performance artist. Using language, found and made objects, she has woven any and all media necessary into performances which bring to life an incisive critique of damaging stereotypes. In "Autonomous Aboriginal High-Tech Teepee Trauma Mama," first performed in 1988 at the Native Student Council at Thunder Bay's Lakehead University, an installation of a Saran-wrapped teepee was accompanied by Belmore's danced and chanted anthem: "Souvenir seeker/I know you are not a bad person/Free me from this plastic/Come on, let's talk!"[3] Inside the teepee —

Trauma Mama's closet — are painted sculptures to 'put on,' identities to wear: a horse dress, a 'Cher' dress, an electric power dress, a strait jacket painting that's a "plush blue velvet painting of a beautiful Indian maiden, complete with white gilded frame and overhanging lamp. All is attached to a corset. With a reputation like this to live up to — my hands are tied!"[4] Image becomes costume becomes the clothing of irony, of ideas.

Irony and parody are potent weapons in Belmore's work. In "True Grit Souvenir Cushion" (1988), beautiful quilt-like patterning surrounds a painting on fabric of the artist in football gear. "I used myself as the central figure, the Northern motif, the Native Indian as a marketable commodity ... the artist/souvenir is strong, free and tough. You have to take up a front line position. But no matter how tough you project — you never win."[5]

"Artifact 671B" was created as a response to "The Spirit Sings," an exhibition of Native art sponsored by Shell Canada then at the Glenbow Museum in celebration of the Olympics. "The Spirit Sings" was criticized by many as a further appropriation of Native culture by White institutions. On January 12, 1988, runners were bringing the Olympic torch through Thunder Bay; Belmore chose this moment to answer the call to boycott Shell's sponsorship. In -18° C weather, she sat inside a life-sized wooden frame hung with signs. Immobile for two hours outside the Thunder Bay Art Gallery, Belmore herself was an exhibit "Artifact 671B." Motorists approaching a nearby stop sign were confronted with Belmore's installation, which prompted stoney disregard from some, a nod of recognition from others. The local newspaper noted: "[Belmore] said her protest expresses her feeling that some want to treat Natives as artifacts and don't want to deal with real people and problems ... as a Native Canadian she feels a responsibility to her people to make social and political comment."[6] Thunder Bay peace activist Josie Wallenuis also noted the impact of Belmore's performance piece: "The Native traditions of respect for the environment and community justice are the only survival tactics for the nuclear age."[7] Belmore's art, thus, becomes a vehicle for communicating connections between the personal and the political which utilize both her presence and social commentary as central to her work. Belmore approaches art "as a tool for healing and change, as well as self-expression."[8] ဆ

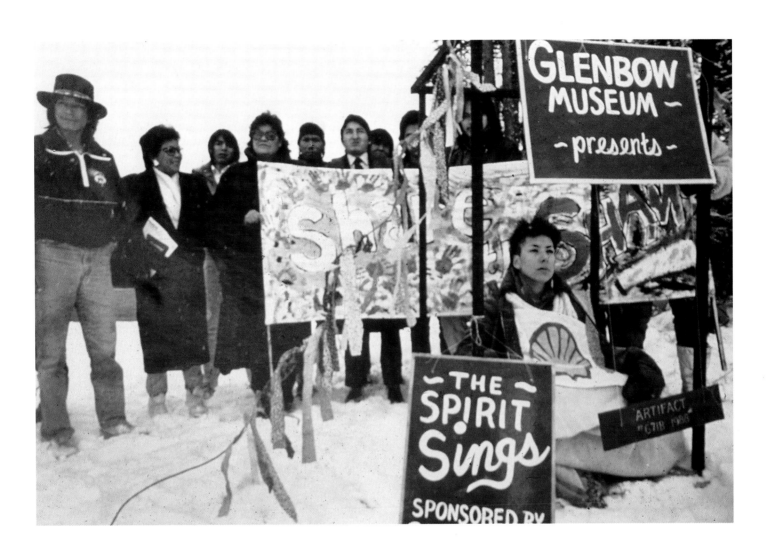

# MIDI ONODERA

(1961 – )   *Ten Cents a Dance (Parallax)*   1985

MIDI ONODERA specialized in Experimental Arts at the Ontario College of Art in Toronto from 1979 to 1983; there she studied film, photography, painting and writing. Eventually she realized that "film was all those things that I was trying to force painting and photography to be ... text, composition, colour, language, form, all of those elements that can be evident in painting and photography."[1] She was one of the founding members of Ontario College of Art's Women Artists Collective in 1982. Before graduation Onodera had already made several short films which explored issues of isolation and alienation in the face of the "constant barrage of everyday life,"[2] as well as sexuality and personal identity. Sexual identity as expressed in feminist vocabulary is probed in "Endocrine Delight," and in "Idiot's Delight" as a personal choice and source of power.[3] Problems of communication, of bridging gaps in meaning, of trying to read unspoken messages are addressed in two later films, "Ten Cents a Dance (Parallax)" and "The Displaced View." A lesbian who has experienced personally the difficulties of family and social acceptance, Onodera has learned strengths she is able to bring to other issues. "Because I had to fight for my sexuality," she says, "I wound up protecting my culture."[4]

In "Ten Cents a Dance," problems in communication are seen through the prism of sexuality, both heterosexual and homosexual. The emotional isolation of the individual is conveyed metaphorically by using a split screen, thus framing each partner in the separate space that a sexual liaison might attempt to break through. There are three encounters, the first between a straight woman and a lesbian who negotiate the possibilities of such a connection, the second between two gay men in a washroom, and the third between a heterosexual man and woman engaged in the disconnected ritual of phone sex. Onodera describes 'parallax' as "the apparent change in the position of an object," which happens when things are viewed first with one eye only and then with the other. Such a viewing is paralleled by her use of a split screen as seen here, and is emblematic of the different points of view present in the interaction depicted — the levels of unspoken apprehension, of desire, of miscommunication.

"The Displaced View" focused attention on Onodera as a Sansei (third generation Japanese-Canadian) film-maker dealing with cultural identity. Her parents, like many Nissei (second-generation Japanese-Canadian) were reticent about discussion of the bitter experience of the internment of Japanese-Canadians during the Second World War. Onodera determined to explore this injustice, looking through it to the stories and experiences of her grandmother's generation, the Issei. She adopts a fictionalized format that incorporates documentary techniques, threading her themes of loss and recovery, of reclamation of family, personal and community history with scenes of herself, her mother and her grandmother to weave an emotional continuity through this difficult history. Making her own sense of these connections, she intercuts interviews, oral histories and photographs of other families, thus constructing a new telling of the links and tensions between the generations. "How does one preserve one's memories, or cope with loss?"[5] Onodera asks, as she examines "the ways in which memory is created and history re-created."[6] Vertical Japanese script fills the side of the screen, paralleling the un-subtitled Japanese spoken in the film. The English is subtitled in Japanese, underscoring to English viewers the dislocation faced by Onodera as she attempts to communicate with her grandmother and, by implication, by other non-Japanese-speaking Sansei. The barrier of age is compounded by the barrier of spoken language — where does the 'true' story lie? The question is asked out of a position of healing.

"Ten Cents a Dance" was screened in 1985 at the Festival of Festivals, and was subsequently shown across North America in galleries and festivals. "The Displaced View" also garnered considerable acclaim, being nominated for a Genie Award. Onodera has gone on to develop work for the CBC's "Inside Stories" anthology and to make film and videos like "Hotel Hoteru," a whimsical story of the power of belief in the self about a Japanese-Canadian Elvis impersonator. Her intention here was to develop "multi-dimensional characters who reflect a variety of experiences," characters who "share with her a multi-ethnic background with mass media influences."[7]

"It doesn't matter if it's a racial issue or an issue of sexuality. It comes down to the same thing, the question of being different, and saying 'Yes I'm different, so what?'"[8] Onodera's films probe the complexities of personal identity informed by "a celebration of the acceptance of self, not only as a Japanese-Canadian, but as a woman, person of colour, lesbian, immigrant."[9] Her work moves beyond any one of these categories to reaffirm the sensibility of an artist working on many levels, an artist who sees herself first and foremost as a film-maker. ✑

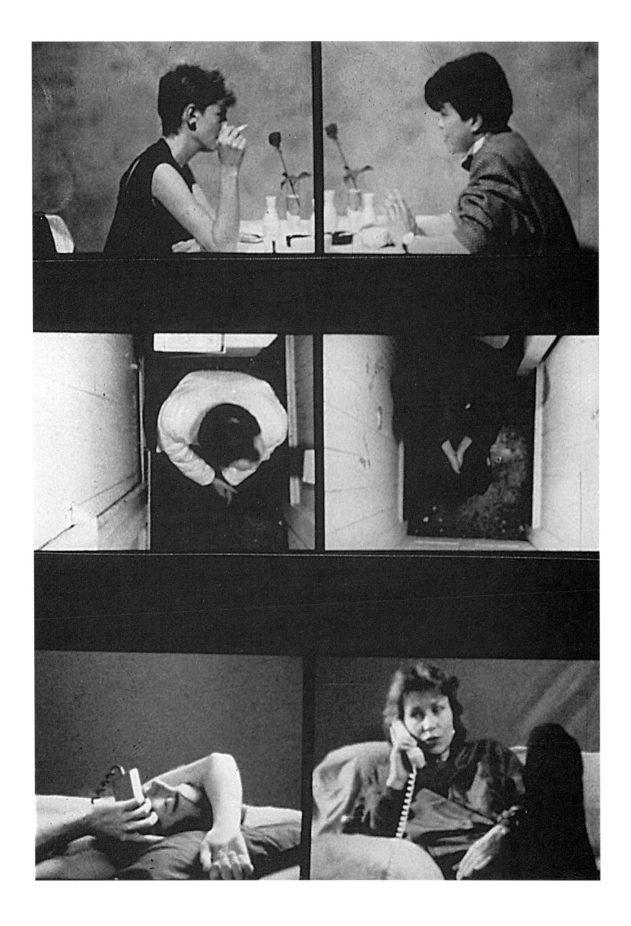

# NOTES

SOFONISBA ANGUISSOLA p. 18

1  Ann Sutherland Harris and Linda Nochlin, *Women Artists: 1550–1950* (New York: Alfred A. Knopf, 1981), 106.

2  Nancy G. Heller, *Women Artists: An Illustrated History* (New York: Abbeville Press, 1987), 15-16.

3  Harris and Nochlin, *Women Artists*, 107.

4  Whitney Chadwick, *Women, Art and Society* (London: Thames and Hudson, 1996), 77.

5  Karen Petersen and J. J. Wilson, *Women Artists: Recognition and Reappraisal, From the Early Middle Ages to the Twentieth Century* (New York: Harper and Row Colophon, 1976), 26.

ARTEMISIA GENTILESCHI p. 20

1  Karen Petersen and J.J. Wilson, *Women Artists: Recognition and Reappraisal, From the Early Middle Ages to the Twentieth Century* (New York: Harper and Row Colophon, 1976), 29.

2  Ann Sutherland Harris and Linda Nochlin, *Women Artists: 1550–1950* (New York: Alfred A. Knopf, 1981), 118.

3  Whitney Chadwick, *Women, Art and Society* (London: Thames and Hudson, 1996), 113.

4  Harris and Nochlin, *Women Artists*, 118.

JUDITH LEYSTER p. 22

1  Whitney Chadwick, *Women, Art and Society* (London: Thames and Hudson, 1996), 22.

2  Ann Sutherland Harris and Linda Nochlin, *Women Artists: 1550–1950* (New York: Alfred A. Knopf, 1981), 91.

3  Eleanor Tufts, *Our Hidden Heritage — Five Centuries of Women Artists* (London: Paddington Press, 1974), 159.

4  Harris and Nochlin, *Women Artists*, 138.

RACHEL RUYSCH p. 24

1  Eleanor Tufts, *Our Hidden Heritage — Five Centuries of Women Artists* (Paddington Press, London, 1974), 101.

2  Nancy G. Heller, *Women Artists: An Illustrated History* (New York: Abbeville Press, 1987), 41.

3  Germaine Greer, *The Obstacle Race: The Fortunes of Women Painters and Their Work* (London: Secker and Warburg, 1979), 35.

4  Ann Sutherland Harris and Linda Nochlin, *Women Artists: 1550–1950* (New York: Alfred A. Knopf, 1981), 160.

5  Harris and Nochlin, *Women Artists*, 158.

FRANÇOISE DUPARC p. 26

1  Ann Sutherland Harris and Linda Nochlin, *Women Artists: 1550–1950* (New York: Alfred A. Knopf, 1981), 171.

2  Ibid., 172.

ANGELICA KAUFFMANN p. 28

1  Eleanor Tufts, *Our Hidden Heritage — Five Centuries of Women Artists* (London: Paddington Press, 1974), 120.

2  Ann Sutherland Harris and Linda Nochlin, *Women Artists: 1550–1950* (New York: Alfred A. Knopf, 1981), l75.

3  Tufts, *Our Hidden Heritage*, 118.

ELISABETH VIGÉE-LEBRUN p. 30

1  Eleanor Tufts, *Our Hidden Heritage — Five Centuries of Women Artists* (London: Paddington Press, 1974), 128.

2  Ibid., 130.

3  Karen Petersen and J.J. Wilson, *Women Artists: Recognition and Reappraisal, From the Early Middle Ages to the Twentieth Century* (New York: Harper and Row Colophon, 1976), 53.

4  Nancy G. Heller, *Women Artists: An Illustrated History* (New York: Abbeville Press, 1987), 60.

SUSANNA MOODIE p. 32

1  Carl Ballstadt, Elizabeth Hopkins and Michael Peterman, eds., *Susanna Moodie: Letters of a Lifetime* (Toronto: University of Toronto Press, 1985),253.

2  Ibid., 231.

3  Maria Tippett, *By a Lady: Celebrating Three Centuries of Art by Canadian Women* (Toronto: Viking/Penguin, 1992), 16.

4  Ballstadt, Hopkins and Peterman, *Susanna Moodie*, 199.

5  Tippett, *By a Lady*, 15.

ANNE WHITNEY p. 34

1  Nancy G. Heller, *Women Artists: An Illustrated History* (New York: Abbeville Press, 1987), 84.

2  Eleanor Tufts, *Our Hidden Heritage — Five Centuries of Women Artists* (London: Paddington Press, 1974), 161.

3  Karen Petersen and J.J. Wilson, *Women Artists: Recognition and Reappraisal, From the Early Middle Ages to the Twentieth Century* (New York: Harper and Row Colophon, 1976), 83.

4  Charlotte Streifer Rubinstein, *American Women Artists: from Early Indian Times to the Present* (New York: Avon Books, 1982), 83.

5  Petersen and Wilson, *Women Artists*, 84.

ROSA BONHEUR p. 36

1  Dore Ashton and Denise Brown Hare, *Rosa Bonheur: A Life and Legend* (New York: The Viking Press, 1981), 51.

2  Ashton, *Rosa Bonheur*, 282.

3  Ibid., 100.

HANNAH MAYNARD p. 38

1  Claire Weissman Wilks, *The Magic Box: The Eccentric Genius of Hannah Maynard* (Toronto: Exile Editions, 1980), 94.

EMILY OSBORN p. 40

1  Ann Sutherland Harris and Linda Nochlin, *Women Artists: 1550–1950* (New York: Alfred A. Knopf, 1981), 54.

2  Whitney Chadwick, *Women, Art and Society* (London: Thames and Hudson, 1996), 180

3  Harris and Nochlin, *Women Artists*, 55.

BERTHE MORISOT p. 42

1  A. Higonnet, *Berthe Morisot* (New York: Random House/Burlingame, 1990), 19.

2  Karen Petersen and J.J. Wilson, *Women Artists: Recognition and Reappraisal, From the Early Middle Ages to the Twentieth Century* (New York: Harper and Row Colophon, 1976), 91.

3 Mara R. Witzling, ed., *Voicing Our Visions: Writings by Women Artists* (New York: Universe, 1991), 64.

4 Ann Sutherland Harris and Linda Nochlin, *Women Artists: 1550–1950* (New York: Alfred A. Knopf, 1981), 244.

5 Petersen and Wilson, *Women Artists*, 91.

MARY CASSATT p. 44

1 Karen Petersen and J.J. Wilson, *Women Artists: Recognition and Reappraisal, From the Early Middle Ages to the Twentieth Century* (New York: Harper and Row Colophon, 1976), 87.

2 Ann Sutherland Harris and Linda Nochlin, *Women Artists: 1550–1950* (New York: Alfred A. Knopf, 1981), 240.

3 Jay Roudebush, *Mary Cassatt* (New York: Crown Publishers, 1979), 22.

4 Elaine Hedges and Ingrid Wendt, *In Her Own Image: Women Working in the Arts* (Old Westbury, New York: The Feminist Press/McGraw-Hill, 1980), 52.

EDMONIA LEWIS p. 46

1 Karen Petersen and J.J. Wilson, *Women Artists: Recognition and Reappraisal, From the Early Middle Ages to the Twentieth Century* (New York: Harper and Row Colophon, 1976), 82.

2 Charlotte Streifer Rubinstein, *American Women Artists: from Early Indian Times to the Present* (New York: Avon Books, 1982), 79.

3 Eleanor Tufts, *Our Hidden Heritage — Five Centuries of Women Artists* (London: Paddington Press, 1974), 163.

4 Nancy G. Heller, *Women Artists: An Illustrated History* (New York: Abbeville Press, 1987), 87.

5 Tufts, *Our Hidden Heritage*, 162.

FRANCES AND MARGARET MACDONALD p. 48

1 Thomas Haworth, *Charles Rennie Macintosh and the Modern Movement* (London: Routledge and Kegan Paul, 1977), 6.

2 Anthea Callen, *Women Artists of the Arts and Crafts Movement: 1870–1914* (New York: Pantheon, 1979), 159-60.

3 Haworth, *Charles Rennie Macintosh*, 40.

4 Ibid., 145.

SUZANNE VALADON p. 50

1 Germaine Greer, *The Obstacle Race: The Fortunes of Women Painters and Their Work* (London: Secker and Warburg, 1979), 66.

2 Eleanor Tufts, *Our Hidden Heritage — Five Centuries of Women Artists* (London: Paddington Press, 1974), 171.

3 Ann Sutherland Harris and Linda Nochlin, *Women Artists: 1550–1950* (New York: Alfred A. Knopf, 1981), 261.

4 Karen Petersen and J.J. Wilson, *Women Artists: Recognition and Reappraisal, From the Early Middle Ages to the Twentieth Century* (New York: Harper and Row Colophon, 1976), 97.

KÄTHE KOLLWITZ p. 52

1 Muriel Rukeyser's poem "Käthe Kollwitz" is quoted in Martha Kearns, *Käthe Kollwitz — Woman and Artist* (Old Westbury, New York: The Feminist Press, 1976), 227-31.

2 Renate Hinz, ed., *Käthe Kollwitz: Graphics, Posters, Drawings*, foreword by Lucy R. Lippard (New York: Pantheon 1981), xix.

3 Ann Sutherland Harris and Linda Nochlin, *Women Artists: 1550–1950* (New York: Alfred A. Knopf, 1981), 65.

4 Hinz, *Käthe Kollwitz: Graphics, Posters, Drawings*, xxiv.

5 Ibid., ix.

EMILY CARR p. 54

1 Marion Endicott, *The Story of Emily Carr* (Toronto: The Women's Press, 1981), 7.

2 Emily Carr, *Hundreds and Thousands* (Toronto: Clarke, Irwin and Co., 1966), xi.

3 Joan Murray, "A Century of Canadian Women Artists," *Art Impressions* 4, no. 2 (Summer 1988), 8–11.

4 Endicott, *The Story of Emily Carr*, 55.

5 Carr, *Hundreds and Thousands*, 301.

GWEN JOHN p. 56

1 Eleanor Tufts, *Our Hidden Heritage — Five Centuries of Women Artists* (London: Paddington Press, 1974), 199.

2 Ann Sutherland Harris and Linda Nochlin, *Women Artists: 1550–1950* (New York: Alfred A. Knopf, 1981), 271.

3 Karen Petersen and J.J. Wilson, *Women Artists: Recognition and Reappraisal, From the Early Middle Ages to the Twentieth Century* (New York: Harper and Row Colophon, 1976), 100.

4 Tufts, *Our Hidden Heritage*, 200.

5 Germaine Greer, *The Obstacle Race: The Fortunes of Women Painters and Their Work* (London: Secker and Warburg, 1979), 327.

META WARRICK FULLER p. 58

1 David Driskell, Lewis Levering and Deborah Willis Ryan, *Harlem Renaissance: Art of Black America* (New York: The Studio Museum in Harlem, 1987), 14.

2 *Black Art — Ancestral Legacy: The African Impulse in African-American Art* (exhibition catalogue, New York: Harry N. Abrams/ Dallas Museum of Art, 1989), 73.

VANESSA BELL p. 60

1 Germaine Greer, *The Obstacle Race: The Fortunes of Women Painters and Their Work* (London: Secker and Warburg, 1979), 57.

2 Ann Sutherland Harris and Linda Nochlin, *Women Artists: 1550–1950* (New York: Alfred A. Knopf, 1981), 284.

3 Ibid., 284.

4 Whitney Chadwick, *Women, Art and Society* (London: Thames and Hudson, 1996), 257.

5 Harris and Nochlin, *Women Artists*, 6.

6 Karen Petersen and J. J. Wilson, *Women Artists: Recognition and Reappraisal, From the Early Middle Ages to the Twentieth Century* (New York: Harper and Row Colophon, 1976), 106.

HELEN McNICOLL p. 62

1 Paul Duval, *Canadian Impressionism* (Toronto: McClelland and Stewart, 1990), 92.

2 Maria Tippett, *By a Lady: Celebrating Three Centuries of Art by Canadian Women* (Toronto: Viking, 1992), 48.

3 Joan Murray, *Impressionism in Canada: 1895-1935* (exhibition catalogue, Toronto: Art Gallery of Ontario, 1973), 8.

4 Ibid., 53.

5 Duval, *Canadian Impressionism*, 94.

NATALIA GONCHAROVA p. 64

1 Rozsika Parker, *The Subversive Stitch: Embroidery and the Making of the Feminine* (London: The Women's Press, 1984), 193.

2 Eleanor Tufts, *Our Hidden Heritage — Five Centuries of Women Artists* (London: Paddington Press, 1974), 212.

3 Ann Sutherland Harris and Linda Nochlin, *Women Artists: 1550–1950* (New York: Alfred A. Knopf, 1981), 63.

4 Whitney Chadwick, *Women, Art and Society* (London: Thames and Hudson, 1996), 265.

5 Tufts, *Our Hidden Heritage*, 212.

FRANCES LORING AND FLORENCE WYLE p. 66

1 Rebecca Sisler, *The Girls: A Biography of Frances Loring and Florence Wyle* (Toronto: Clarke, Irwin and Co., 1972), 20.

2 Ibid., 22.

3 Christine Boyanoski, *Loring and Wyle: Sculptors' Legacy* (Toronto: Art Gallery of Ontario, 1987), 10.

4 Sisler, *The Girls*.

5 Boyanoski, *Loring and Wyle*.

6 Ibid.

GEORGIA O'KEEFFE p. 68

1 Mara R. Witzling, ed., *Voicing Our Visions: Writings by Women Artists* (New York: Universe, 1991), 6

2 Witzling, *Voicing Our Visions*, 218.

3 Georgia O'Keeffe, *Georgia O'Keeffe* (New York: The Viking Press, A Studio Book, 1976), unpaginated.

4 Ann Sutherland Harris and Linda Nochlin, *Women Artists: 1550–1950* (New York: Alfred A. Knopf, 1981), 306.

5 Ibid., 304.

DOROTHEA LANGE p. 70

1 Jan Arrow, *Dorothea Lange* (Masters of Photography Series, London: Macdonald and Co. Ltd., 1985), 5.

2 Ibid., 7.

3 Peter Pollack, *The Picture History of Photography: from the Earliest Beginnings to the Present Day* (New York: Harry N. Abrams Inc., 1977), 102.

KAY SAGE p. 72

1 Ann Sutherland Harris and Linda Nochlin, *Women Artists: 1550–1950* (New York: Alfred A. Knopf, 1981), 320.

2 Mara R. Witzling, ed., *Voicing Our Visions: Writings by Women Artists* (New York: Universe, 1991), 231.

PARASKEVA CLARK p. 74

1 Janice Cameron et al., eds., *Eclectic Eve* (Toronto: OFY Project, 1973), unpaginated.

2 Christopher Hume, "Painting is Not a Woman's Job," *The Toronto Star*, 29 January 1983.

3 *The Globe and Mail*, 13 June 1988.

4 David Miller, "Gifted Political Artist Paraskeva Clark Dies,"*The Toronto Star*, 12 August 1986.

LOUISE NEVELSON p. 76

1 Cindy Nemser, *Art Talk: Conversations with Twelve Women Artists* (New York: Charles Scribner's Sons, 1975), 55.

2 Elizabeth Fisher, "The Woman as Artist, Louise Nevelson," *Aphra* 1 (Spring, 1970), 32.

3 Nemser, *Art Talk*, 53.

4 Karen Petersen and J.J. Wilson, *Women Artists: Recognition and Reappraisal, From the Early Middle Ages to the Twentieth Century* (New York: Harper and Row Colophon, 1976), 123.

5 Nemser, *Art Talk*, 61.

6 Ibid., 56.

7 Ibid., 60.

8 Charlotte Streifer Rubinstein, *American Women Artists: from Early Indian Times to the Present* (New York: Avon, 1982), 310.

ALICE NEEL p. 78

1 Cindy Nemser, *Art Talk: Conversations with Twelve Women Artists* (New York: Charles Scribner's Sons, 1975), 122.

2 Nemser, *Art Talk*, 123.

3 *National Museum of Women in the Arts* (New York: Harry N. Abrams Inc., 1984), 88.

4 Nemser, *Art Talk*, 130.

5 *National Museum of Women in the Arts*, 88.

ALEXANDRA LUKE p. 80

1 *Daily Times Gazette* (Oshawa), 8 April 1950.

2 Alexandra Luke, "Art Thoughts," *Daily Times Gazette*, 1 June 1951.

3 Alexandra Luke, "Artist's Statement for the Canadian Abstract Exhibition" (1952).

4 Joan Murray, *Alexandra Luke: Continued Searching* (exhibition catalogue, Oshawa: The Robert McLaughlin Gallery, 1987).

ISABEL BISHOP p. 82

1 Charlotte Streifer Rubinstein, *American Women Artists: from Early Indian Times to the Present* (New York: Avon Books, 1982), 231.

2 Ann Sutherland Harris and Linda Nochlin, *Women Artists: 1550–1950* (New York: Alfred A. Knopf, 1981), 325.

3 Ibid., 325.

BARBARA HEPWORTH p. 84

1 Karen Petersen and J. J. Wilson, *Women Artists: Recognition and Reappraisal, From the Early Middle Ages to the Twentieth Century* (New York: Harper and Row Colophon, 1976), 120.

2 Cindy Nemser, *Art Talk: Conversations with Twelve Women Artists* (New York: Charles Scribner's Sons, 1975), 25.

3 Nemser, *Art Talk*, 17.

4 Ibid., 14.

5 *National Museum of Women in the Arts* (New York: Harry N. Abrams Inc., 1984), 118.

PITSEOLAK p. 86

1 John Reeves, "Cape Dorset Women," *City and Country Home* (April 1985), 43.

2 Dorothy Eber, ed., *Pitseolak: Pictures Out of My Life* (Montreal: Design Collaboration Books, 1971), unpaginated.

3 Ibid.

4 O. Leroux, M.E. Jackson and M.A. Freeman, *Inuit Women Artists: Voices from Cape Dorset* (Vancouver/Toronto: Douglas and McIntyre, 1994).

LOIS MAILOU JONES p. 88

1 Karen Petersen and J.J. Wilson, *Women Artists: Recognition and Reappraisal, From the Early Middle Ages to the Twentieth Century* (New York: Harper and Row Colophon, 1976), 125.

2 *Black Art — Ancestral Legacy: The African Impulse in African-American Art* (exhibition catalogue, New York: Harry N. Abrams/ Dallas Museum of Art, 1989), 21.

3 Betty LaDuke, "The Grande Dame of Afro-American Art: Lois Mailou Jones," *Sage, A Journal of Black Women* 4, no. 1 (Spring 1987), 53.

4 Charlotte Streifer Rubinstein, *American Women Artists: from Early Indian Times to the Present* (New York: Avon Books, 1982), 227.

5 LaDuke, "The Grande Dame of Afro-American Art: Lois Mailou Jones," 53.

6 Ibid., 57.

LEE KRASNER p. 90

1 Cindy Nemser, *Art Talk: Conversations with Twelve Women Artists* (New York: Charles Scribner's Sons, 1975), 85.

2 Ibid., 86.

3 Nancy G. Heller, *Women Artists: An Illustrated History* (New York: Abbeville Press, 1987), 164.

4 Nemser, *Art Talk*, 99.

5 Ann Sutherland Harris and Linda Nochlin, *Women Artists: 1550–1950* (New York: Alfred A. Knopf, 1981), 332.

6 Ibid., 333.

7 Nemser, *Art Talk*, 89.

FRIDA KAHLO p. 92

1 Mara R. Witzling, ed., *Voicing Our Visions: Writings by Women Artists* (New York: Universe, 1991), 289.

2 Ibid., 291.

3 Ann Sutherland Harris and Linda Nochlin, *Women Artists: 1550–1950* (New York: Alfred A. Knopf, 1981), 336.

4 Ibid.

DORIS MCCARTHY p. 94

1 Doris McCarthy, *A Fool in Paradise: An Artist's Early Life* (Toronto: Macfarlane Walter and Ross, Publishers, 1990), 61.

2 Doris McCarthy, *The Good Wine: An Artist Comes of Age* (Toronto: Macarlane Walter and Ross, Publishers, 1991), 43.

3 McCarthy, *The Good Wine*, 112.

4 Ibid., 118.

5 John Bentley Mays, "Portraits of the Edge of the World," *The Globe and Mail*, 31 October 1980, 19.

AGNES MARTIN p. 96

1 John Bentley Mays, "Simple gifts," *The Globe and Mail*, 7 November 1992, C15.

2 Barbara Haskell, *Agnes Martin* (exhibition catalogue with essays by Barbara Haskell, Anna Chavew and Rosalind Krauss, New York: Whitney Museum of American Art, 1992), 96.

3 Ibid., 107.

4 Cindy Richards and Lawrence Lin, *Agnes Martin* (exhibition catalogue, Regina: Mackenzie Art Gallery, 1995), 11.

5 Régine Basha, *Diary of a Human Hand: Betty Goodwin, Brice Marden, Agnes Martin, Susan Rothenberg* (exhibition catalogue, Montreal: Gallery of the Saidye Bronfman Centre for the Arts, 1996,) 12.

6 Haskell, *Agnes Martin*, 28.

7 Dieter Schwartz, ed., *Writings = Shriften/Agnes Martin* (Ostfildern: Cantz-Verlag, 1993), 55.

ELIZABETH CATLETT p. 98

1 Mara R. Witzling, ed., *Voicing Our Visions: Writings by Women Artists* (New York: Universe, 1991), 345.

2 Ibid., 336.

3 Betty LaDuke, *Women Artists: Multi-Cultural Visions* (Trenton, NJ: Red Sea Press Inc., 1992), 130.

4 Brian Lanker, *I Dream a World: Portraits of Black Women Who Changed America* (New York: Stewart, Tabori and Chang, 1989), 122.

5 LaDuke, *Women Artists*, 133.

6 Witzling, *Voicing Our Visions*, 343.

DAPHNE ODJIG p. 100

1 Elizabeth McLuhan and R.M. Vanderburgh, *Daphne Odjig — A Retrospective 1946–1985* (exhibition catalogue, Thunder Bay, Ontario: Thunder Bay National Exhibition Centre and Centre Fox Indian Art, 1985).

2 Ibid, 9.

3 Ibid.

4 Ibid., 16.

5 Bernard Cinader, *Contemporary Art of Canada — The Woodland Indians* (Toronto: Royal Ontario Museum Ethnology Department, 1976).

6 McLuhan and Vanderburgh, *Daphne Odjig*, 29.

GATHIE FALK p. 102

1 Gathie Falk, *Statements by Gathie Falk* (Gathie Falk Retrospective, Vancouver: Vancouver Art Gallery, 1985), 17.

2 Jane Lind, *Gathie Falk* (Vancouver/Toronto: Douglas and McIntyre, 1989), 24.

3 John Bentley Mays, "Christian Faith Permeates Work of Artangel Falk," *The Globe and Mail*, 24 March 1990, C15.

4 Falk, *Statements by Gathie Falk*, 21.

5 Lind, *Gathie Falk*, 20.

HELEN FRANKENTHALER p. 104

1 Cindy Nemser, *Art Talk: Conversations with Twelve Women Artists* (New York: Charles Scribner's Sons, 1975), 169.

2 Whitney Chadwick, *Women, Art and Society* (London: Thames and Hudson, 1996), 328.

3 Chadwick, *Women, Art and Society*, 326.

4 Rozsika Parker and Griselda Pollock, *Old Mistresses: Women, Art and Ideology* (New York: Pantheon Books, 1981), 149.

5 Charlotte Streifer Rubinstein, *American Women Artists: from Early Indian Times to the Present* (New York: Avon Books, 1982), 328.

6 Ibid., 330.

BESSIE HARVEY p. 106

1 *Black Art — Ancestral Legacy: The African Impulse in African-American Art* (exhibition catalogue, New York: Harry N. Abrams/ Dallas Museum of Art, 1989), 46.

2 Shari Cavin Morris, "Bessie Harvey: The Spirit in the Wood," *The Clarion* 12, no. 2/3 (Spring/Summer 1987),46.

3 Lucy Lippard, *Mixed Blessings: New Art in Multicultural America* (New York: Pantheon, 1990), 66.

4 Morris, "Bessie Harvey: The Spirit in the Wood," 45.

5 *Black Art — Ancestral Legacy*, 47.

6 Ibid., 223.

MARISOL p. 108

1 Charlotte Streifer Rubinstein, *American Women Artists: from Early Indian Times to the Present* (New York: Avon Books, 1982), 347.

2 Cindy Nemser, *Art Talk: Conversations with Twelve Women Artists* (New York: Charles Scribner's Sons, 1975), 188.

3 Ibid., 187.

4 Ibid., 182.

5 Ibid.

FAITH RINGGOLD p. 110

1 Thalia Gouma-Peterson, *Modern Dilemma Tales: Faith Ringgold's Story Quilts* (New York: Fine Arts Museum of Long Island, 1990), 23.

2 Lucy Lippard, *Get The Message: A Decade of Art for Social Change* (New York: J.P. Dutton, 1984), 244.

3 Eleanor Munro, *The Originals: American Women Artists* (New York: Simon and Schuster, 1979), 410.

4 Charlotte Streifer Rubinstein, *American Women Artists: from Early Indian Times to the Present* (New York: Avon, 1982), 427.

5 "Interviewing Faith Ringgold: A Contemporary Heroine," *Sage, A Journal of Black Women* IV, no. 1, 7.

6 Rubinstein, *American Women Artists*, 927.

AUDREY FLACK p. 112

1 Cindy Nemser, *Art Talk: Conversations with Twelve Women Artists* (New York: Charles Scribner's Sons, 1975), 306.

2 Ibid., 305.

3 Ibid., 308.

4 Ibid.

5 Ibid., 313.

JOYCE WIELAND p. 114

1 Judy Steed, "A life of fire and pain," *The Toronto Star*, 8 September 1996, C1.

2 Adele Freedman, "Roughing it with a Brush," *Toronto Magazine* (April, 1987), 79.

3 Lucy Lippard, *Watershed, Joyce Wieland* (exhibition catalogue, Toronto: Art Gallery of Ontario/Key Porter Books, 1987), 6.

4 Charlotte Townsend-Gault, "Redefining the Role," in R. Bringhurst, G. James, R. Keziere and D. Shadbolt, eds., *Visions: Contemporary Art in Canada* (Vancouver: Douglas and McIntyre, 1983), 125.

5 Marie Fleming, *Joyce Wieland, Joyce Wieland* (exhibition catalogue, Toronto: Art Gallery of Ontario/Key Porter Books, 1987), 71.

6 Susan Crean, "Forbidden Fruit: The Erotic Nationalism of Joyce Wieland," *This Magazine* 21 no. 4 (August/September 1987), 16.

MARYON KANTAROFF p. 116

1 Sol Littman, "Liberationist Ideals Appear in Sculptures,"*The Toronto Star*, 5 March 1974, PE8.

2 *Peterborough Examiner*, 28 March 1984.

3 Ibid.

4 Johanna Stuckey and Eric Stanford, *Images of Origin: Sculpture by Maryon Kantaroff* (exhibition catalogue, Toronto: Prince Arthur Galleries, 1979), 10.

5 Ibid., 13.

MARY PRATT p. 118

1 Christopher Hume, "Mary Pratt, Turning on to Everyday Objects," *Art Impressions*, 20–22.

2 Mayo Graham, *Some Canadian Women Artists* (Ottawa: National Gallery of Canada, 1975), 55.

3 Ibid.

4 Ibid.

5 Paddy O'Brien, "Mary Pratt," *Canadian Woman Studies* (Spring 1982).

6 Tom Smart, *The Art of Mary Pratt: The Substance of Light* (Fredericton, NB: Goose Lane Editions and the Beaverbrook Art Gallery, 1995), 100.

7 Ibid., front jacket flap.

8 Christopher Hume, "Mary Pratt Lives to Paint," *The Toronto Star*, 16 June 1996, B1.

EVA HESSE p. 120

1 Rozsika Parker and Griselda Pollock, *Old Mistresses: Women, Art and Ideology* (New York: Pantheon Books, 1981), 155.

2 Charlotte Streifer Rubinstein, *American Women Artists: from Early Indian Times to the Present* (New York: Avon Books, 1982), 370.

3 Ellen H. Johnson, *Drawing in Eva Hesse's Work* (exhibition catalogue, Oberlin, Ohio: Allen Memorial Art Museum, Oberlin College, April 20 to May 30, 1982), 25.

4 Ibid., 70.

CHRISTIANE PFLUG p. 122

1 Colin S. Macdonald, *Dictionary of Canadian Artists* (Ottawa, Canadian Paperbacks Publishing, 1968).

2 Mary Allodi, *artscanada* 174/175 (December/January 1972/73), 42–47.

3 Ibid.

4 Ibid.

5 *Christiane Pflug* (exhibition catalogue, Winnipeg: The Winnipeg Art Gallery, 1974), unpaginated.

AGANETHA DYCK p. 124

1 Joan Borsa, "Beework: The Absent Bride, Intimate Acts and Interior Movements," essay in *Aganetha Dyck* (exhibition catalogue, Winnipeg: Winnipeg Art Gallery and St. Norbert Arts and Cultural Centre, 1995), 51.

2 Nancy Tousley, "Aganetha Dyck," *Canadian Art* 9, no. 3 (Fall, 1992), 61.

3 "Aganetha Dyck," (Exhibition Companion Number One, The Lateral Gallery at Women in Focus), unpaginated.

4 Tousley, "Aganetha Dyck," 63.

5 Ibid., 64.

6   Chris Dafoe, "Minding Her Beeswax," *The Globe and Mail*, 28 February 1996, C2.

7   Sigrid Dable, "Talking with Aganetha Dyck: A Ten Year Conversation," essay in *Aganetha Dyck* (exhibition catalogue, Winnipeg: Winnipeg Art Gallery and St. Norbert Arts and Cultural Centre, 1995), 27.

EVELYN ROTH  p. 126

1   Stephen Godfrey, "The Shapes of Roth," *The Globe and Mail*, 6 December 1986, E1.

2   Ibid.

3   Ibid.

4   Ibid.

5   Evelyn Roth, letter to the authors, 1989.

6   Evelyn Roth, *The Evelyn Roth Recycling Book* (Vancouver: Talonbooks, 1975).

AIKO SUZUKI  p. 128

1   G.M. Dault, *The Toronto Star*, 12 August 1978.

2   *The Globe and Mail*, 1 May 1985.

3   Ibid.

4   Lisa Balfour Bowen, "The Ceiling's the Limit for Fibre Art," *The Toronto Star*, 7 March 1981.

5   Ibid.

VERA FRENKEL  p. 130

1   John Noel Chandler, "Vera Frenkel: A Room with a View," *artscanada* 228/229 (August/September, 1979), 1.

2   Jay Scott, "Vera Frenkel," *Canadian Art* 9, no. 2 (Summer 1992), 46–51.

3   Elizabeth Legge, "Of Loss and Leaving," *Canadian Art* 13, no. 4 (Winter 1996), 62.

4   Ibid.

5   Ibid., 64.

6   Ibid., 63.

JUDY CHICAGO  p. 132

1   Judy Chicago, *The Dinner Party* (New York: Anchor Press/Doubleday, 1979), 252.

2   Karen Petersen and J.J. Wilson, *Women Artists: Recognition and Reappraisal, From the Early Middle Ages to the Twentieth Century* (New York: Harper and Row Colophon, 1976), 136.

3   Rozsika Parker and Griselda Pollock, *Old Mistresses: Women, Art and Ideology* (New York: Pantheon Books, 1981), 127.

4   Chicago, *The Dinner Party*, 8.

5   Petersen and Wilson, *Women Artists*, 38.

6   Chicago, *The Dinner Party*, 8.

JUNE CLARK  p. 134

1   Deirdre Hanna, "Minimalism Meets with Sentiment in Poignant Family Secrets Boxes," *NOW*, 2–8 July 1992, 55.

2   June Clark, "February," *The Women's Daybook 1990* (Toronto: Second Story Press, 1990), unpaginated.

3   Ibid.

4   June Clark, "April," *The Women's Daybook 1992* (Toronto: Second Story Press, 1991), unpaginated.

5   Clark, "February."

YOLANDA M. LOPEZ  p. 136

1   Betty LaDuke, *Women Artists: Multi-Cultural Visions* (Trenton, NJ: Red Sea Press Inc., 1992), 104.

2   Ibid.

3   Ibid., 105.

4   Lucy Lippard, *Mixed Blessings: New Art in Multicultural America* (New York: Pantheon, 1990), 42.

5   Ibid., 24.

6   LaDuke, *Women Artists*, 106.

7   Lippard, *Mixed Blessings*, 42.

8   LaDuke, *Women Artists*, 112.

MILLY RISTVEDT  p. 138

1   *Artists with their Work, Milly Ristvedt* (Toronto: Art Gallery of Ontario, Winter 1982/3).

2   Gail Dexter, *The Toronto Star*, 1 February 1969.

3   Milly Ristvedt, "A Critical Note on the Open Exhibition of Women's Art," *Mediart* 12 (December 1972), 28.

4   *Toronto Telegram*, 16 December 1967.

5   Karen Wilkin, *Exhibition Catalogue* (La Tour du Roy Rene, Marseilles: Triangle Artists' Workshop, 1995), 42.

6   Michael Greenwood, "A Selection of Painting in Toronto:the David Mirvish Gallery," *artscanada* 33 (April/May 1976), 73.

HELEN HARDIN  p. 140

1   Betty LaDuke, *Women Artists: Multi-Cultural Visions* (Trenton, NJ: Red Sea Press Inc., 1992), 92.

2   "Helen Hardin — Too Short a Life," *Santa Fe Reporter*, 6–12 December 1989, 30.

3   LaDuke, *Women Artists*, 86.

4   "Helen Hardin — Too Short a Life," 30.

5   Lou Ann Farrus Culley, "Helen Hardin: A Retrospective," *American Indian Art Magazine* 4, no. 3 (Summer 1979), 69.

6   *Southwest Visions Address Book* (Flagstaff, Arizona: Northland Publishing, 1993), 3.

COLETTE WHITEN  p. 142

1   John Chandler, "Persona: The Sculpture of Colette Whiten," *artscanada* 35 (April/May, 1978), 9.

2   Colette Whiten, "Colette Whiten," *artscanada* 34 (May/June 1977), 55.

3   Deirdre Hanna, "Whiten's Fine Needleworks Test Media Patterns," *Now*, 16 March 1992, 59.

4   Mayo Graham, *Some Canadian Women Artists* (Ottawa: National Gallery of Canada, 1975), 81.

NICOLE JOLICOEUR  p. 144

1   Monika Gagnon, "Nicole Jolicoeur, YYZ Gallery," *Parachute* 44 (1986), 63.

2   Nicole Jolicoeur, letter to authors, September 1989.

3   Carole Corbeil, "Nicole Jolicoeur, Drawings and Bookwork at YYZ," *The Globe and Mail*, 17 April 1986.

4   Gagnon, "Nicole Jolicoeur, YYZ Gallery," 62

JANA STERBAK  p. 146

1 Diana Nemiroff, *Jana Sterbak: States of Being* (exhibition catalogue, Ottawa: National Gallery of Canada, 1991), 24.

2 Sarah Milroy, "The Flesh Dress: A Defence," *Canadian Art* (Summer 1991), 71.

3 Ibid.

4 Marni Jackson, "The Body Electric," *Canadian Art* (Spring 1989), 70.

5 Jana Sterbak, interview with authors.

JAMELIE HASSAN  p. 148

1 Text from "Bench from Cordoba," 1982, an artwork by Jamelie Hassan which recreates a tiled bench through recollection of observed experience. The work is shown with a photograph of the actual bench in Spain, an 'actualization' across time and space.

2 Diana Nemiroff, *Songs of Experience* (exhibition catalogue, 1985), 99.

3 Ibid., 101.

4 Christopher Dewdney, *Jamelie Hassan, Material Knowledge: A Moral Art of Crisis* (exhibition catalogue, Ottawa: National Gallery of Canada/ London, Ontario: London Regional Art Gallery, 1984), 6.

5 Nemiroff, *Songs of Experience*, 104.

6 Judith Doyle, "Judith Doyle Interviews Jamelie Hassan," *Matriart, A Canadian Feminist Art Journal* 1 no. 1 (Spring 1990), 8.

7 Doyle, "Judith Doyle Interviews Jamelie Hassan," 9.

8 Jamelie Hassan, *Primer for War* (artist's statement, exhibition catalogue, Halifax, Nova Scotia: Art Gallery of Mt. St. Vincent University, 1985).

LIZ MAGOR  p. 150

1 John Bentley Mays, "Installation Art Wise Choice for Venice," *The Globe and Mail*, 28 January 1984, E11.

2 Artsnews press release on the 1984 Venice Biennale (London: Canada House Cultural Centre, November 1984).

3 Ibid.

4 John Lowndes, "Review of Exhibit by Liz Magor at the V-SHAPED," *artscanada* 37, no. 3 (December/January 1981), 39.

5 John Bentley Mays, "Liz Magor Defies the March of Time," *The Globe and Mail*, 18 December 1982, 13.

JANICE GURNEY  p. 152

1 *Janice Gurney* (exhibition catalogue, New York: 49th Parallel Gallery, in association with Wynick/Tuck Gallery, 1989).

2 Andy Patton, "Civil Space," *Parachute* 31 (Summer 1983), 23.

3 Nancy Tousley, "Show Based on Female Experience," *Calgary Herald*, Friday, 17 May 1985, C5.

4 Barbara Fischer, *She Writes in White Ink* (exhibition catalogue, Banff, Alberta: The Banff Centre, The Walter Phillips Gallery, 1985), unpaginated.

SHIRLEY WIITASALO  p. 154

1 Mayo Graham, *Some Canadian Women Artists* (Ottawa: National Gallery of Canada, 1975), 104.

2 Gillian MacKay, "Radiant Days," *Canadian Art* 10, no. 1 (Spring 1993), 46.

3 Ibid., 47.

4 Philip Monk, *Shirley Wiitasalo* (Toronto: Art Gallery of Ontario, 1987), 7.

5 Ibid., 8.

6 MacKay, "Radiant Days," 47.

BARBARA KLUNDER  p. 156

1 Bruce Gates with files from Brian Thomson, "Poster Has Flavor of Folk Arts," *The Financial Post*, 3 April 1989, 44.

2 Ibid. 43.

3 Barbara Klunder, interview with authors, September 1989.

4 Ibid.

5 Barbara Klunder, letter to authors, August 1989.

6 Barbara Klunder, *Artist's Statement* (exhibition catalogue, Toronto: Woodlawn Arts Foundation, 1995), 44.

7 Anne Hosier, "The Art of Survival," *Las Vegas Sun*, 24 July 1997, 4C.

8 Sheila Robertson, "Artists Face Horror of Breast Cancer," *The Star Phoenix* (Saskatoon), 10 February 1996, C16.

GRACE CHANNER  p. 158

1 Sarah Denison, ed., *Women On Site* (a project of the Community Arts Committee, Toronto: A Space, 1987), 32.

2 Nkiru Nzegwu, *The Creation ... of the African-Canadian Odyssey* (exhibition catalogue, Toronto: The Power Plant, 1992), 13.

3 Colin Campbell, "Lesbians on the Loose," *Fuse* (Spring 1987), 22-23

4 Denison, *Women on Site*, 16

5 Nzegwu, *The Creation ... of the African-Canadian Odyssey*, 13

6 Ibid., 13

7 Ibid., 14

REBECCA BELMORE  p. 160

1 Rebecca Belmore, "Autonomous Aboriginal High-Tech Teepee Trauma Mama," *Canadian Theatre Review* (Fall 1991), 44.

2 Lynne Sharman, "Report from Northern Ontario," *Fuse* 5 (September 1988), 26.

3 Belmore, "Autonomous Aboriginal High-Tech Teepee Trauma Mama," 45.

4 Ibid.

5 Rebecca Belmore, "Artist's Statement" (Toronto: Women's Art Resource Centre Files).

6 Shirley Bear, *Changers: A Spiritual Revival* (exhibition catalogue, Touring Exhibition of Contemporary Art by Women of Native Ancestry, Ottawa: National Indian Arts and Crafts Corporation, 1990).

7 Ibid.

8 Deirdre Hanna, "Low-budget Video Tracks Blockade's High Purpose," *NOW*, 8-14 October, 1992, 79.

MIDI ONODERA  p. 162

1 Francie Duran, "... Words from a Sansei," *Surface* (November 1990), 9.

2 Midi Onodera, "Artist's Statement," *Incite*, July 1983.

3 Midi Onodera, "FemFest Artist's Statement" (January 4, 1985).

4 Laiwan, "Midi Onodera Talks with Laiwan," *Angles* 5 no. 5 (May 1988), 15.

5 Danielle Comeau, "Margins of Memory," *Montreal Mirror*, November 1989, 3–9.

6 *The New Canadian* 53 no. 92 (November 24, 1989), 1.

7 Kat Motosune, *Nikkei Voice* (March 1991), 9.

8 C. McDowell and L. Waldorf, "Close-Up," *The Body Politic* (May 1986).

9 Laiwan, "Midi Onodera Talks with Laiwan," 15.

# SELECTED BIBLIOGRAPHY

## GENERAL

*Black Art — Ancestral Legacy: The African Impulse in African-American Art.* New York: Dallas Museum of Art/Harry N. Abrams, 1989.

Broude, Norma, and Mary D. Garrard. *Feminism and Art History: Questioning the Litany.* New York: Harper and Row, 1982.

Callen, Anthea. *Women Artists of the Arts and Crafts Movement, 1870-1914.* New York: Pantheon, 1979.

Chadwick, Whitney. *Women Art and Society.* 2d ed. London: Thames and Hudson, 1996.

Chicago, Judy. *The Complete Dinner Party.* New York: Anchor Press/Doubleday, 1980.

Del Castilo, R., T. McKenna, and V. Varbro Bejarano, eds. *Chicano Art: Resistance and Affirmation, 1965-1985.* Los Angeles: UCLA Wight Gallery, 1991.

Driskell, David, Lewis Levering, and Deborah Willis Ryan. *Harlem Renaissance, Art of Black America.* New York: The Studio Museum in Harlem, 1987.

Fine, Elsa Honig. *Women and Art: A History of Women Painters and Sculptors from the Renaissance to the Twentieth Century.* Montclair, New Jersey: Allanheld and Schram, 1978.

Greer, Germaine. *The Obstacle Race: The Fortunes of Women Painters and Their Work.* London: Secker and Warburg, 1979.

Harris, Ann Sutherland, and Linda Nochlin, eds. *Women Artists: 1550-1950.* New York: Alfred. A. Knopf, 1981.

Hedges, Elaine, and Ingrid Wend. *In Her Own Image: Women Working in the Arts.* Old Westerburg, New York: The Feminist Press/McGraw Hill, 1980.

Heller, Nancy G. *Women Artists: An Illustrated History.* New York: Abbeville Press, 1987.

Hess, Thomas B., and Elizabeth C. Baker, eds. *Art and Sexual Politics: Women's Liberation, Women Artists and Art History.* New York: Macmillan Publishing Co., 1973.

La Duke, Betty. *Women Artists: Multi-Cultural Visions.* Trenton, New Jersey: The Red Sea Press, 1992.

Lippard, Lucy. *From the Center: Feminist Essays on Women's Art.* New York: E.P. Dutton, 1976.

Mulvey, Laura. *Visual and Other Pleasures.* Bloomington: Indiana University Press, 1989.

*National Museum of Women in the Arts.* New York: Harry N. Abrams Inc., 1984.

Nemser, Cindy. *Art Talk: Conversations with Twelve Women Artists.* New York: Charles Scribner's Sons, 1975.

Parker, Rozsika. *The Subversive Stitch: Embroidery and the Making of the Feminine.* London: The Women's Press, 1984.

Parker, Rozsika, and Griselda Pollock. *Old Mistresses: Women, Art and Ideology.* New York: Pantheon Books, 1981.

Petersen, Karen, and J.J. Wilson. *Women Artists: Recognition and Reappraisal from the Early Middle Ages to the Twentieth Century.* New York: Harper and Row Colophon, 1976.

Petteys, Chris. *Women Artists: An International Dictionary of Women Artists Born before 1900.* Boston: G.K. Hall, 1985.

Pollock, Griselda. *Vision and Difference: Femininity, Feminism and the Histories of Art.* New York: Routledge, Chapman and Hall, 1988.

Raven, Arlene, Cassandra Langer, and Joanna Frueh, eds. *Feminist Art Criticism: An Anthology.* Ann Arbor: UMI Research Press, 1988.

Rubinstein, Charlotte Streifer. *American Women Artists: From Early Indian Times to the Present.* New York: Avon Books, 1982.

Tufts, Eleanor. *Our Hidden Heritage — Five Centuries of Women Artists.* London: Paddington Press, 1974.

Witzling, Mara R., ed. *Voicing Our Visions: Writings by Women Artists.* New York: Universe, 1991.

## CANADIAN

Bringhurst, Robert, Geoffrey James, Russell Keziere, and Doris Shadbolt, eds. *Visions: Contemporary Art in Canada.* Vancouver/Toronto: Douglas and McIntyre, 1983.

Burnett, David, and Marilyn Schiff. *Contemporary Canadian Art.* Edmonton: Hurtig Publishers, 1983.

Cameron, Janice, et al., eds. *Eclectic Eve.* Toronto: OFY Project, 1973.

Denison, Sarah, ed. *Women On Site.* Toronto: A Project of the Community Arts Committee, A Space, 1987.

Duval, Paul. *Canadian Impressionism.* Toronto: McClelland and Stewart, 1990.

Farr, Dorothy, and Natalie Luckyj. *From Women's Eyes: Women Painters in Canada.* Kingston: Agnes Etherington Art Centre, 1975.

Graham, Mayo. *Some Canadian Women Artists.* Ottawa: National Gallery of Canada, 1975.

Macdonald, Colin S. *Dictionary of Canadian Artists.* Ottawa: Canadian Paperbacks Publishing, 1968.

Nzegwu, Nkiru. *The Creation ... of the African-Canadian Odyssey.* Toronto: The Power Plant, 1992.

Reid, Dennis. *A Concise History of Canadian Painting.* 2d ed. Toronto: Oxford University Press, 1988.

Tippett, Maria. *By A Lady: Celebrating Three Centuries of Art by Canadian Women.* Toronto: Penguin, 1992.

## PERIODICALS

*Heresies: A Feminist Publication on Art and Politics*

*Matriart: A Canadian Feminist Art Journal*

*Calyx: A Journal of Art and Literature by Women*

## RESOURCES

Library, slides, course outlines, research materials:
*National Museum of Women's Art Library*
4849 Connecticut Ave. N.W., Washington, DC 2000

Library, slides, research materials, educational outreach activities:
*Women's Art Resource Centre (WARC)*
401 Richmond Street West, Suite 389, Toronto, ON M5V 3A8

# LIST OF ILLUSTRATIONS

KANTAROFF, MARYON *Daughter of the Moon* (1977). Bronze, Height: 51 cm, Courtesy of Maryon Kantaroff, Photo: Paul Buer, p. 116.

KAUFFMANN, ANGELICA *The Artist Hesitating Between the Arts of Music and Painting* (c. 1794). Oil on canvas, 58" x 85". This painting which hangs at Nostell Priory, Yorkshire has been reproduced by kind permission of the Winn family and the National Trust, p. 28.

KLUNDER, BARBARA *MonkeyBusinessMen Medicine Chest* (1994). Painted and collaged medicine chest, with embroidered bra, 18" x 24" x 6", "Survivors in Search of a Voice" Breast Cancer Show, 1994; Photo courtesy of Woodlawn Arts Foundation, Photo: Cheryl O'Brian, p. 156.

KOLLWITZ, KÄTHE *Solidarity — The Propeller Song* (1931–32). Lithograph, 56 x 83 cm, © Käthe Kollwitz 1997/Vis-Art Copyright Inc., p. 52.

KRASNER, LEE *Cornucopia* (1958). Oil on canvas, 229.8 x 177.8 cm, © 1997 The Pollock-Krasner Foundation/Artists Rights Society (ARS), NY; Photo: Robert Miller Gallery, p. 90.

LANGE, DOROTHEA *Migrant Mother, Nipomo, California* (1936). Gelatin-silver print, 31.9 x 25.2 cm, The Museum of Modern Art, New York. Purchase. Copy Print © 1997 The Museum of Modern Art, New York, p. 70.

LEWIS, EDMONIA *Old Arrow Maker* (modeled 1866). Marble, 54.5 x 34.5 x 34.0 cm, National Museum of American Art, Smithsonian Institution, Gift of Mr. and Mrs. Norman B. Robbins, p. 46.

LEYSTER, JUDITH *The Flute Player* (1630). Oil on canvas, 73 x 62 cm, © Photo Nationalmuseum, SKM Stockholm, p. 22.

LOPEZ, YOLANDA M. *Portrait of the Artist as the Virgin of Guadalupe* (1978). Oil pastel on paper, 22½" x 30", Courtesy of Yoland M. Lopez, p. 136.

LORING, FRANCES *The Furnace Girl* (1918–19). Metal, bronze, Height: 61.5 cm, Cat. no. 8502, Copyright Canadian War Museum; Photo: William Kent for Canadian War Museum, p. 66.

LUKE, ALEXANDRA *Surge into Summer* (c. 1950). Oil on canvas, From the collection of E. R. S. McLaughlin, p. 80.

MACDONALD, FRANCES AND MARGARET *Poster for the Institute of Fine Arts* (c. 1896). © Hunterian Art Gallery, University of Glasgow, Mackintosh Collection, p. 48.

MAGOR, LIZ *4 Boys and a Girl* (1979). 5 components: fabric, steel, organic clippings, glue, wood, 1 – "machine" press, each component: 30.0 x 179.0 x 83.9 cm, "machine" press: 81.0 x 183.0 x 83.9 cm, Collection of Art Gallery of Ontario, Purchase, 1985, Acc. no. 85/297; Permission courtesy of artist; Photo: William Wilson, AGO, p. 150.

MARISOL *Women and Dog* (1964). Wood, plaster, synthetic polymer, taxidermed dog head and miscellaneous items, Installed: 183.5 x 185.4 x 78.6 cm, Collection of the Whitney Museum of American Art, Purchase, with funds from the Friends of the Whitney Museum of American Art, 64.17a-g, Photograph © 1996, Whitney Museum of American Art, NY, Photo: Sandak/Macmillan; © Marisol 1997/Vis-Art Copyright Inc., p. 108.

MARTIN, AGNES *Falling Blue* (1963). Oil and pencil on canvas, 182.6 x 182. 9 cm, San Francisco Museum of Modern Art, Gift of Mr. and Mrs. Moses Lasky, p. 96.

MAYNARD, HANNAH *Self-Portrait* (C. 1894). British Columbia Archives and Records Service, Cat. #F-02852, p. 38.

McCARTHY, DORIS *Iceberg Fantasy #24* (1976). Oil on canvas, 152.4 x 213.4 cm, By kind permission of Doris McCarthy (represented by Wynick/Tuck Gallery), p. 94.

McNICOLL, HELEN GALLOWAY *Under the Shadow of the Tent* (1914). Oil on canvas, 83.5 x 101.2 cm, The Montreal Museum of Fine Arts, Gift of Mr. and Mrs. David McNicoll, 1915.122; Photo: The Montreal Museum of Fine Arts, p. 62.

MOODIE, SUSANNA *Bouquet of Garden Flowers* (1869). Watercolour on pencil, 36 x 31.1 cm, Courtesy of the Royal Ontario Museum, Toronto, Canada, p. 32.

MORISOT, BERTHE *Young Girl by the Window* (1878). Oil on canvas, 30" x 24", Musée Fabre, Montpellier, France, Photo: Fédéric Jaulmes, p. 42.

NEEL, ALICE *Margaret Evans Pregnant* (1978). Oil on canvas, 57¾"x 38" Courtesy of the Robert Miller Gallery, p. 78.

NEVELSON, LOUISE *Mirror-Shadow II* (1985). Wood painted black, 292.1 x 358.1 x 53.3 cm, By permission of the Estate of Louise Nevelson; Photo: PaceWildenstein, p. 76.

ODJIG, DAPHNE *Beauty in Transition* (1990). Acrylic, 30" x 38", Courtesy of Daphne Odjig, RCA; Photo: Courtesy of Gallery Phillip, p. 100.

O'KEEFFE, GEORGIA *Yellow Calla* (1926). Oil on fibreboard, 9⅜" x 12¾", National Museum of American Art, Washington, DC/Art Resource, NY; © 1997 The Georgia O'Keeffe Foundation/Artists Rights Society (ARS), NY p. 68.

ONODERA, MIDI *Ten Cents a Dance (Parallax)* (1985). Film stills, Courtesy of the artist, Photo: Midi Onodera, p. 162.

OSBORN, EMILY MARY *Nameless and Friendless* (1857). Oil on canvas, 86.4 x 111.8 cm, Private collection; Photo: Courtauld Institute of Art, p. 40.

PFLUG, CHRISTIANE *Kitchen Door with Esther* (1965). Oil on canvas, 63½" x 77", On loan to the National Gallery of Canada; Photo: Courtesy of Dr. Michael Pflug, p. 122.

PITSEOLAK *Woman Hiding from Spirit* (1968). Stone cut, 27" x 24½", By permission of the West Baffin Eskimo Co-operative Ltd., p. 86.

PRATT, MARY *Salmon on Saran* (1974). Oil on panel, 45.7 x 50.8 cm, Courtesy of Mary Pratt, p. 118.

RINGGOLD, FAITH *Tar Beach* (1988). Acrylic on canvas, fabric, 74" x 69", Collection of Solomon R. Guggenheim Museum, NY; Copyright © 1988 Faith Ringgold Inc., p. 110.

RISTVEDT, MILLY *After Rameau's Nephew* (1978). Acrylic on canvas, 198.1 x 228.6 cm, Collection of Agnes Etherington Art Centre, Queen's University, Kingston, Permanent Collection; Photo: Courtesy of the artist, p. 138.

ROTH, EVELYN *Shell Knit* (1974). Nylon fabric, life size, Courtesy of Evelyn Roth, p. 126.

RUYSCH, RACHEL *Flower Still Life* (after 1700). Oil on canvas, 75.6 x 60.6 cm, The Toledo Museum of Art, Toledo, Ohio, Purchased with funds from the Libbey Endowment, Gift of Edward Drummond Libbey, (1956.57), p. 24.

SAGE, KAY *I Saw Three Cities* (1944). Oil on canvas, 91.5 x 71.0 cm, The Art Museum, Princeton University, Gift of the Estate of Kay Sage Tanguy; Photo: Clem Fiori. p. 72.

STERBAK, JANA *Remote Control, I* (1989). Aluminum, canvas, motor in wheels, castors, batteries, 142 x 185 x 202 cm, Courtesy: Galerie Chantal Crousel, Paris; Photo: Kleinefenn, Paris, p. 146.

SUZUKI, AIKO *Lyra* (1981). Permanent fibre installation at Metro Toronto Reference Library; Permission courtesy of the artist; Photo: Applied Photography Ltd., p. 128.

VALADON, SUZANNE *Adam and Eve* (1909). Oil on canvas, 63¾" x 51⅝", Musée National d'Art Moderne, France, Collections Mnam/Cci/ Centre Georges Pompidou, Photo: Photothèque des collections du Mnam-Cci, Centre Georges Pompidou, Paris, p. 50.

VIGÉE-LEBRUN, LOUISE ELIZABETH *Self-portrait* (n.d.). Oil on canvas, Uffizi, Florence, Italy, Giraudon/Art Resource, NY, p. 30.

WHITEN, COLETTE *Family* (1977–78). Plaster and burlap, life size, Courtesy of Colette Whiten, p. 142.

WHITNEY, ANNE *Charles Sumner* (n.d.). Bronze, Courtesy Cambridge Historical Commission, p. 34.

WIELAND, JOYCE *The Water Quilt* (1970–71). Fabric, embroidery thread, thread, metal grommets, braided rope, ink on fabric, 121.9 x 121.9 cm, Art Gallery of Ontario, Toronto, Purchase with assistance from Wintario, 1977, Acc. no. 76/221; Photo: Larry Ostrom, AGO; © Joyce Wieland 1997/Vis-Art Copyright Inc., p. 114.

WIITASALO, SHIRLEY *Black and White* (1986). Oil on cavas, 167 x 213 cm, Collection of Allison and Allan Schwartz, Toronto, Photo: Courtesy of the artist, p. 154.

WYLE, FLORENCE *Noon Hour* (1918–19). Metal, bronze, Height: 64 cm, Cat. no. 8523, Copyright Canadian War Museum; Photo: William Kent for Canadian War Museum, p. 66.

# INDEX TO ARTISTS